LEONARDO

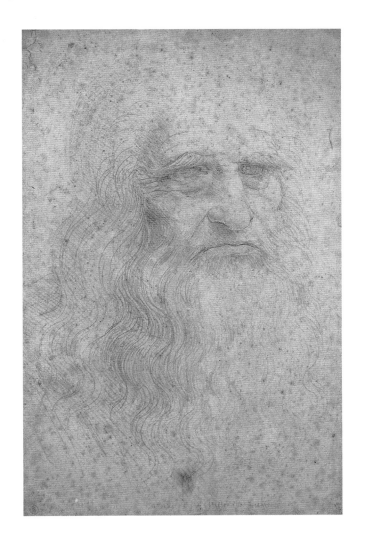

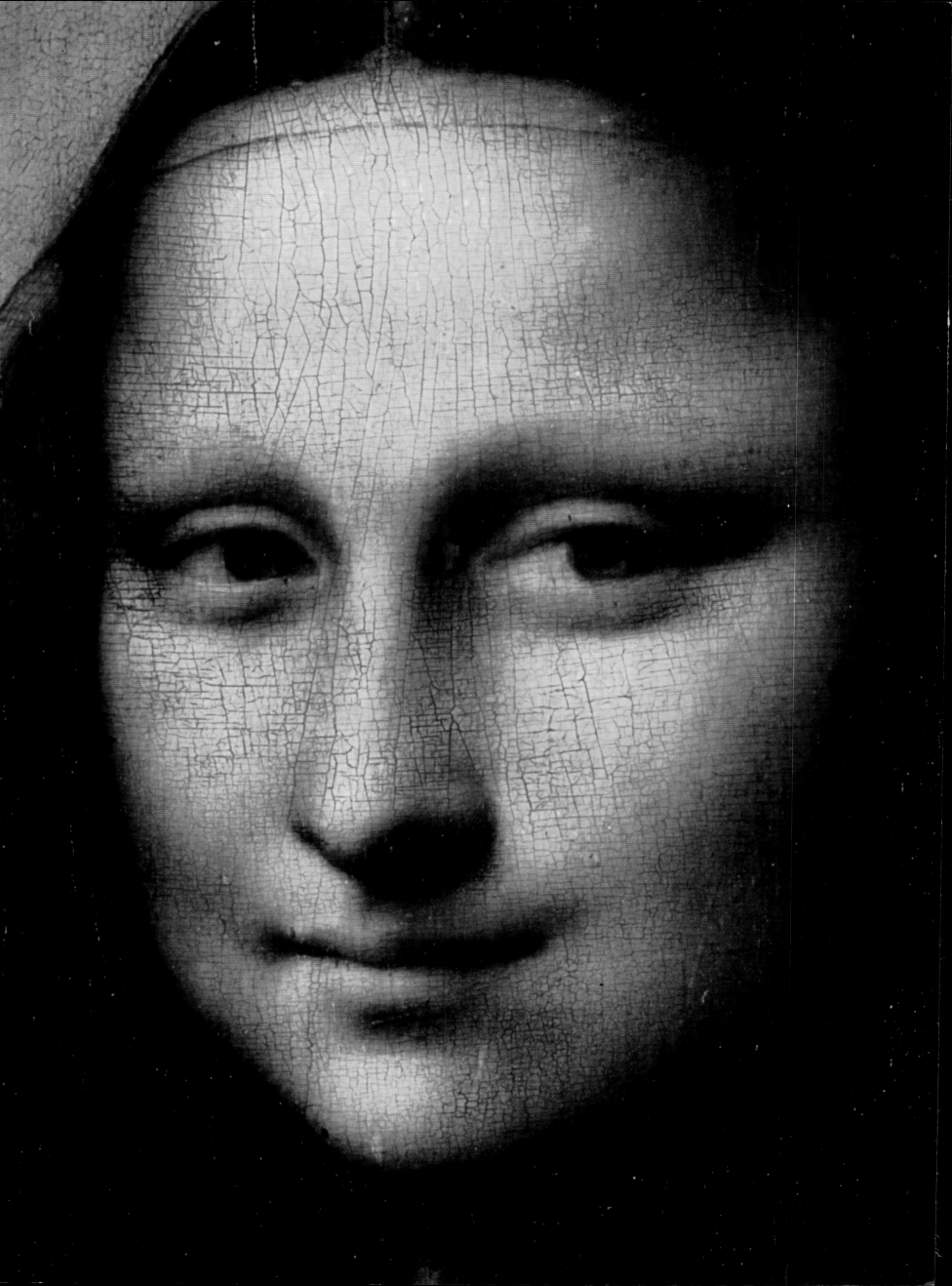

LEONARDO

Maria Costantino

SMITHMARK

This edition published in 1994 by SMITHMARK Publishers, a division of U.S. Media Holdings, Inc., 16 East 32nd Street New York, New York 10016.

SMITHMARK books are available for bulk purchase for sales promotion and premium use. For details write or telephone the Manager of Special Sales, SMITHMARK Publishers, a division of U.S. Media Holdings, Inc., 16 East 32nd Street, New York, NY 10016. (212) 532-6600.

Produced by Saturn Books Ltd Kiln House, 210 New Kings Road London SW6 4NZ

ISBN 0-8317-5698-5

Printed in China

10 9 8 7 6 5 4 3 2

PAGE 1: *Self-Portrait*, c.1516, Palazzo Reale, Turin.

PAGE 2: *Mona Lisa*, detail, c.1505-13, Musée du Louvre, Paris.

BELOW: *A Long-stemmed Plant*, c.1505-08, pen and ink over black chalk, 8⅝ × 9 inches, (21.2 × 23 cm), Windsor Castle, Royal Library 12429. © 1994 Her Majesty The Queen.

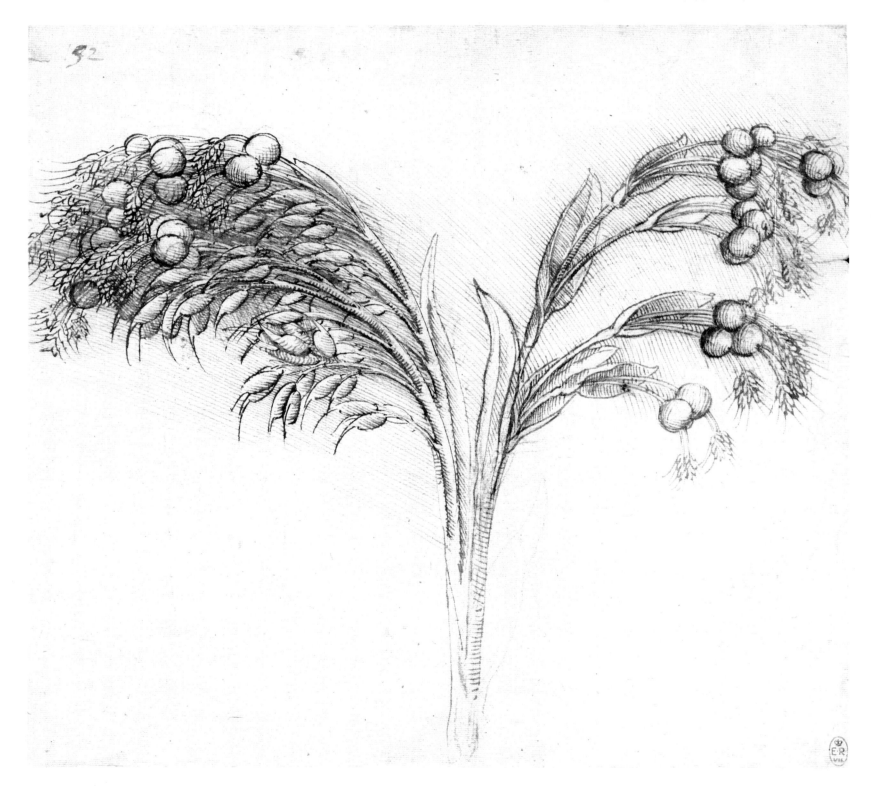

Contents

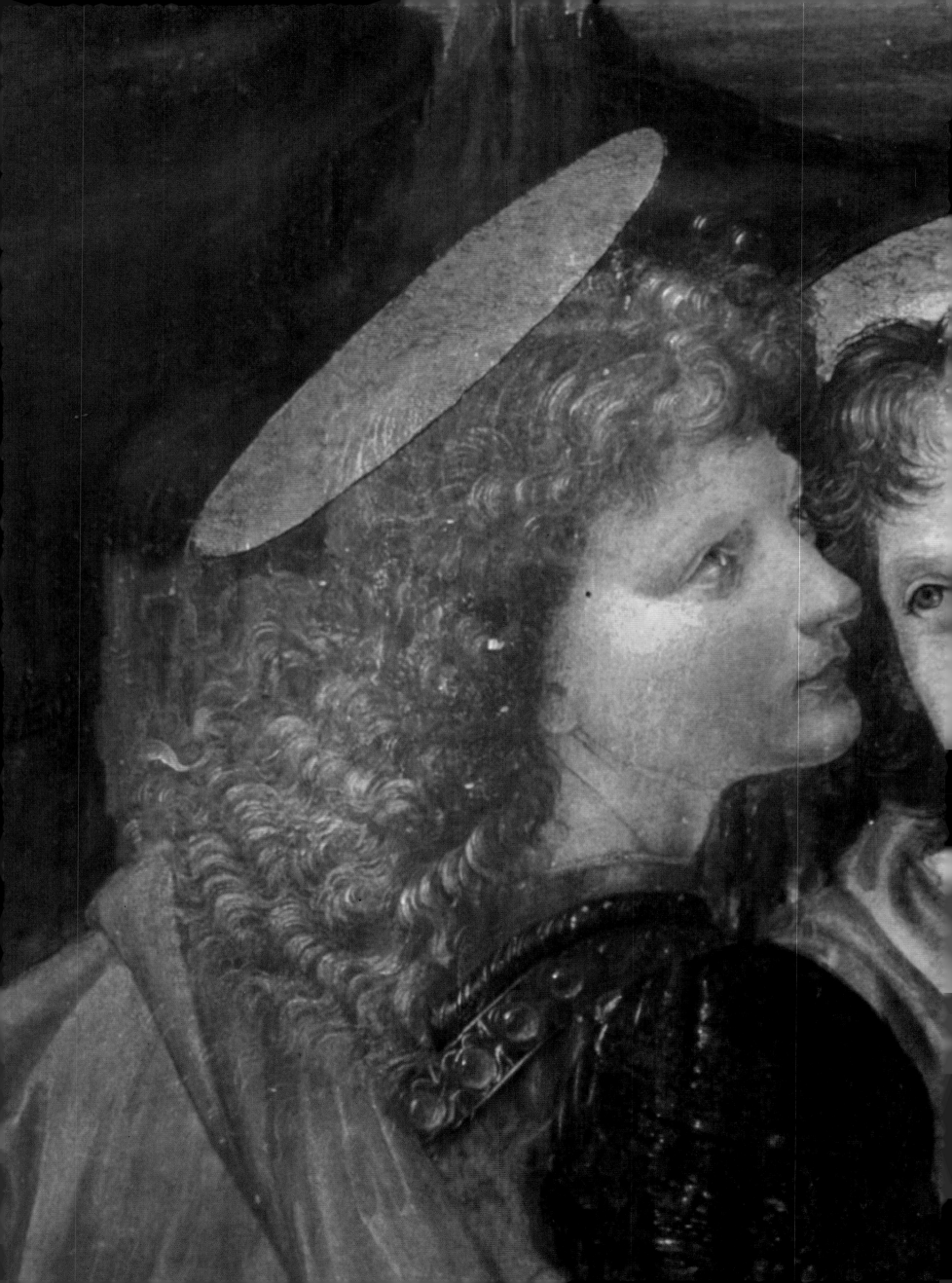

CHAPTER 1
Florence, 1452–82

Despite the fact that only about a dozen paintings can be attributed to him with any certainty, Leonardo da Vinci is remembered as one of the greatest artists of the Renaissance. Much of what has been written about Leonardo stemmed initially from the writings of Giorgio Vasari (1511-74), whose *Le Vite dei pittori, sculteri et architetti italiani* was written some fifty years after Leonardo's death. Vasari began his biography by saying:

Occasionally heaven sends us someone
who is not only human but divine . . .

Subsequent biographies, particularly those written in the nineteenth-century milieu of Romanticism, or following Freudian psychoanalytical tendencies in the twentieth century, have all added to the 'legend' of Leonardo. In his own time Leonardo was appreciated by a mere handful of his contemporaries.

In 1452, in a small village called Anchiano near to the Tuscan town of Vinci, Leonardo was born to Ser Piero — the 'Ser' before his name denoted the traditional family occupation of notary — and a woman variously called Chateria or Caterina. Caterina's origins are unclear but she seems to have been regarded in rather a low light; in the same year that Leonardo was born, his father married

another woman, Albiera di Giovanni Amadori. Ser Piero was in fact to marry four times, and had eleven other children by his third and fourth wives. By the time these children were born, Leonardo was already in his early twenties. In the municipal archive in Florence the documentary evidence (discovered only in 1930 by Emil Moeller) of Leonardo's birth reads: 'Born a grandson, son of Ser Piero, my son on the 15th of April.' This notice was written by grandfather Antonio and confirmed that Leonardo was accepted as a member of the family. The entry continues with a list of the people present at Leonardo's baptism, evidence that he was also accepted by the community as a Christian and a member of the Catholic Church. It has been said that Antonio hedged his bets: many of those present at the baptism were either tenants on his land or in some way in debt to him.

Nevertheless Leonardo was brought up by his mother Caterina for the first four years of his life, until she herself married a local man, Attacabrigi di Piero del Vacca, who was by trade a kiln builder. Leonardo then moved into the grander house in Vinci belonging to his father, where he grew up as an only child since his father's first two wives bore him no children. These facts have been deduced by historians from the fact that

grandfather Antonio first registered Leonardo as a dependent living with the family in his income tax return for 1457.

Antonio died in 1469, when Leonardo was aged about 16 or 17, and the family moved to another house in Vinci. They also rented the ground floor of a house in the Piazza di San Firenze, close to the Bargello, or prison, in Florence. Leonardo's father was now notary to the Signoria, the ruling council of Florence. According to Vasari, it was because Ser Piero was a friend of Andrea di Cione, better known to us as Andrea del Verrocchio (c.1435-88), that Leonardo entered his studio. Verrocchio was Florence's leading painter, goldsmith and sculptor, famed for his exquisite craftsmanship.

It was the usual practice at this time for boys to be appointed to a *bottegha* or workshop after their preliminary schooling had been completed around the age of 13. Apprenticeships lasted around six years with the newcomer progressing from pupil, cleaning brushes, preparing pigments and generally fetching and carrying, to assistant, who had learnt all the techniques and tricks of the trade from his master and was able to take a hand in painting commissions where the contract between the master and client allowed.

LEFT: *Baptism of Christ*, detail of an angel's head, believed to be by Leonardo, Andrea del Verrocchio, c.1473-78, Galleria degli Uffizi, Florence.

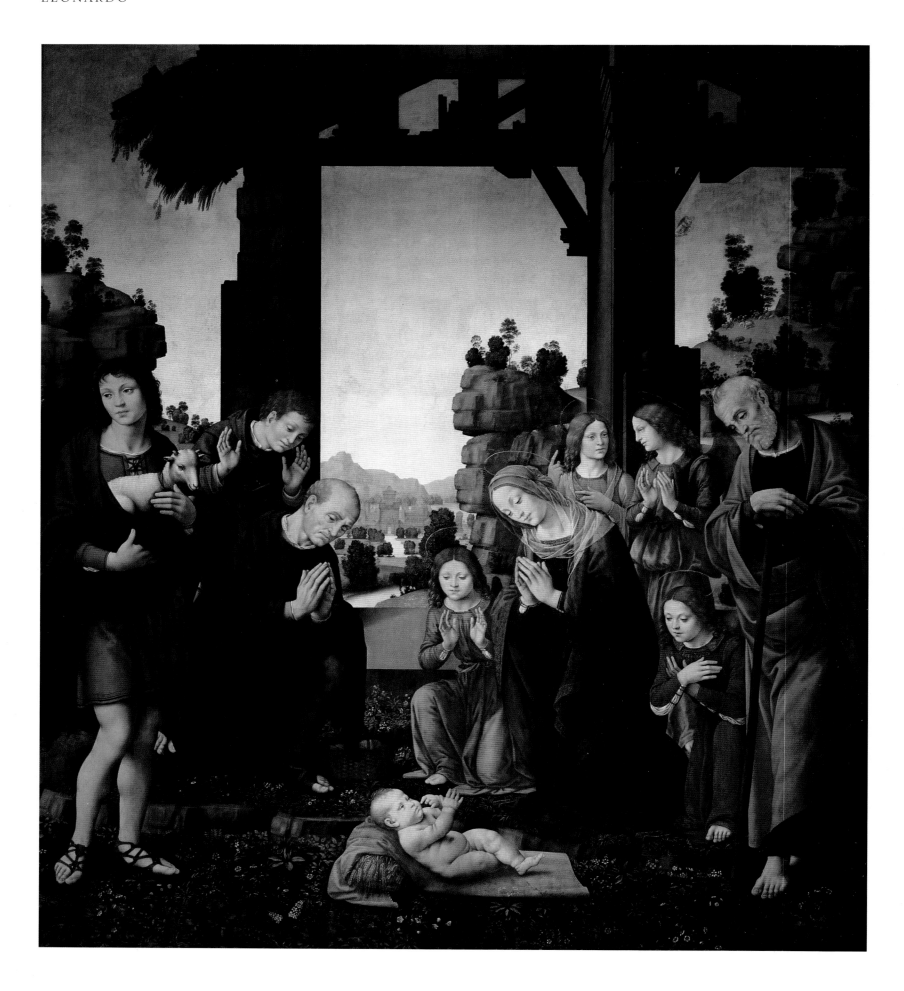

ABOVE: Lorenzo di Credi (1459-1537),
Adoration of the Shepherds, oil on wood, 88⅛ ×
77⅛ inches (224 × 196 cm), Galleria degli
Uffizi, Florence. A pupil in Verrochio's
workshop at the same time as Leonardo,
Lorenzo's style follows very closely that of his
master.

RIGHT: Leonardo's registration as a painter with the Guild of St. Luke, recorded in 1472.

Legend would have it that Leonardo was some 'boy-genius'. In fact, however, his schooling was modest and he was largely self-taught. He himself was acutely aware that he was 'unlettered': unable, that is, to write in Ciceronian prose, and because of this difficulty with Latin, Leonardo's reading, initially at least, was largely confined to works translated into Tuscan Italian. This deprived him of access to the new Humanistic works written in Latin at the educated courts of Italy. Instead, Leonardo compensated for his academic shortcomings by relying on his own sensory experiences.

Rather than the usual six years in Verrocchio's studio, Leonardo remained with his master for nine years. During the 1470s he would have been training and working alongside a number of other young assistants: Pietro Perugino (c.1450-1523), Lorenzo di Credi (1459-1537), Domenico Ghirlandaio (1449-94), Francesco Botticini (1446-97) and Cosimo Rosselli (1439-1507). Verrocchio's studio in Florence was rivaled in its output and talent only by the bottegha run by the brothers Pietro and Ambrosio Pollaiuolo. In all the studios at this time the atmosphere and methods of production were dominated by a communal spirit. A work of art was not yet regarded as the expression of a single personality, and during this period Verrocchio's workshops turned out a variety of work which Leonardo probably had a hand in producing.

By 1472 Leonardo's name was inscribed on the roll of the Guild of St Luke as a painter: 'Leonardo di Ser Piero da Vinci dipintore.' He was then just 20 years old and, having paid his guild fees, he was entitled to set up his own independent workshop. The guilds acted in a manner similar to trades unions: they were responsible for guidelines for training within each profession, whether law, medicine or the arts. Only when a student had completed the set period for his instruction and had mastered the various skills could he join the guild. Leonardo, however, chose to spend at least four more years with his master, during which time he was responsible for a number of projects. As well as probably taking part in arranging pageants for Lorenzo de' Medici and Giuliano de' Medici in 1469 and 1475, Leonardo was also involved in the arrangements for the festivities to welcome Galeazzo Maria Sforza, Duke of Milan, to Florence in 1471. It is also believed that Leonardo was asked to paint a watercolor cartoon for a tapestry representing the *Fall in Paradise*, to be woven in Flanders as a gift for the King of Portugal. It seems, however, that the tapestry never reached the weaving stage.

In addition to two paintings of the Virgin attributed to Leonardo, the *Benois Madonna* and the *Madonna and Child with a Vase of Flowers*, which are believed to date from this period in Verrocchio's workshop, Leonardo no doubt assisted his master with a number of other works

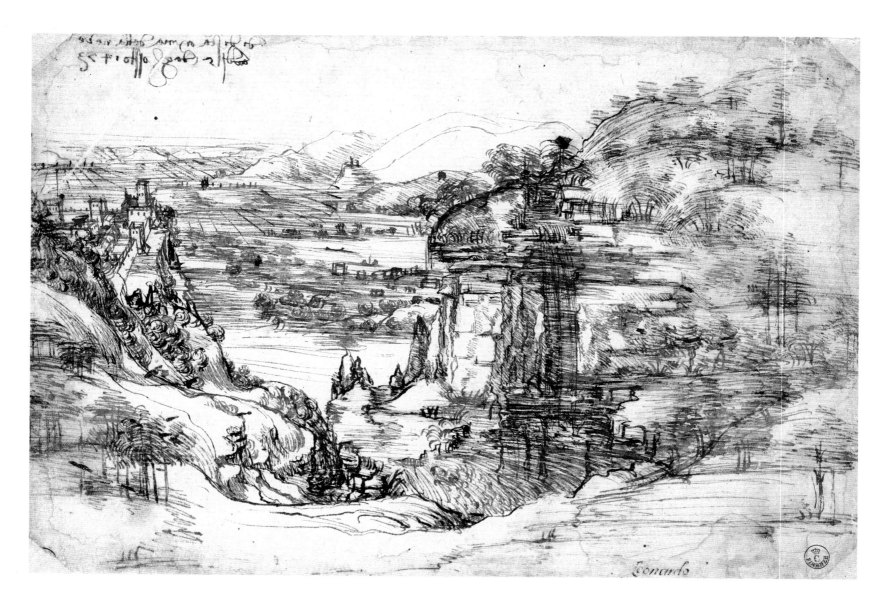

then in hand: the gilded copper ball for the lantern over the dome of the Cathedral in 1471; the tomb of Piero de' Medici for the sacristy of the Medici church of San Lorenzo in 1472, and the bronze *David* for the town hall in 1476, for which many believe Leonardo was the model. According to Vasari, Leonardo was working with Verrocchio on *The Baptism of Christ* for the church of San Salvi when, as the story goes, Verrocchio saw his young assistant's work and promptly gave up painting because Leonardo was more capable than he was. It is more likely that, in such a busy commercial workshop, the master was able safely to entrust painting commissions to his assistant, while he himself concentrated on the more public and profitable sculptural commissions.

The Baptism of Christ is traditionally accepted as Leonardo's earliest surviving painted work. From the same period (August 1473) is his earliest dated drawing, a landscape depicting the valley of the river Arno. These two works are in fact related: a study of the drawing, particularly the background features of the mountains and lakes with their atmospherically rendered aerial perspective, leaves no doubt that Leonardo was responsible for the background painting in *The Baptism of Christ*. This is especially evident when the background features are compared with other natural features in the painting, such as the palm tree on the left and the rocks in the right foreground, which are painted in a much more conventional manner. Vasari records that Leonardo worked on the

painting but, even without documentary evidence, a comparison of the two angels suggests that they were painted by two different hands, and the left-hand one is accepted as by Leonardo. Nevertheless, the monks of San Salvi appear not to have noticed any discernible differences and the painting passed into their hands.

With the *Benois Madonna*, Leonardo found a formula that he was to apply again in the figure of the Virgin in the Louvre *Virgin and Child with St Anne* (page 80) about 30 years later, and that was to be influential on a number of later artists. The Virgin's body is placed in a three-quarter view to the right, with the right leg extended forward and the left bent back to support the figure of the Christ Child. The figures are solidly modeled, as is the drapery which billows

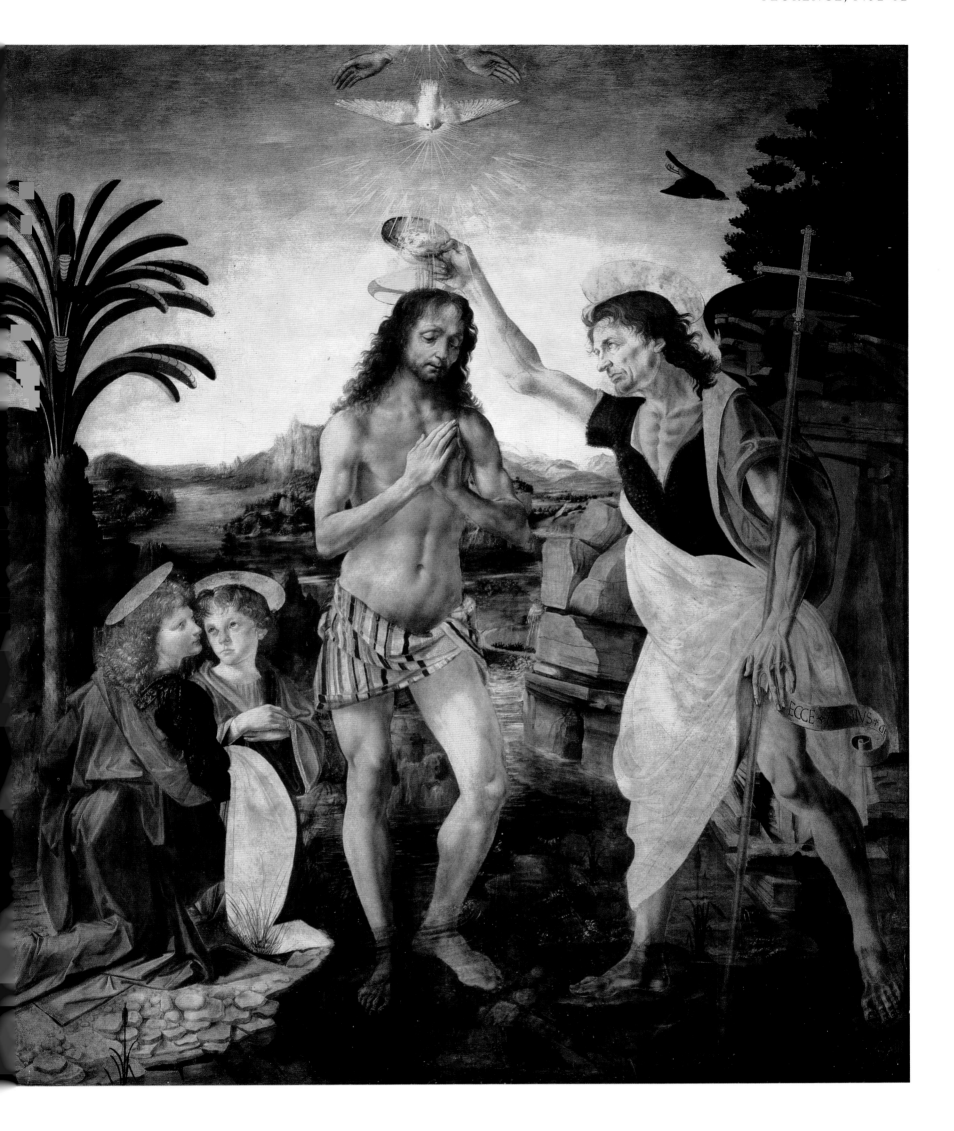

ABOVE: Andrea del Verrocchio (1435-88), *Baptism of Christ* c.1473-78, oil on wood, 69⅝ × 59½ inches (177 × 151 cm), Galleria degli Uffizi, Florence. This work was painted for the monastery of San Salvi. The figure of the left-hand angel is generally accepted as Leonardo's earliest surviving painted work.

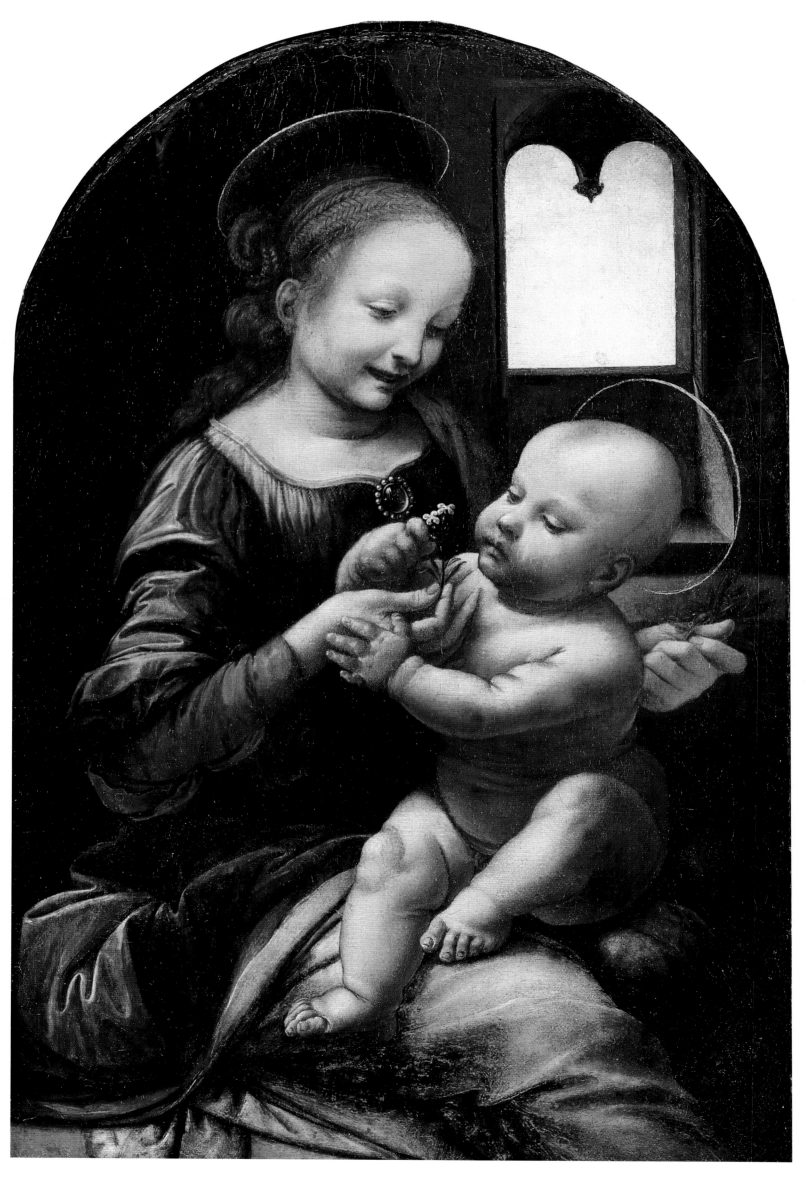

LEFT: *Benois Madonna*, c.1478, oil on wood
panel, 18⅞ × 12¼ inches (48 × 31 cm),
Hermitage Museum, St Petersburg.

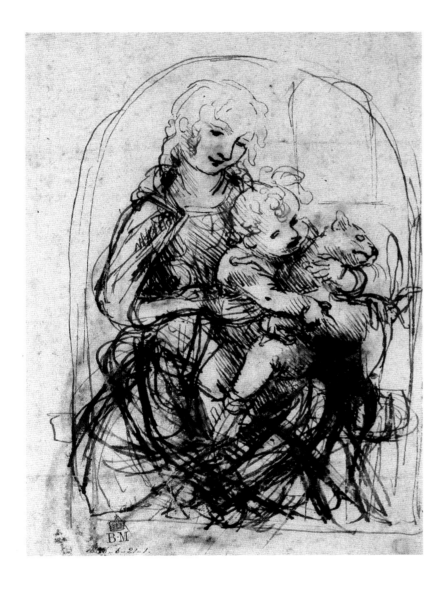

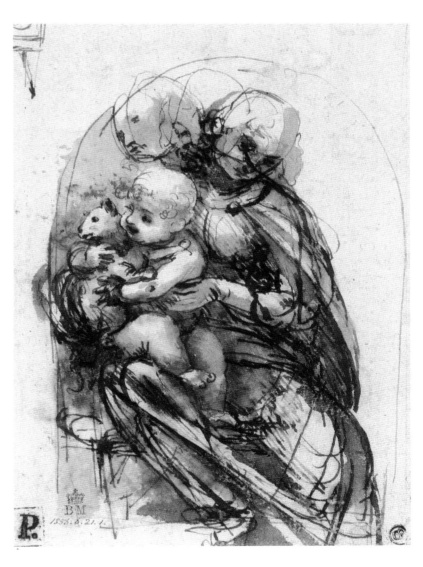

ABOVE LEFT: *Madonna and Child with a Cat*,
c.1478, pen and ink, 5³⁄₁₆ × 3¾ inches (13.2 ×
9.5 cm), Courtesy of the Trustees of the British
Museum, London.

ABOVE RIGHT: *Madonna and Child with a Cat*,
c.1478, pen, ink and wash, 5³⁄₁₆ × 3¾ inches
(13.2 × 9.5 cm), Courtesy of the Trustees of the
British Museum, London. These two drawings
are the recto and verso of a single sheet of paper.
The outline of the right-hand drawing has been
pressed through from the left-hand one, using a
stylus, and then inked and washed in. These two
drawings may have been preparatory studies for
the *Benois Madonna*.

out from the Virgin's hips. The overall
effect is enhanced by the strong light
which falls from the top left to the bot-
tom right across the figures, with a sub-
sidiary soft light brought in from the win-
dow in the background. Preliminary
drawings – the *Madonna and Child with a
Cat* drawings could well be early studies
– as well as other drawings of the period
show that achieving this sense of volume
was one of Leonardo's chief aims.

A second painting, the *Madonna and
Child with a Vase of Flowers*, is sometimes
associated with the 'finished' Madonna
which Leonardo listed as one of his works
in an inventory of his possessions in 1482,

when he left Florence for Milan. There is,
however, no consensus that this painting
is in fact by Leonardo. It could be that
Leonardo began it but that it was com-
pleted by a fellow pupil such as Lorenzo
di Credi. As we shall see, it was not
unusual for Leonardo to leave works un-
finished.

While Leonardo's part in painting the
Baptism of Christ has been accepted since
around 1510, it was only in 1869 that the
painting of the *Annunciation* was finally
attributed to him. The painting came
from the monastery of San Bartolomeo at
Monteolivieto near Florence and was
originally ascribed to Ghirlandaio, a con-

13

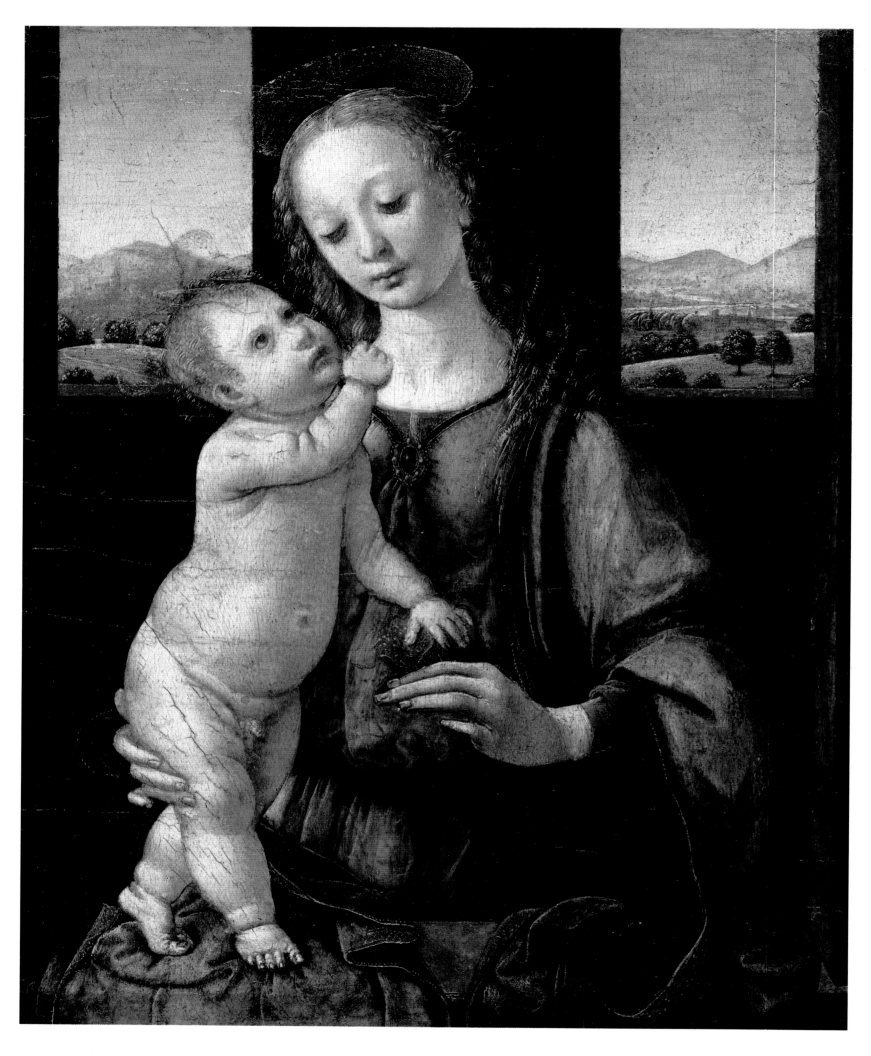

ABOVE: School of Verrocchio, *Madonna and Child with a Pomegranate*, c.1470-75, oil on wood panel, 6⅛ × 5 inches (15.7 × 12.8 cm), National Gallery of Art, Washington, Samuel R. Kress Collection. Characteristic of the 'Verrocchio style', the Virgin has a calm, static pose and her eyes are downcast. These elements were often copied by Verrocchio's pupils.

RIGHT: *Madonna and Child with a Vase of Flowers*, c.1475, oil on wood panel, 24½ × 18¾ inches (62 × 47.5 cm), Alte Pinakothek, Munich. This painting is sometimes associated with the 'finished' Madonna listed in Leonardo's inventory in 1482. While Leonardo may have begun the painting, Lorenzo di Credi may possibly have completed it.

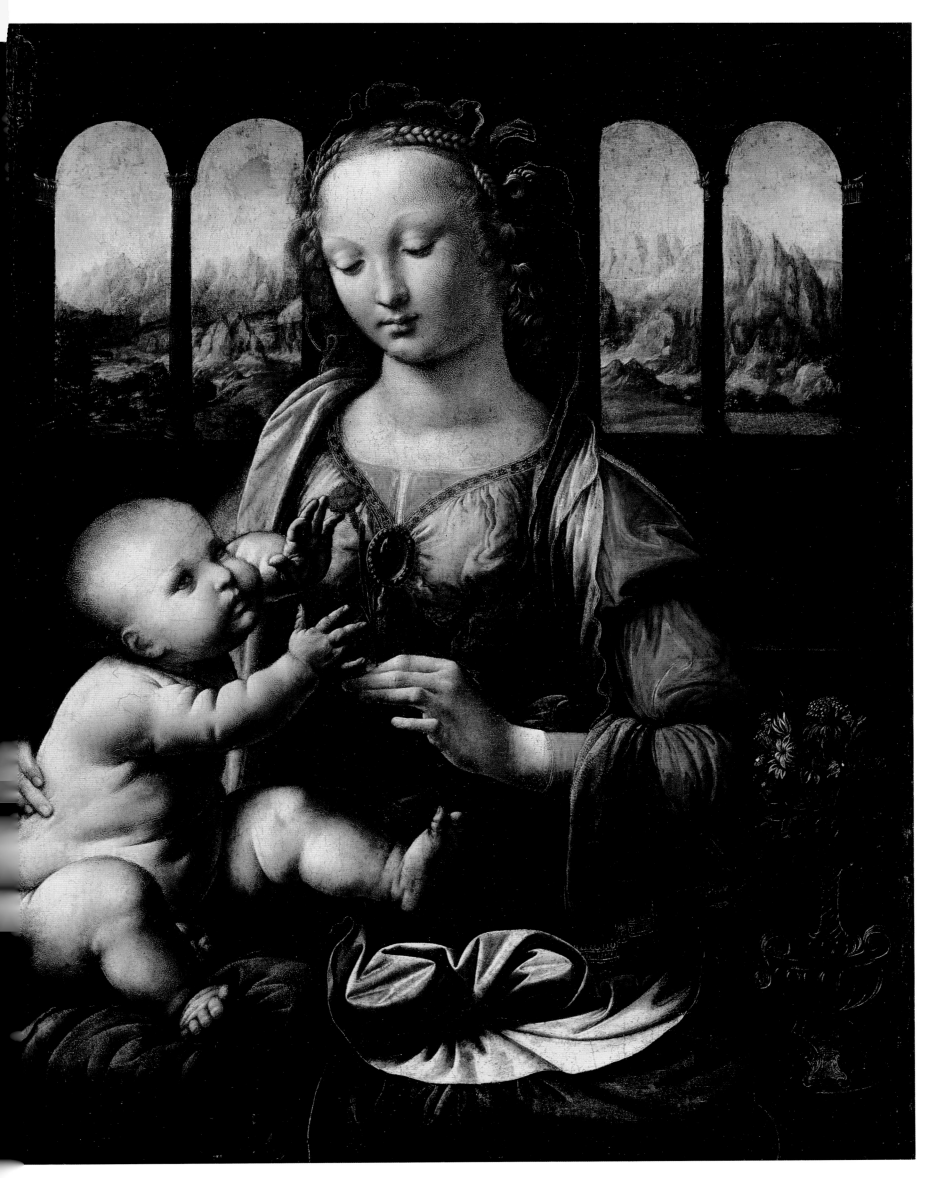

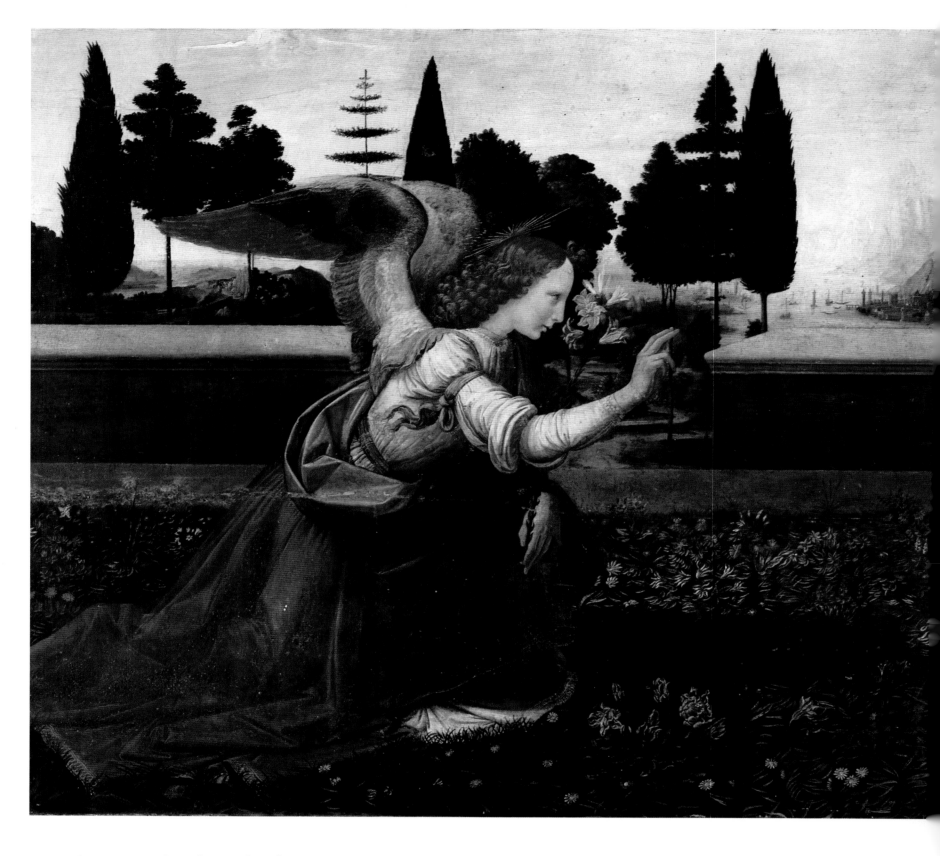

ABOVE: *Annunciation*, c.1473, oil on wood panel, 38⅜ × 85½ inches (98 × 217 cm), Galleria degli Uffizi, Florence. Now accepted as by Leonardo, this painting was only attributed to him in 1869.

temporary of Leonardo's and a fellow apprentice in Verrocchio's studio. Another theory has it that the *Annunciation* was begun by Ghirlandaio and completed by Leonardo, although this thesis is somewhat contradicted by the existence of a drawing by Leonardo of the right sleeve of the angel, complete with the fluttering ribbon. In addition there are two other drawings which are related, but differ in too many small details for them to be considered as direct studies for the painting. One of these is the finished drawing of *A Lily* such as the one held by the archangel. The other is a study of drapery similar to that worn by the Virgin. The drapery drawing is an example of the studies which Leonardo continued to make throughout his

career, and which Vasari describes as having been taken from clay models draped in plaster-soaked cloths.

The subject of the painting is the annunciation to the Virgin by the Angel Gabriel of her unique destiny, as detailed in Luke I, 26-38. The figures are set in the enclosed courtyard garden of a Florentine villa. Again certain features seem to have been drawn from the works of Verrocchio, in particular the base of the lectern, which recalls Verrocchio's decoration of the Medici tomb in San Lorenzo, and the rigid perspective of the building and pavement, which is also to be found in Verrocchio's *Madonna and Child* of 1468, now in the National Gallery of Scotland. The landscape background, however, is Leonardoesque, with its

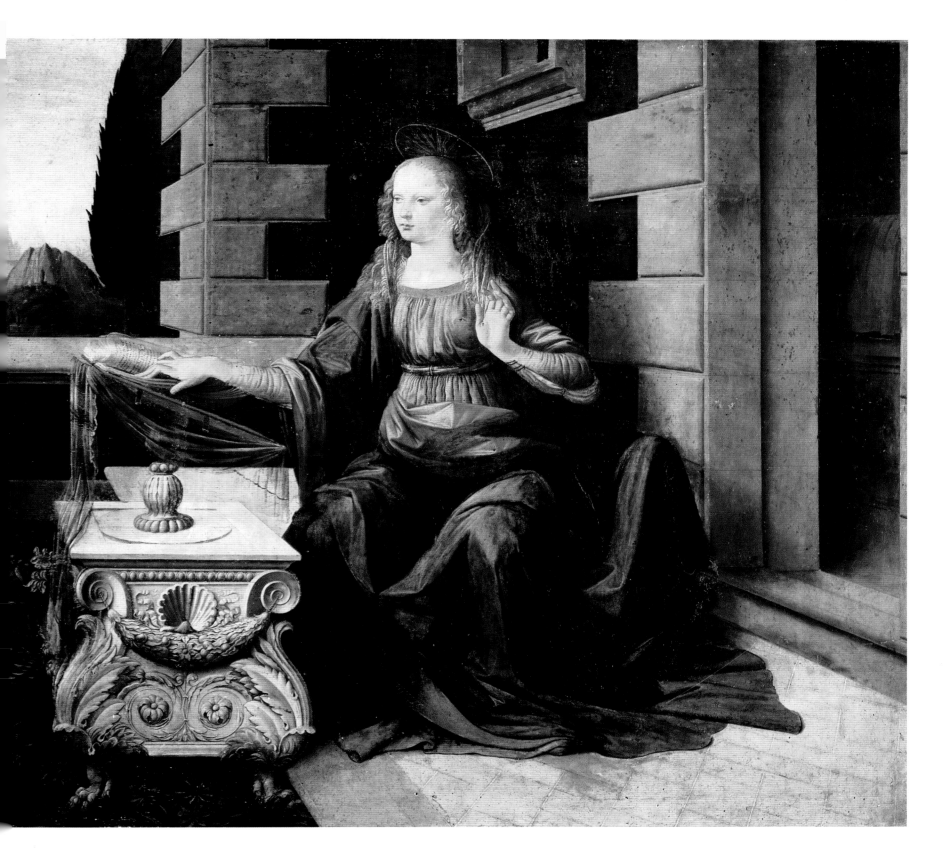

misty mountains and lakes stretching into infinity. This background looks forward to both the *Madonna of the Rocks* (pages 40, 44) and the *Mona Lisa* (page 97), while the flower-strewn garden is a foretaste of the vegetation in the *Leda* (pages 95-99). The treatment of the plantlife in the *Annunciation* also reflects Leonardo's interest in botany; the inventory of items in his possession which he made around 1482 states that he had drawings of 'many flowers from nature'. It also serves to remind us of the volume of Leonardo's works that have been lost, since the bulk of his surviving botanical studies are related to the years 1508 and after, when he was working on the *Leda* theme.

The *Annunciation* can be dated by Vincian scholars, from the evidence of style and from the style of its associated drawings, to around 1473, and it must be assumed that Leonardo began work on the *Portrait of Ginevra de' Benci* soon after this date. Such portraits of Florentine women were frequently commissioned on the occasion of their marriage, and we know from documentary evidence that Ginevra was married to Luigi di Bernardo Niccolini in January 1474. However doubt has always surrounded this painting, which only came to light in 1733 in the collection of the Prince of Liechtenstein. Vasari describes Leonardo painting a portrait of Ginevra after his return to Florence, between 1500 and 1506, but by this time Ginevra would have been in her forties and the portrait is of a much younger woman. Nevertheless the painting is very accomplished, especially when compared to the *Annunciation*. Recent research has identified the device on the reverse of the panel as the personal seal of Bernardo Bembo, the Venetian ambassador to Florence in 1475-76 and 1478-80. The close but platonic relationship between Ginevra and Bembo has long been recognized, and was even celebrated in its day by the poets Alessandro Braccesi and Christoforo Landino. While there is no definite proof linking Leonardo and Bembo (supposing Bembo to be the commissioner of the portrait), Bembo was in fact a friend of Lorenzo de' Medici, one of Verrocchio's major patrons. It is not therefore impossible that the Venetian ambassador commissioned the portrait via the studio.

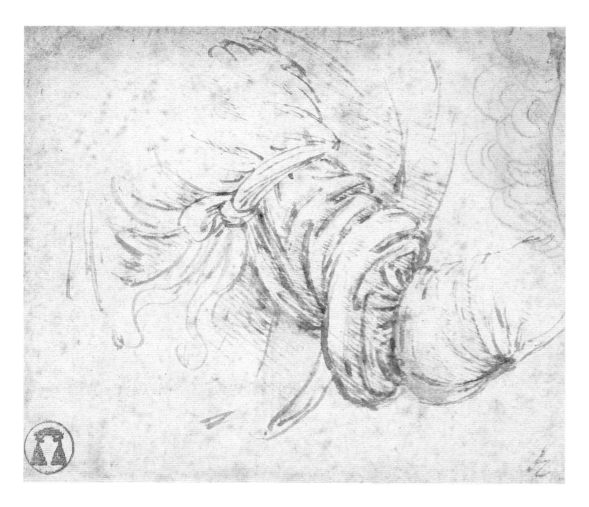

LEFT: *Study of a Sleeve*, c.1473, pen and brown ink, 3¼ × 3⅝ inches (8.2 × 9.3 cm), Courtesy of the Governing Body, Christ Church, Oxford. This drawing is almost certainly a preparatory study for the right sleeve of the angel in the *Annunciation* (pages 16-17).

BELOW: *Study of the Drapery of a Figure Kneeling to the Right*, c.1473, Cabinet des Dessins, Musée du Louvre, Paris. Leonardo made studies of drapery throughout his career and Vasari mentions that many were drawn from clay models draped in plaster-soaked cloths.

RIGHT: *A Lily*, c.1475, pen, ink and brown wash over black, heightened with white, the outlines pricked for transfer, 12⅜ × 7 inches (31.4 × 17.7 cm), Windsor Castle, Royal Library 12418. © 1994 Her Majesty The Queen. The earliest surviving plant drawing by Leonardo is of the Madonna Lily. It cannot be identified as the direct model for the lily held by the angel in the *Annunciation* because it differs in too many details. It is likely that this pricked drawing was used in another, now lost, painting. Notice also the faint geometrical drawing; this may relate to a perspective projection like that for the *Adoration of the Magi* (pages 30-31).

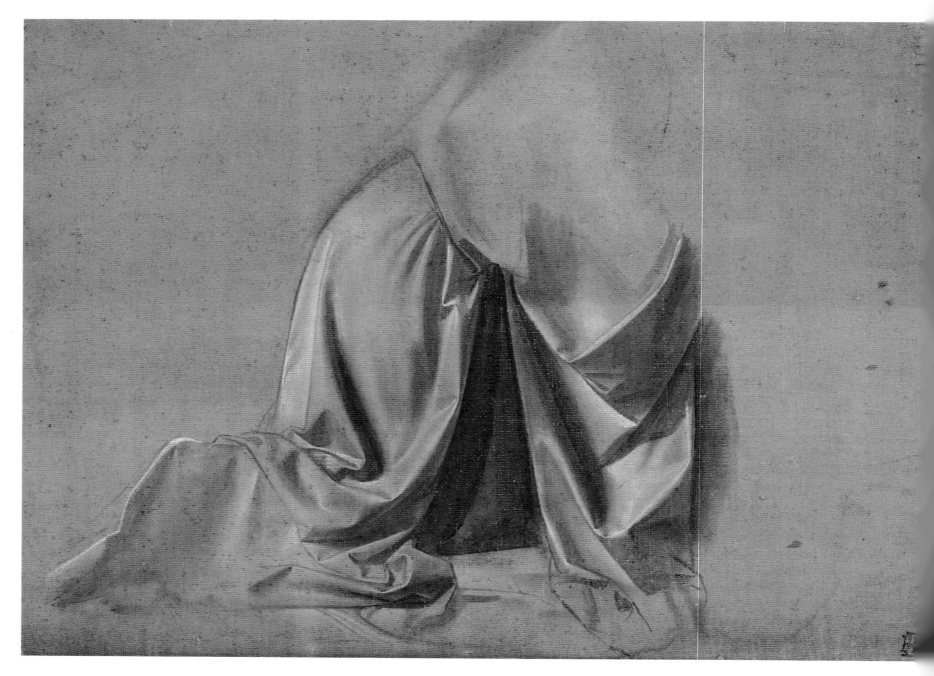

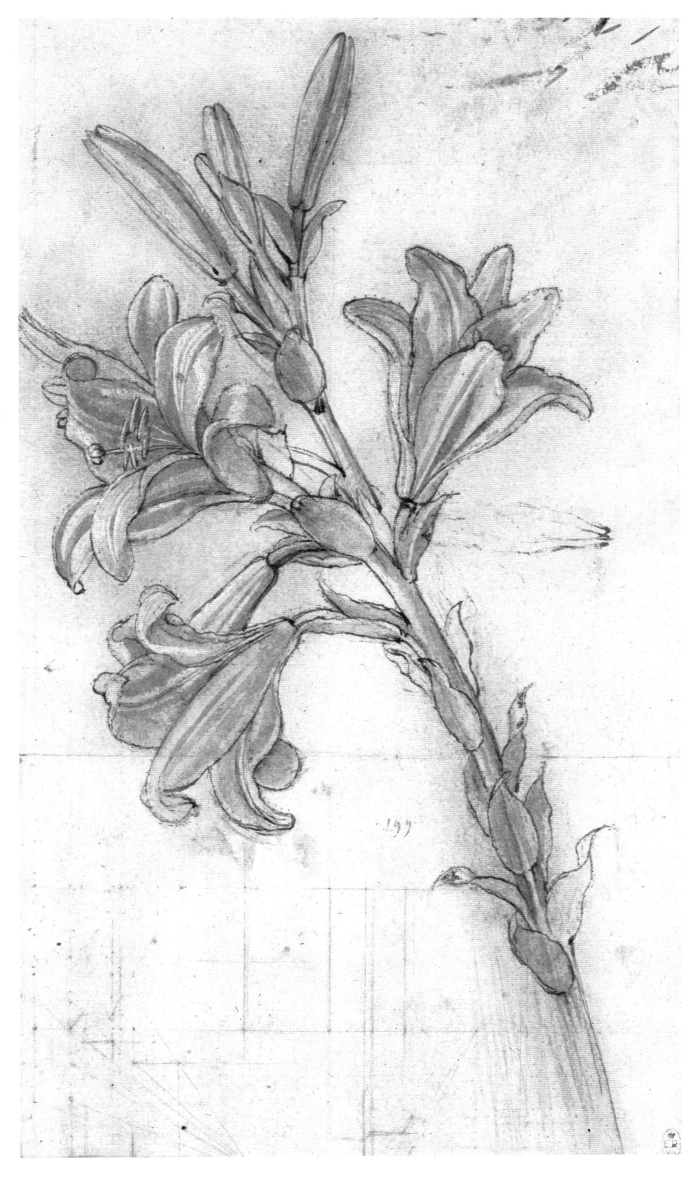

199

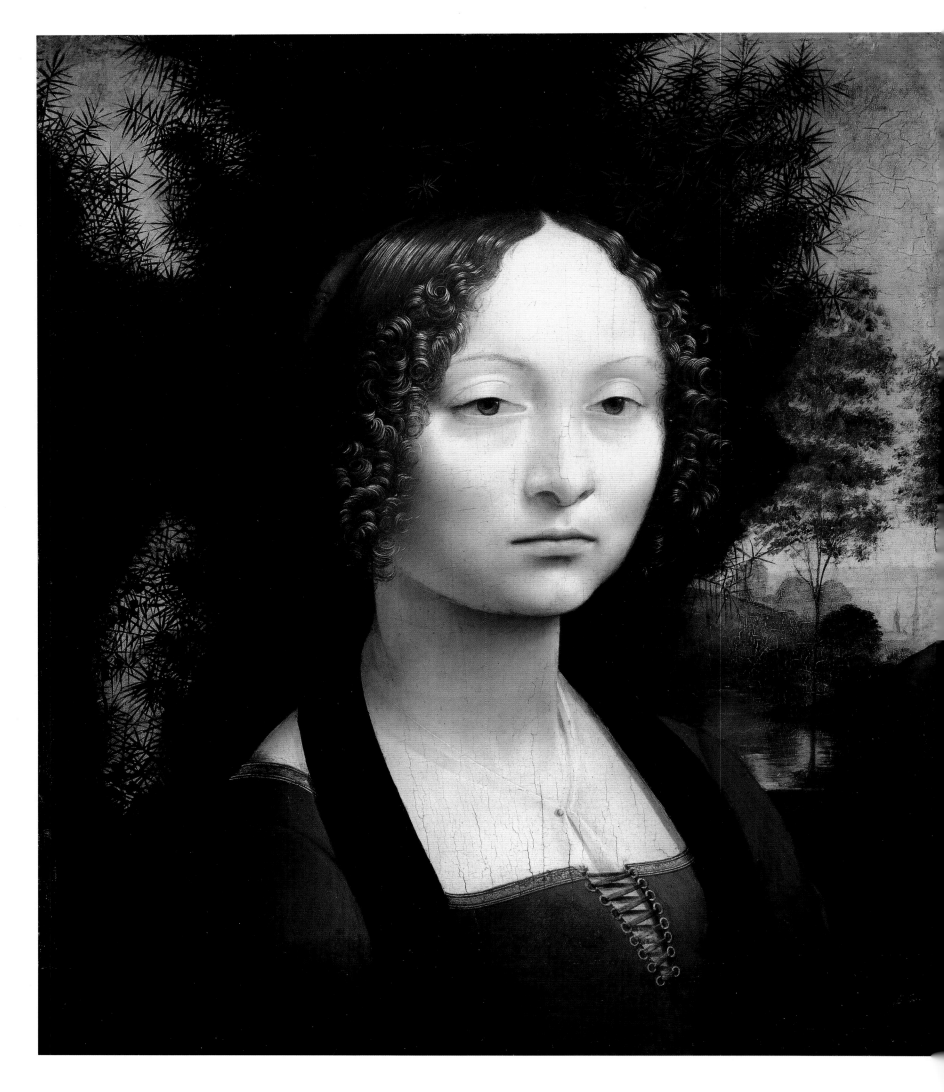

ABOVE: *Portrait of Ginevra de' Benci*, c.1476, oil on wood panel, 15¼ × 14½ inches (38.8 × 36.7 cm), National Gallery of Art, Washington, Ailsa Mellon Bruce Fund. This portrait only came to light in 1733 in the collection of the Prince of Liechtenstein.

RIGHT: Andrea del Verrocchio (c.1435-1488), *Madonna and Child*, c.1469, oil on wood panel, 42 × 30 inches (106.7 × 76.3 cm), National Gallery of Scotland, Edinburgh. As well as the 'sweet calm' of the Virgin often emulated by Verrocchio's pupils, the precisely worked out

perspective of the background and pavement reveal that Leonardo's studies, such as those for the *Adoration of the Magi*, also have their precedent in Verrocchio's work.

Further assessment of the portrait is complicated by the fact that it has lost about a quarter of its original height due to cropping of the lower edge: part of Bembo's device is missing. There is, however, a magnificent study of a pair of woman's hands done in silverpoint which would fit very well onto the portrait. Although the 1482 inventory mentions various portraits, no item on the list has been firmly linked with the Ginevra portrait. It seems to be the sole surviving secular painting from Leonardo's first Florentine period.

In the spring of 1476 Leonardo was living in Verrocchio's house. On 8 April a note was dropped in the *tamburo*, a box outside the Palazzo Vecchio into which Florentines could place accusations, whether signed or anonymous. This unsigned note accused Leonardo and three other young men of engaging in homosexual acts with a seventeen-year-old artist's model, Jacopo Saltarelli. Although no witnesses ever came forward, the matter was serious enough to go to court twice in two months. In distress, Leonardo petitioned Bernardo di Simone Cortigiano, influential head of the Florentine guilds, with the words: 'You know, as I have told you before, that I am without any of my friends.' After the intervention of the families of the other defendants, and of Verrocchio himself, Leonardo was acquitted, with the pro-

viso that he was never again the subject of an accusation. He was lucky: a couple of decades later the same charge in Florence would have condemned him as a heretic, resulting in the death penalty. The fanatical monk Savonarola, leader of the Florentine republic 1494-98, believed that all homosexuals should be burnt at the stake.

There has been much speculation about Leonardo's sexual proclivities. Two barely legible lines, from a sheet dating from 1478 in the Uffizi Gallery, Florence, of studies of heads and machines, contribute to the thesis that Leonardo was homosexual: 'Fioravante di Domenico . . . in Florence is my most cherished companion, as though he were my . . .' Writing some years after the initial accusation, Leonardo recalled an incident in connection with a representation of the infant Christ: 'When I made a Christ Child, you put me in prison. Now if I represent Him grown up you will treat me worse.' The following statement appeared in Vasari's first edition of his *Lives* but was suppressed in the second: 'Leonardo was of so heretical a cast, that he conformed to no religion whatsoever . . .' More recently the nature of Leonardo's sexuality was further discussed and explored by Sigmund Freud in his book *Leonardo da Vinci and a Memory of Childhood*. In a discussion on the flight of birds, Leonardo made the note:

Among the first recollections of my childhood it seemed to me that, as I lay in my cradle, a kite came to me and opened my mouth with its tail and struck me several times with its tail between my lips.

In Freud's analysis he unfortunately translated *nibbio* (kite) as 'vulture', and based his theory on the fact that in Egyptian hieroglyphics 'vulture' and 'mother' were both represented by the same sign, since they were phonetically linked: both were pronounced 'mut'. Later psychosexual analysts, anxious to shed light on the meaning of the smile of the *Mona Lisa*, or even on some of the drawings that Leonardo made of his own right hand, have somehow been able to see the outline of Freud's vulture in the drapery of the Virgin's cloak in the Louvre *Virgin and Child with St Anne and a Lamb* (page 80).

While many now accept Leonardo's homosexuality, few are probably aware of his vegetarianism. He did in fact believe that plant life affords sufficient nutrients for man, and encouraged his contemporaries to forgo meat. He wrote:

Now does not nature produce enough simple food for thee to satisfy thyself. And if thou art not content with such canst thou not by the mixture of them make infinite compounds . . .

Further evidence of Leonardo's diet is provided by a letter dated 1515 from

RIGHT: *Study of a Woman's Hands*, c.1476, silverpoint on pink prepared paper, 8½ × 6 inches (21.5 × 15 cm), Windsor Castle, Royal Library 12558. © 1994 Her Majesty The Queen. The *Portrait of Ginevra de' Benci* (page 20) has lost around a quarter of its original height due to cropping of the lower edge. This preparatory drawing would fit very well onto the portrait.

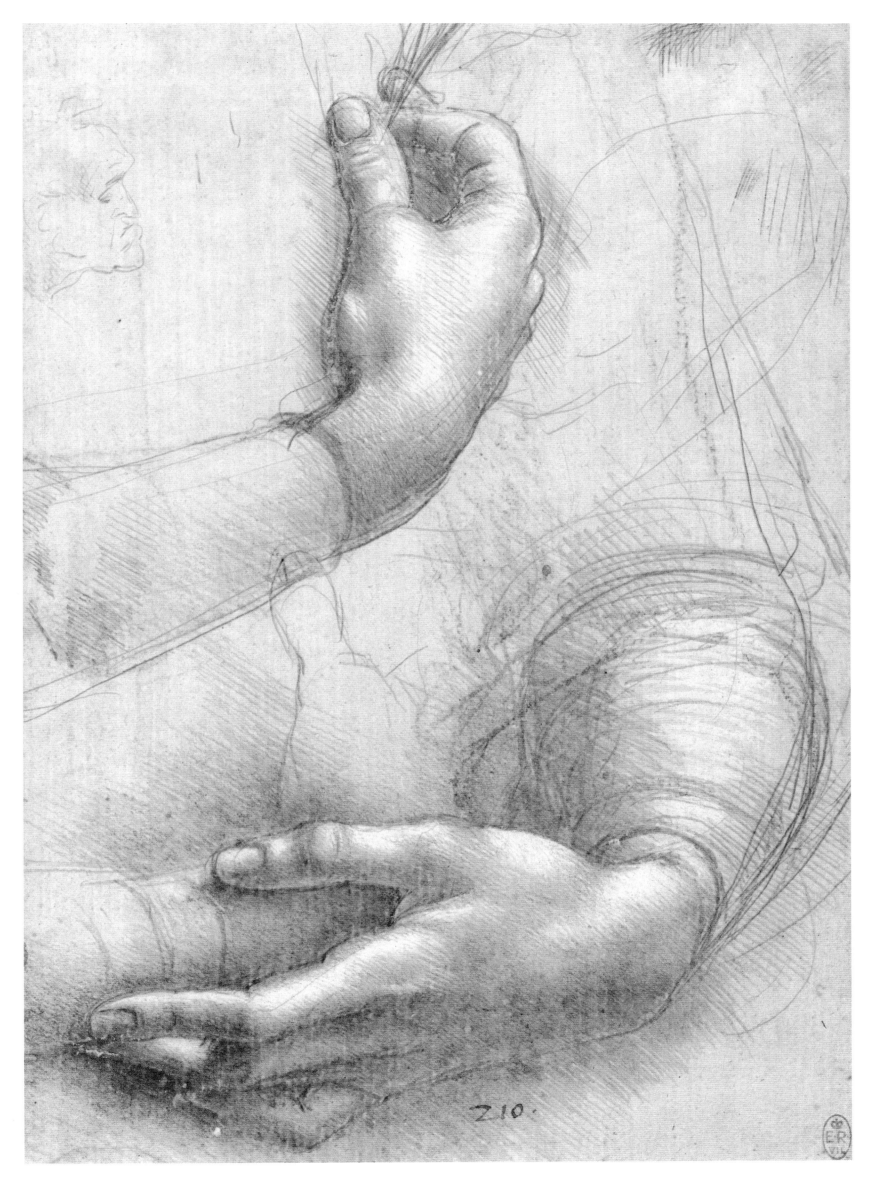

Z10.

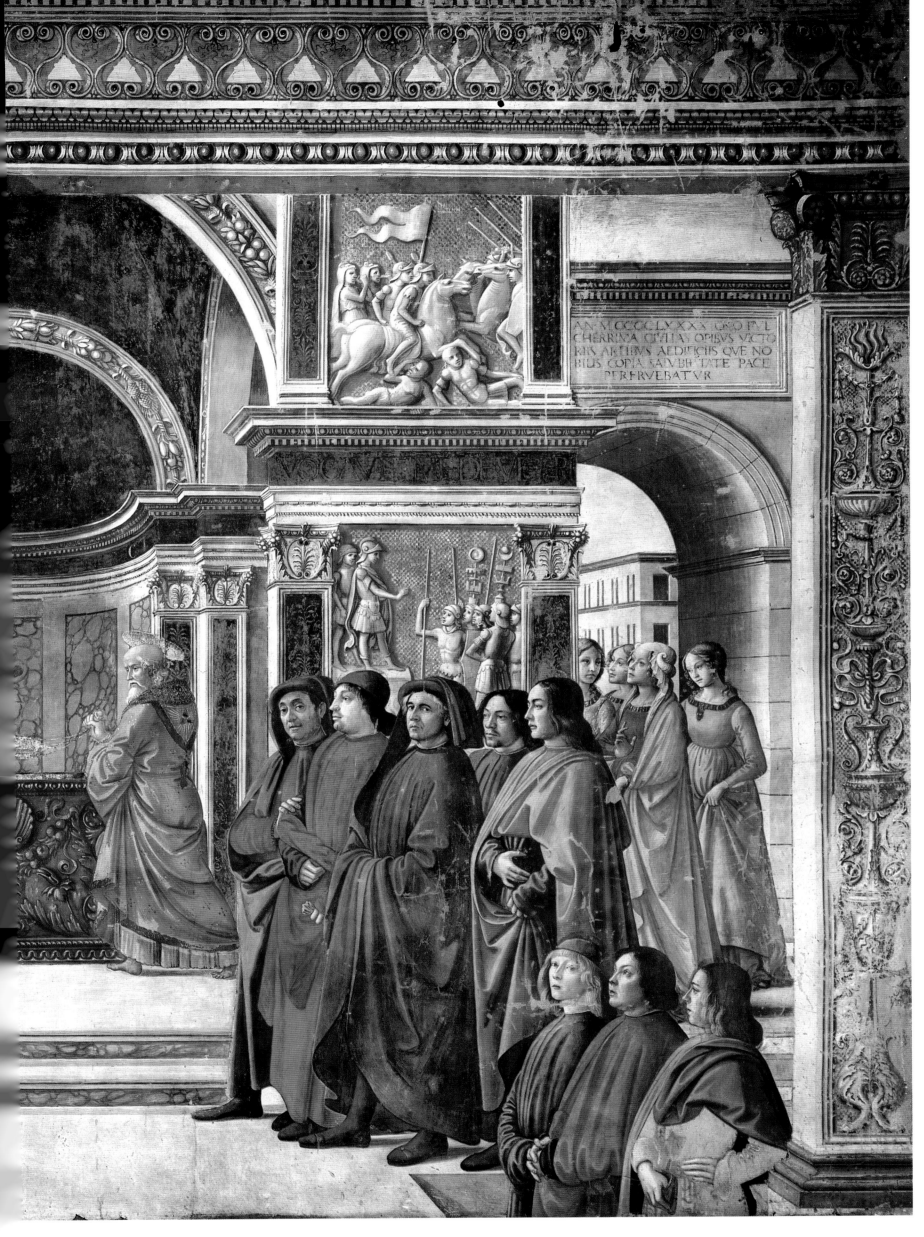

AN·MCCCCLXXXII·QVO·PVL
CHERRIMA·CIVITAS·OPIBVS·VICTO
RIIS·ARTIBVS·AEDIFICIIS·QVE·NO
BILIS·COPIA·SALVBRITATE·PACE
PERFRVEBATVR

PREVIOUS PAGES: Domenico Ghirlandaio (1449-94), *Apparition of the Angel to Zacharius*, 1485-90. This biblical scene also shows many of the most important members of fifteenth-century Florentine society.

BELOW: A fifteenth-century view of a Florentine garden; the garden was of great financial and symbolic value to Renaissance Florentines. In one of his manuscripts Leonardo mentions the Medici gardens where Lorenzo 'Il Magnifico' established the world's first academy of art.

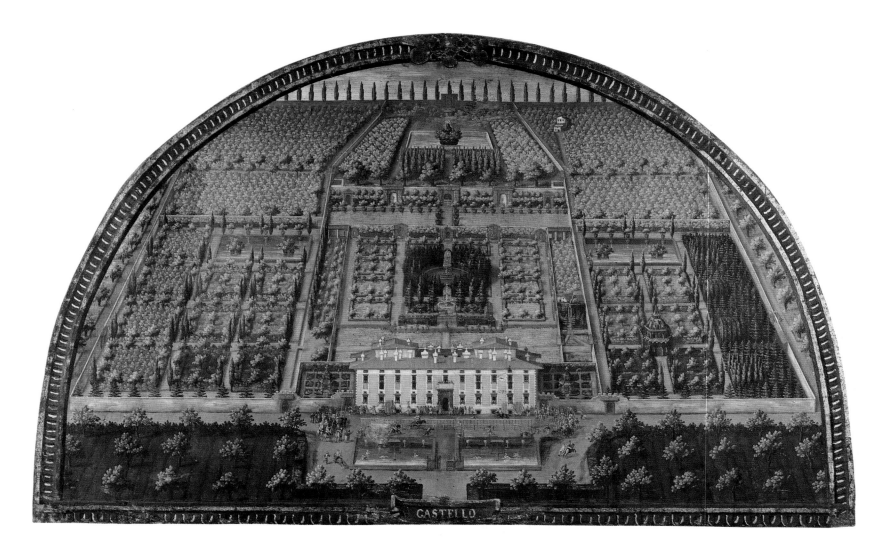

Andrea Corsali to Giuliano de' Medici about some people called *Guzzati*, who refused to eat food that contained blood and who had agreed among themselves not to do harm to any living thing, as Corsali wrote: 'Just like our Leonardo da Vinci.'

In 1477 Leonardo left Verrocchio's studio and began working independently. Florence at that time represented all that was modern in fifteenth-century Italy and was governed by the top political family, the Medici, whose banking network throughout Europe lent money to other top political families. On the basis of loans of money by the Medici, Edward IV of England (1442-83) won his battles against Henry VI and the Lancastrians

and successfully laid the foundations for the Tudor state. Maximilian I (1459-1519), the Holy Roman Emperor, and his wife Margaret of Burgundy also borrowed heavily – so heavily that they broke the Bruges branch of the Medici bank.

Although the Medici were technically private citizens in Florence, during Leonardo's lifetime their influence was at its height; there was hardly anyone in power in Christendom who had not received or was looking forward to financial support from the Medici family. The Medici also contributed considerably to the artistic, literary and philosophical life of the city. Under Cosimo de' Medici, Lorenzo's grandfather, an ecumenical

council had been held in Florence in 1438 for the union of the Greek Orthodox and Roman Catholic churches. Although the union did not take place, many Greeks found their way to Florence, bringing with them manuscripts and ideas that were new to western Europe. Cosimo himself financed several trips for scholars to search out treasures from Greece and the Levant.

The courts of Italy in the late fifteenth and early sixteenth centuries were not always peaceful places of artistic and scholarly activity, however, but were more akin to warring feudal cities. The prince of the court, whether pope, cardinal or duke, as well as being able to attract to his court those in search of his favors

BELOW: Filippino Lippi (1457-1504), *Adoration of the Magi*, 1496, tempera on wood panel, 101½ × 95⅝ inches (258 × 243 cm), Galleria degli Uffizi, Florence. The commission for an altarpiece for the chapel of San Bernardo in the Palazzo Vecchio was originally awarded to Piero Pollaiuolo in December 1477. Seventeen days later the job was transferred to Leonardo, whose *Adoration of the Shepherds* may have been a study. It seems Leonardo abandoned the project soon afterwards and left for Milan, and the commission passed to Domenico Ghirlandaio. In the end, the final altarpiece was painted by Lippi.

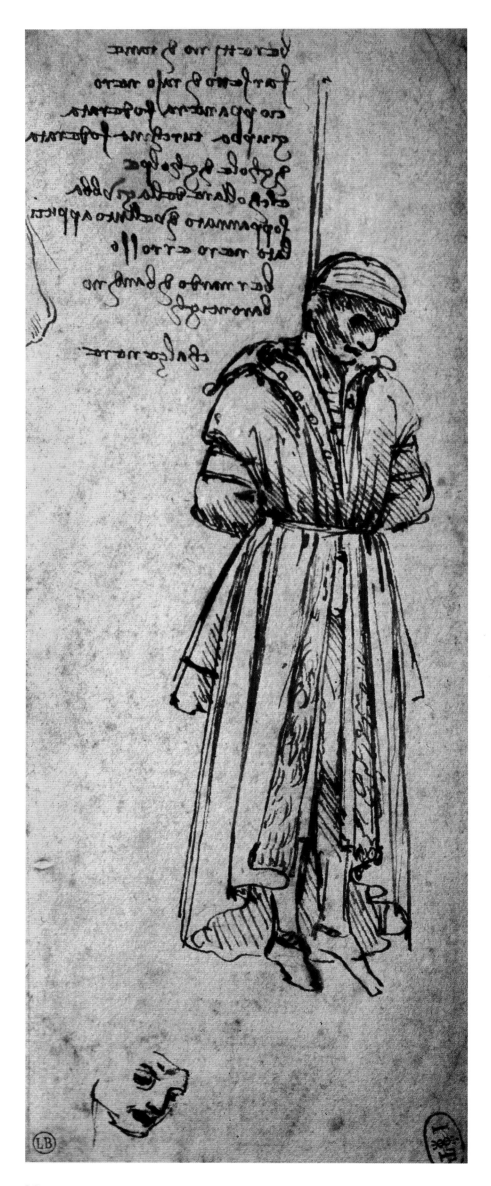

LEFT: A co-conspirator in the Pazzi plot to kill Lorenzo and Guiliano de' Medici in 1478, Bernardo Baroncelli was publicly executed in 1479, along with his wife. In this drawing Leonardo showed Baroncelli hanging from the noose, and at the top of the page carefully noted details of his clothing.

and patronage, could also call on his infinite resources to repel his enemies. The most powerful court in fifteenth-century Italy was that at Milan under the Sforza family. This was followed in power and prestige by the Papal court in Rome, the court at Ferrara under the d'Este family, and the court at Mantua under the rule of the Gonzaga. In Milan the Sforza residence was not a large villa but a castle in the middle of the city: a walled fortress capable of withstanding wars, revolution and riots. In addition to its defensive moat, the Castello Sforzesco boasted 62 drawbridges and, by 1500, could call upon an army of between 800 and 1200 mercenary troops armed with some 1800 machines of war. It is not surprising that alliances with the Sforza family, through treaties and marriages of convenience, were assiduously sought by other ruling families.

The smaller Florentine court of the Medici under Lorenzo 'Il Magnifico' was dominated by Neoplatonic thought. Lorenzo himself was a poet and philosopher, as well as the founder of the world's first academy of art. According to Anonimo Gaddiano in his *Codex Maggliabechiano*, Leonardo was set to work in the gardens of the Piazza San Marco where the academy was to be established. In a note on a sheet of calculations and a drawing of a pair of scales, Leonardo mentions the gardens and the work on which he may have been employed:

The Labors of Hercules for Piero F.Ginori.
The Gardens of the Medici.

Despite Medici rule, Florence was still nominally a republic and Florentine artists continued to operate the time-honored system of payment for goods produced or services rendered. Leonardo appears to have been ill-suited to this business-like atmosphere. In the nine years after his registration with the guild of St Luke, he produced very little saleable material.

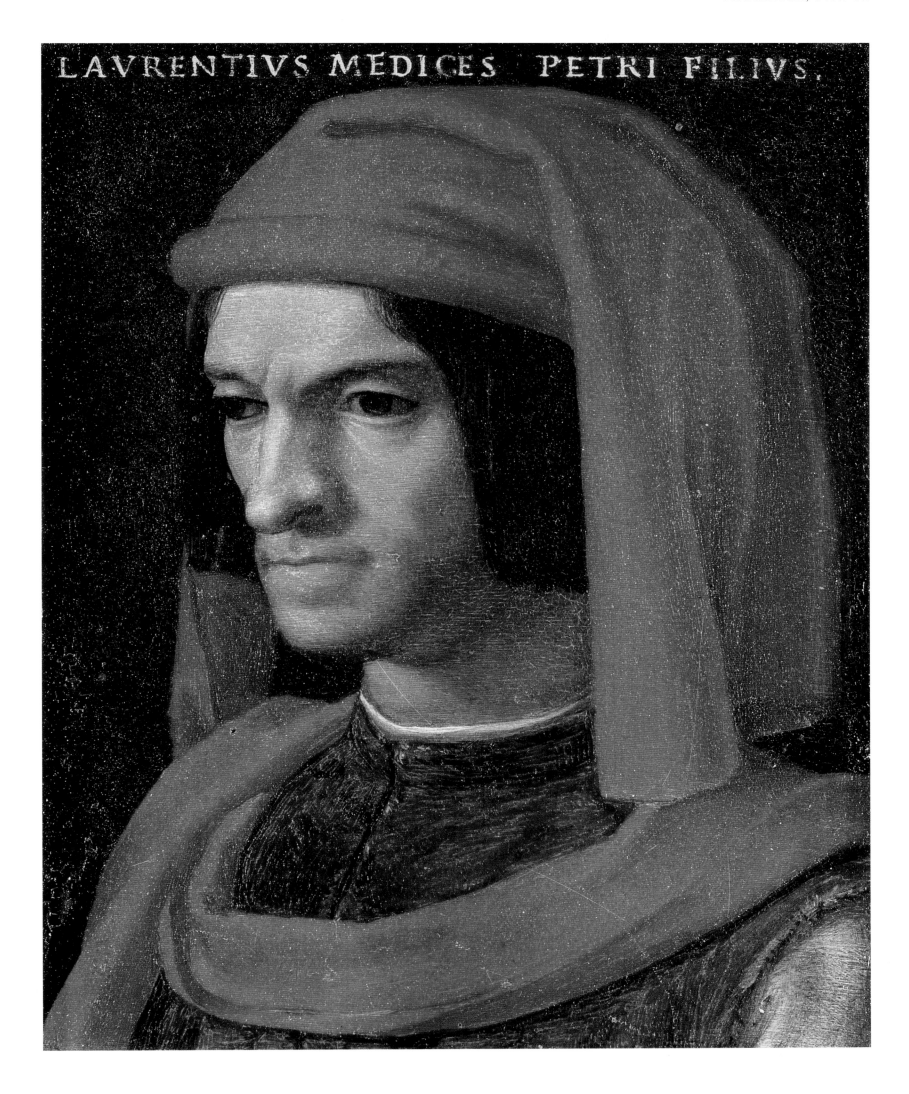

LAVRENTIVS MEDICES PETRI FILIVS.

ABOVE: A posthumous portrait of Lorenzo 'Il Magnifico' de' Medici, the effective ruler of Florence for 23 years. Although Lorenzo was a patron of artists, writers and philosophers, there is no definite proof of any direct patronage of Leonardo.

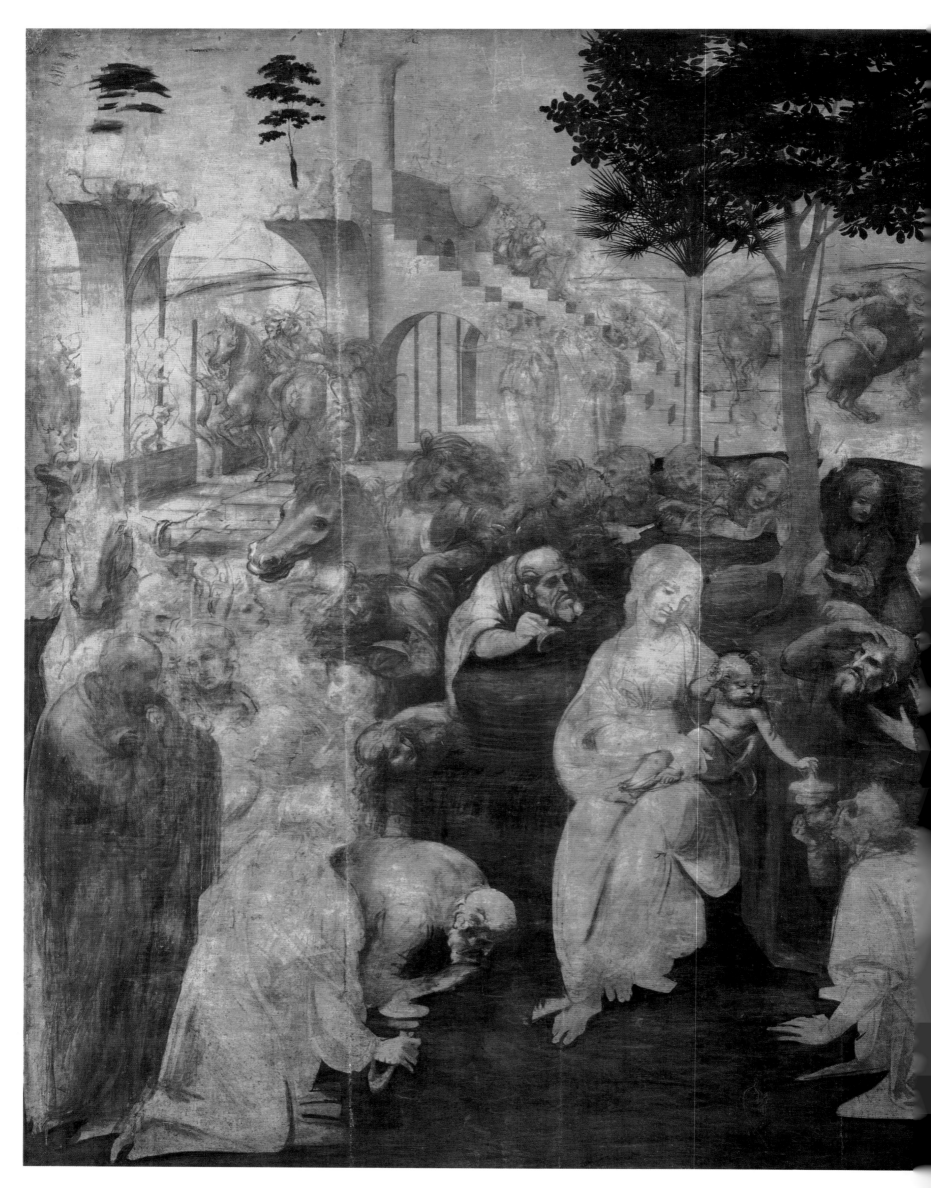

LEFT: *Adoration of the Magi*, 1481, oil on wood panel, 96⅞ × 95⅝ inches (246 × 243 cm), Galleria degli Uffizi, Florence. Leonardo's first large group painting was this unfinished altarpiece commissioned by the monks of San Donato a Scopeto in Florence. The painting was left unfinished when Leonardo left for Milan in 1481-82.

From the minutes of the Florentine executive council, the Signoria, we learn that a commission for an altarpiece for the chapel of San Bernardo in the Palazzo Vecchio was awarded to Piero Pollaiuolo on 24 December 1477. Seventeen days later, the commission was re-awarded to Leonardo. On 16 March 1478, Leonardo received the first payment of 25 florins and began work, but the altarpiece was not far advanced when Leonardo abandoned work on it altogether. In May 1483, a resolution passed by the Signoria transferred the project once again, this time to Domenico Ghirlandaio. The final altarpiece, dating from 1485, is in fact the work of a fourth artist, Filippino Lippi. It has been suggested that a drawing of *The Adoration of the Shepherds* may have been a study for Leonardo's initial effort. His inability to work to deadlines, or even to complete commissions, was to dog him throughout his career.

In the same year that Leonardo was awarded the San Bernardo commission, Florence was rocked by a conspiracy that eventually dragged the Republic into war and nearly bankrupted the city. The 1478 Pazzi conspiracy involved the Archbishop of Pisa, a mercenary soldier called Montesecco, two priests and the Pope himself, among others. Lorenzo de' Medici had incurred the wrath of the Pontiff by refusing him a loan to buy the town of Imola. Lorenzo had in fact had his eye on the territory for himself, and gave instructions to Francesco de' Pazzi, who was the head of the Pazzi bank in Rome, not to advance the money to Pope Sixtus IV. Pazzi saw his chance to damage the Medicis' standing with the Pope and to advance his own position, however, and instead of following Lorenzo's orders, himself offered the Pope most of the money. The Pope promptly transferred his account from the Medici to the Pazzi bank. Meanwhile Jacopo Pazzi, Francesco's uncle (who lived up to the family name: Pazzi is a corrupt form of 'mad' or 'crazy' and Jacopo was known

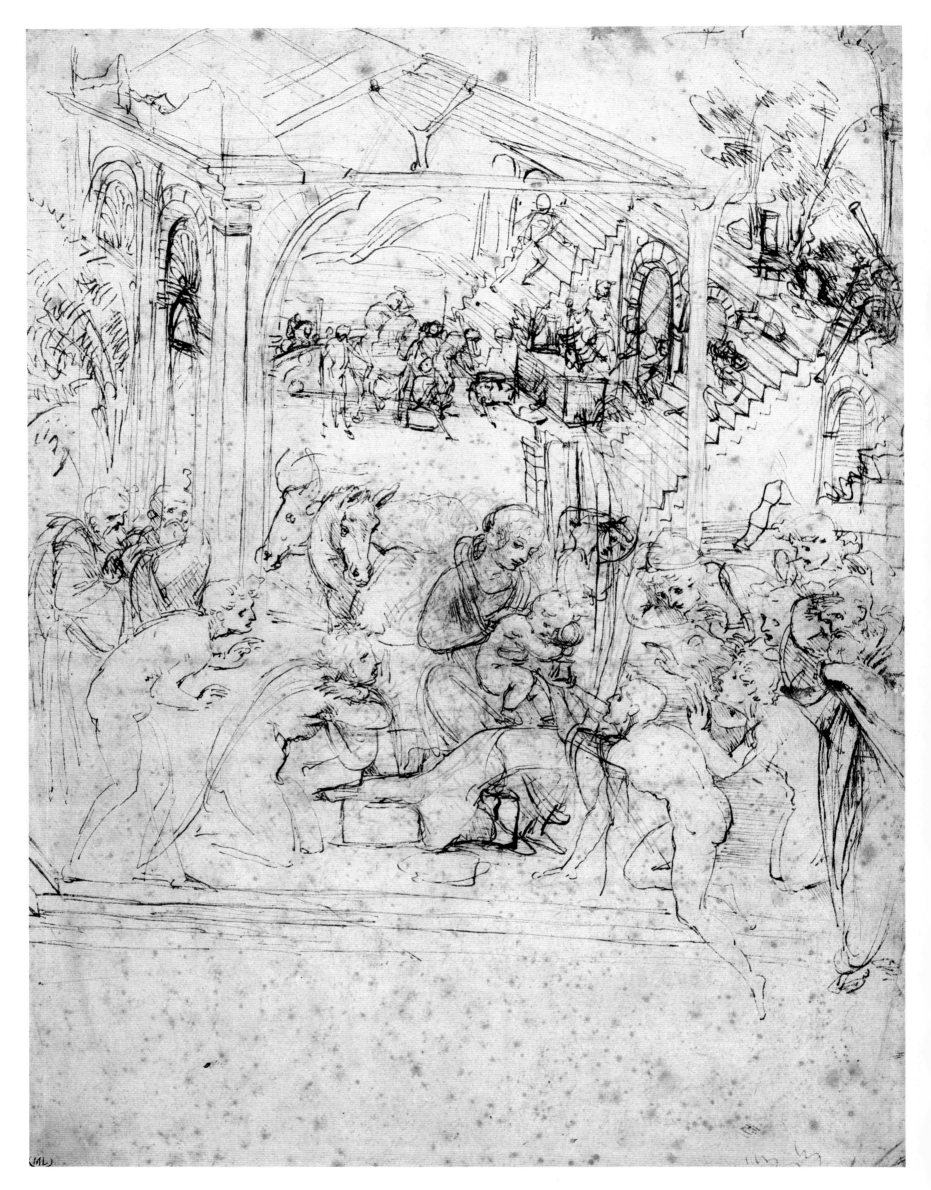

LEFT: *Compositional Sketch for the 'Adoration of the Magi'*, c.1481, pen and ink over metalpoint, 11¼ × 8½ inches (28.5 × 21.5 cm), Cabinet des Dessins, Musée du Louvre, Paris. In addition to the unfinished panel painting on this subject, two general compositional sketches exist. This sketch contains elements that appear in the painting, including the ruined architecture and the grouping with the Virgin and Child and adoring figures to the right.

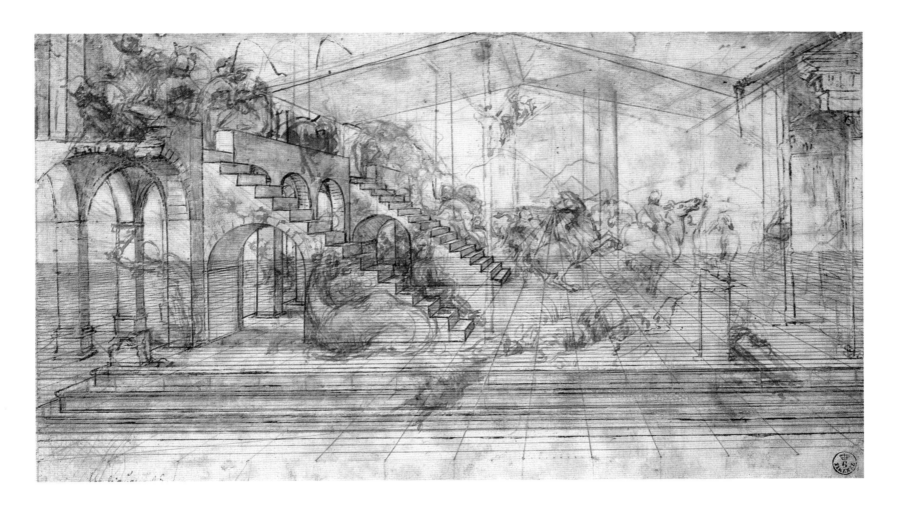

ABOVE: *Perspective Study for the Background of the 'Adoration of the Magi'*, c.1481, pen and ink over metalpoint with wash, 6½ × 11½ inches (16.5 × 29 cm), Galleria degli Uffizi, Florence. This second compositional sketch shows how Leonardo overcame some of the problems involved in relating the figures to each other and to their architectural setting. In this drawing the vanishing point is off-center on the horizon line, while the ground space is divided up according to a scheme devised by Leon Alberti (1404-72), providing the checkerboard effect floor space.

to hit his opponents over the head if he lost at dice!), gave the final touches to the conspiracy: a double assassination was planned to take place in Florence Cathedral during high mass, the intended victims Lorenzo and his brother Giuliano de' Medici. Although the plot failed, Giuliano was fatally wounded. Lorenzo and some of his followers barricaded themselves in the sacristy for safety and the city was in uproar. To cap it all, mad Jacopo Pazzi galloped into the main square shouting 'People and Liberty!', to which the assembled Florentine crowds supposedly replied, 'Balls!' – meaning, of course, the six golden balls of the Medici coat of arms.

Jacopo was forced to flee for his life, and Francesco and some of his co-conspirators were caught and hanged.

Lorenzo appeared on the balcony of the Signoria, his neck bandaged against a knife wound sustained in the assault in the Cathedral and called for the jubilant crowds to disperse. It was not the end, however, for the Pope never forgave the Medici for murdering the Archbishop of Pisa. There were also conspirators on the loose. One of them, Bernardo Baroncelli, had escaped to Turkey, but the Sultan obliged Florence the following year by extraditing him and his wife and on 29 December, 1479, the couple were publicly hanged. Leonardo drew Baroncelli hanging from his noose and carefully noted his clothing:

A tan colored skull-cap, a doublet of black serge, a black jerkin, lined and the collar covered with a black and red stippled velvet.

33

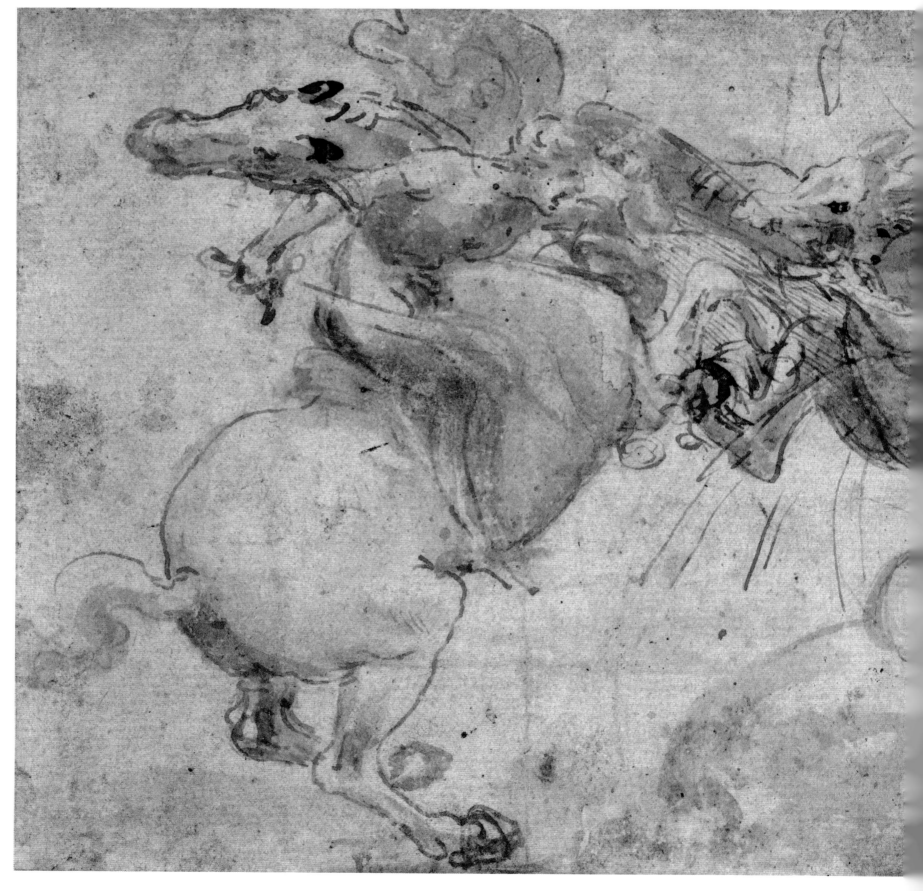

LEFT: *Battle Between Horsemen and a Dragon*,
c.1481, pen ink and wash, 5½ × 7½ inches (13.9
× 19 cm), courtesy of the Trustees of the British
Museum, London. While many of the elements
in the *Adoration of the Magi* were designed to
serve as symbolic devices, more difficult to
understand are the battling figures in the
background. These appear to have begun life in
this drawing, which demonstrates Leonardo's
interest in depicting mythical beasts. The
horsemen are also a foretaste of his interest in
equine compositions demonstrated in *The Battle
of Anghiari* some 20 years later.

A blue coat lined with fur of fox's breasts.
Black hose.
Bernardo di Bandino Baroncelli.

On the day of the conspiracy Leonardo
had gone about the city and drawn
people's excited faces. It was said that,
throughout his career, he would follow a
man with an interesting face through the
streets, to get his portrait down on paper.
 Leonardo's inability to fulfil his
contractual obligations was already well
known and in March 1481, when a com-
mission for the *Adoration of the Magi* was
awarded to him, the friars at the monas-
tery of San Donato a Scopeto drew up a
complicated contract pinning Leonardo
down to a strict timetable. Even this
contract failed to impel Leonardo to
work and the commission was eventually
awarded to Filippino Lippi. Leonardo's
first large group painting, the unfinished
Adoration of the Magi gives us a foretaste
of the large and complex later works,
such as *The Last Supper* (pages 66-67)
and the *Battle of Anghiari* (page 90-91). It
is also the earliest of his paintings which
can be identified with a specific commis-
sion. In 1475 a saddler had made an en-
dowment to the monastery, to provide a
painting for the high altar and a dowry for
his grand-daughter. Leonardo's father
(who conveniently was the notary to the
monastery and so it may have been
through him that Leonardo was awarded
the commission in the first place) drew
up the contract, which required that the
painting be delivered within 24 months
with the possibility of an extension of a
further six months. Shortly after the
contract was agreed and signed, early in
1481, the monks advanced Leonardo
money to buy paints. In July he requested
another 28 florins, and between July and
September the monks also provided him
with firewood, wheat and wine; on 28
September 1481, three monks delivered a
barrel of wine to Leonardo's house. Un-
fortunately for the monks – and for the
saddler's grand-daughter, who never got
her dowry because of the complicated
contract – Leonardo never completed

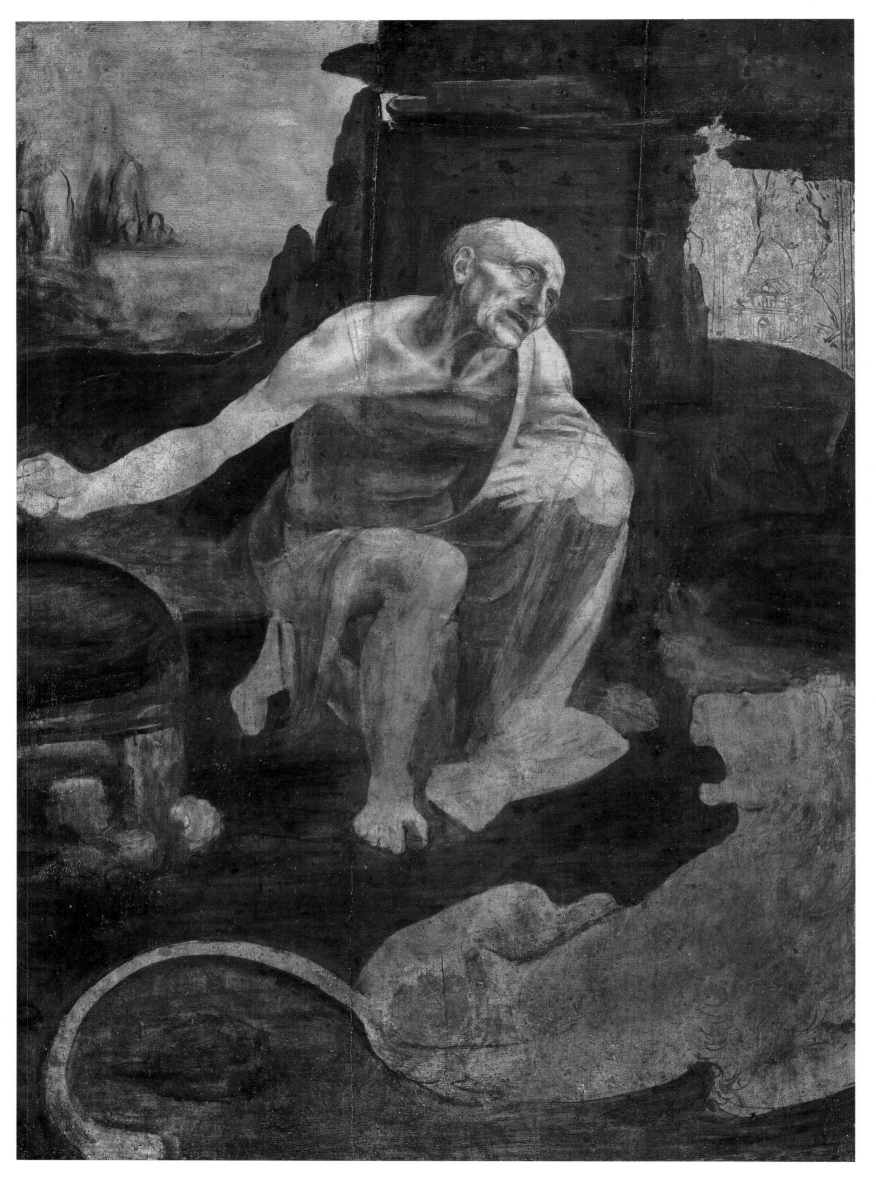

LEFT: *St Jerome*, c.1481, oil on wood panel, 40½ × 29½ inches (103 × 75 cm), Vatican Museum, Rome. This painting was discovered in two pieces in the nineteenth century; one part of it had been used as a tabletop. In his 1482 inventory, Leonardo mentions 'various Jeromes' in his possession, but once again work on this version appears to have been halted. Only parts of the underdrawing have been completed, including the torso and face of the saint, while other elements, such as the church in the right background, are merely sketched in. Nevertheless, the misty mountain background remains a recognizable Leonardoesque feature.

the painting. Soon after the wine was delivered, he left Florence for Milan. What remains of Leonardo's painting is the unfinished panel in the Uffizi and two general compositional sketches.

The earlier sketch contains important elements which appear in the painting, including the ruined background architecture of vaults and a staircase, with the stables rising within it, and the figure grouping of the Virgin and Child with the adoring figures to the right. But on the whole the drawing lacks coherence in the relations of the figures to each other and to their architectural setting, with its rather clumsy perspective scheme. The second drawing shows how Leonardo overcame these problems to create a scheme that is more convincing spatially. This he achieved by placing the vanishing point off-center on the horizon line, and by dividing up the ground space according to a scheme devised by the architect Leon Alberti (1404-72), and here shown in the checkerboard floor effect. Despite these reworkings, Leonardo was to diverge from them in the painting itself. In this the stable, which figured so largely in the first drawing, is banished to the right background. This seems to have allowed Leonardo to organize the central space, which accommodates the triangular foreground group of the Virgin, Child and Magi, within a semicircle formed by the accompanying figures. This semicircle thus separates the foreground scene from the background of ruined architecture and battling figures.

Some of the elements in the painting were designed to serve as symbolic devices; the classical ruins, for example, may refer to the Basilica of Maxentius in Rome, popularly known as the Temple of Peace. The Romans claimed that the building would stand until a Virgin gave birth, and it fell, according to legend, on the very night of Christ's birth. The tree easily identifiable as a palm is symbolic of peace and victory and also has associations with the Virgin. The phrase 'You are stately as a palm tree' (*Song of Solomon* VII, 7) is taken to prefigure the Virgin. The other tree has been variously identified as an ilex (the tree which provided the wood for Christ's cross) and a carob (the tree from which Judas hanged himself and which had also provided the 'locusts' or carob pods on which John the Baptist fed himself in the wilderness). This in turn provides further allusions: John the Baptist was also the patron saint of Florence.

More difficult to understand are the battling figures in the background of the painting. These appear to have begun life as a pen, ink and wash drawing, the *Battle Between Horsemen and Dragon* c.1481. They demonstrate Leonardo's penchant for mythical beasts, confirmed by Vasari in his story of Leonardo's painting of a Gorgon's head on a shield, sold to a merchant for 100 ducats. They are also a foretaste of Leonardo's interest in equine compositions, such as the *Battle of Anghiari* 20 years later.

The only other painting which may be dated with any certainty to this first period in Florence is the *St Jerome* now in the Vatican Museum in Rome. This painting came to light only recently; it was discovered in two pieces in the nineteenth century by Cardinal Fesch, who had been using one of the pieces as a tabletop, which accounts for the damage and subsequent re-touching. Leonardo in fact mentions 'various Jeromes' in his 1482 inventory, but once again work on this painting appears to have been halted before its completion. Some of the underdrawing was completed, including the torso and face of the Saint, while other elements like the church to the right have merely been sketched in. The misty background to the left remains a recognizable Leonardoesque feature, despite its unfinished state.

CHAPTER 2
Milan, 1482–99

Toward the end of 1481 Leonardo left Florence. Some say it was his restless spirit that drove him on to Milan, others cite his apparent lack of recognition by Lorenzo de' Medici. Since the attempt on Lorenzo's life, the Medici had been in political difficulties and had little time to devote to artistic matters; Lorenzo had been excommunicated by the Pope (for the killing of the Archbishop of Pisa) and the expected war had materialized, with Pisa and Naples allied against him. Florence, which depended on trade for its survival, was facing a severe financial crisis with its road and sea routes cut off. The Pope demanded that Lorenzo give himself up and leave Florence. In a desperate attempt to save himself, Lorenzo traveled in secret to see King Ferrante of Naples and threatened him with an onslaught by the Turks. Ferrante agreed to peace in February 1480. When the Pope threatened war later in that year, the Turks besieged Otranto, possibly at Lorenzo's request, and the Pope was forced to back down.

Later in 1481, Pope Sixtus IV summoned to Rome the finest artists in Tuscany to decorate the Vatican. Following

new discussions with the Medici, Botticelli, Ghirlandaio, Signorelli, Perugino and Pintoricchio were summoned to Rome, but not Leonardo. Lorenzo had not entirely overlooked Leonardo, however; in 1478, during Ludovico Sforza's visit to Florence, Lorenzo is said to have recommended Leonardo to the duke as the artist most capable of undertaking the monument that Sforza was planning to erect as a tribute to his father Francesco Sforza. It is possible that Leonardo was in fact sent to Milan by the Medici as an emissary with the gift of a lute, for it seems that, when he left Florence, Leonardo was accompanied by a renowned sixteen-year-old lutenist, Atalante Migliarotti.

It was essential that the Medici remained on good terms with the court of Ludovico, 'Il Moro' (the Moor – so called because of his dark complexion and equally dark character). The rightful duke was in fact Gian Galeazzo Sforza, who was only thirteen years old. Il Moro, Duke of Bari, was virtual ruler of Milan, with serious designs on ruling all of Italy. In Milan, Il Moro was attempting to create the strongest and finest court in Europe. One of the great trade centers, Milan was ideally situated on the plain of Lombardy and the Artiglio canal. Furthermore Ludovico was able to exploit Milan's proximity to its political ally, France. At any time Il Moro could call upon the King of France to use his forces against any Italian city that threatened either Milan or Ludovico's plans.

Unlike his master Verrocchio, Leonardo enjoyed little direct Medici patronage. Furthermore the Florentine court could never offer the kind of patronage enjoyed by artists, writers and musicians at the courts of Milan, Mantua or Ferrara. It seems that Leonardo had an eye for opportunity; he wrote a letter of introduction to Ludovico Sforza listing his abilities and attainments and stating that he had plans for portable bridges, ramming devices, for cannon, catapults and armored cars. Only at the end of his letter did Leonardo assure Il Moro that he could also:

Execute sculpture in marble, bronze or clay and also painting, in which my works will stand comparison with that of anyone else, whoever he may be.

Leonardo also added that he could undertake the bronze equestrian statue of Ludovico's father. We can assume that Leonardo was well aware of the opportunities afforded by the court at Milan but where exactly he gained all this technical knowledge and skill is uncertain, as is the date of his letter. There are indeed gaps in the chronology of his life between 1482 and 1487 and it has even been suggested that he visited the Near East where Kait Bey, the Sultan of Egypt, was engaged in warfare. In his notebooks there are letters to the Sultan and to the Devatdor of Syria which suggest official duties while in the employ of the Sultan in Armenia. There are also some drawings of rock formations near Mount Taurus and a sketch map of Armenia, but it is possible that these were taken from contemporary books.

The first definite proof we have of his being in Milan comes from 1483. A contract of 25 April, 1483, came not from Ludovico Sforza but from a religious brotherhood. The contract, between Leonardo and the brothers Evangelista and Giovanni Ambrogio da Predis, was drawn up and signed by Prior Bartolomeo Scorlione, Giovanni Sant'Angelo and the members of the Confraternity of the Immaculate Conception. The commission was for an altarpiece with an elaborately carved frame for the brotherhood's chapel in the church of San Francesco Grande in Milan. Leonardo and the da Predis brothers were to supply not only a central panel on the theme of 'Our Lady with Her Son', but also the wing panels, along with the painted and gilded decorative framework.

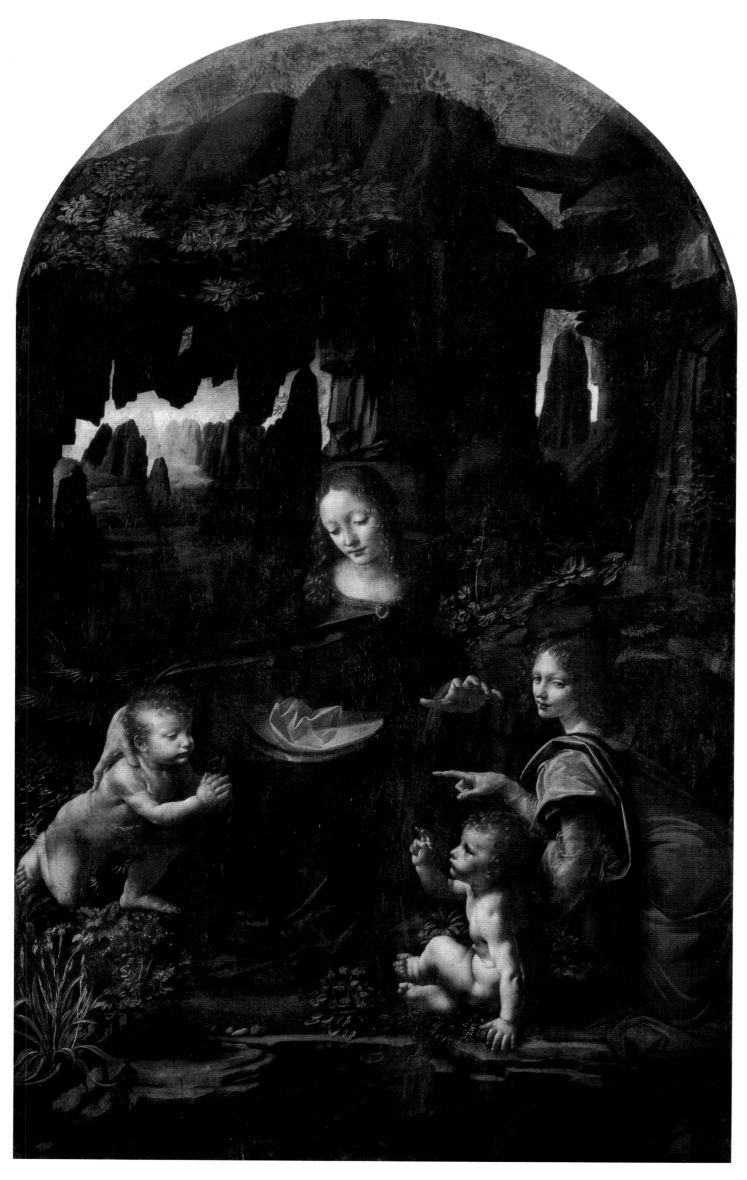

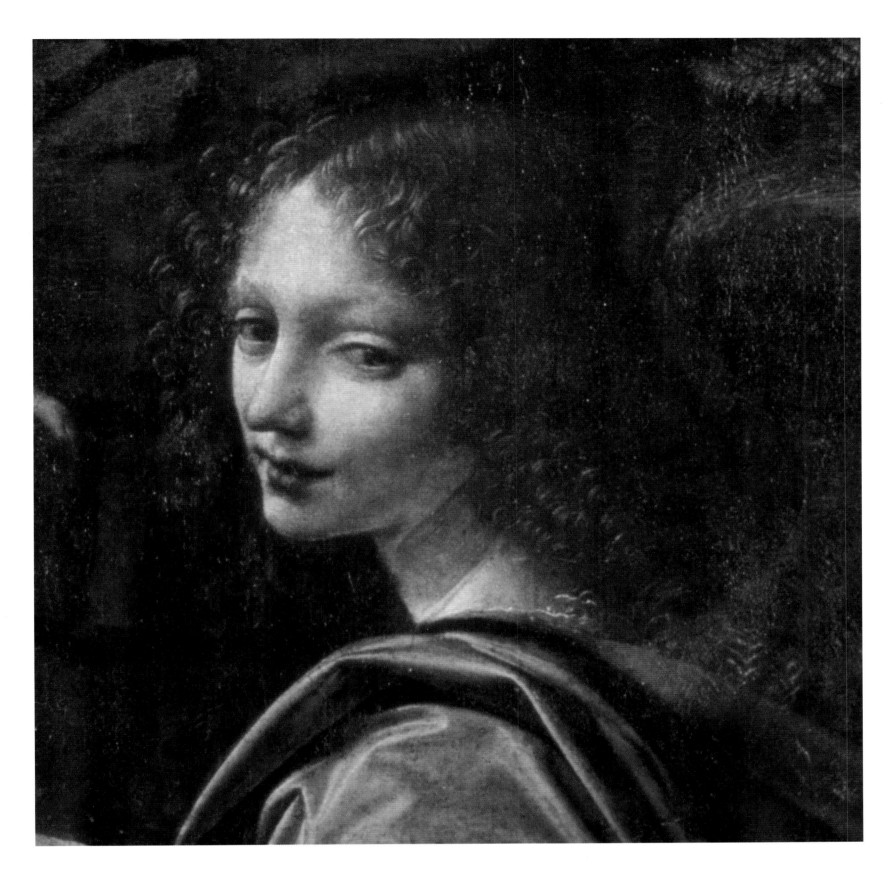

LEFT: *Madonna of the Rocks*, c.1483, oil on wood, transferred to canvas, 78⅜ × 48 inches (199 × 122 cm), Musée de Louvre, Paris. This painting formed the central panel in the altarpiece commissioned in 1483 from Leonardo and the da Predis brothers by the Confraternity of the Immaculate Conception in Milan. It is possible that the panel was sold privately when the brotherhood refused to pay the painters a further fee. In order to fulfil the terms of the contract, it appears that Leonardo painted a second version, now in the National Gallery in London.

ABOVE: Detail of the angel's head from the *Madonna of the Rocks*.

All did not go well with this commission and two versions exist of the *Madonna of the Rocks*, one in the Louvre in Paris, the other in the National Gallery in London. The contract for the commission named Leonardo as *maestro* over the da Predis brothers and stated that the fee was set at 800 Imperial Lire (200 ducats), the initial sum of 100 lire to be paid on 1 May 1483, with the balance in monthly instalments of 40 lire beginning in July. The final payment was to be made in January or February of 1485 when, on completion, the three brothers would be entitled to a bonus to be determined by the Brotherhood. The contract further stipulated that the altarpiece was to be completed no later than the Feast of the Immaculate Conception (8 December) 1485.

The subject of the central panel to be painted by 'the Florentine' was to be of the Virgin and Child with a group of angels and two prophets. On each of the wing panels there were to be four angels singing or playing musical instruments. These wing panels were entrusted to Ambrogio, while Evangelista undertook the gilding, coloring and retouching. The wooden retable into which the entire painting was to fit was contracted out and was carved by Giacomo de Mairo. In the end the decoration of the frame alone was to use up the entire 800 lire fee and, although they had completed the project, Leonardo and Ambrogio had to

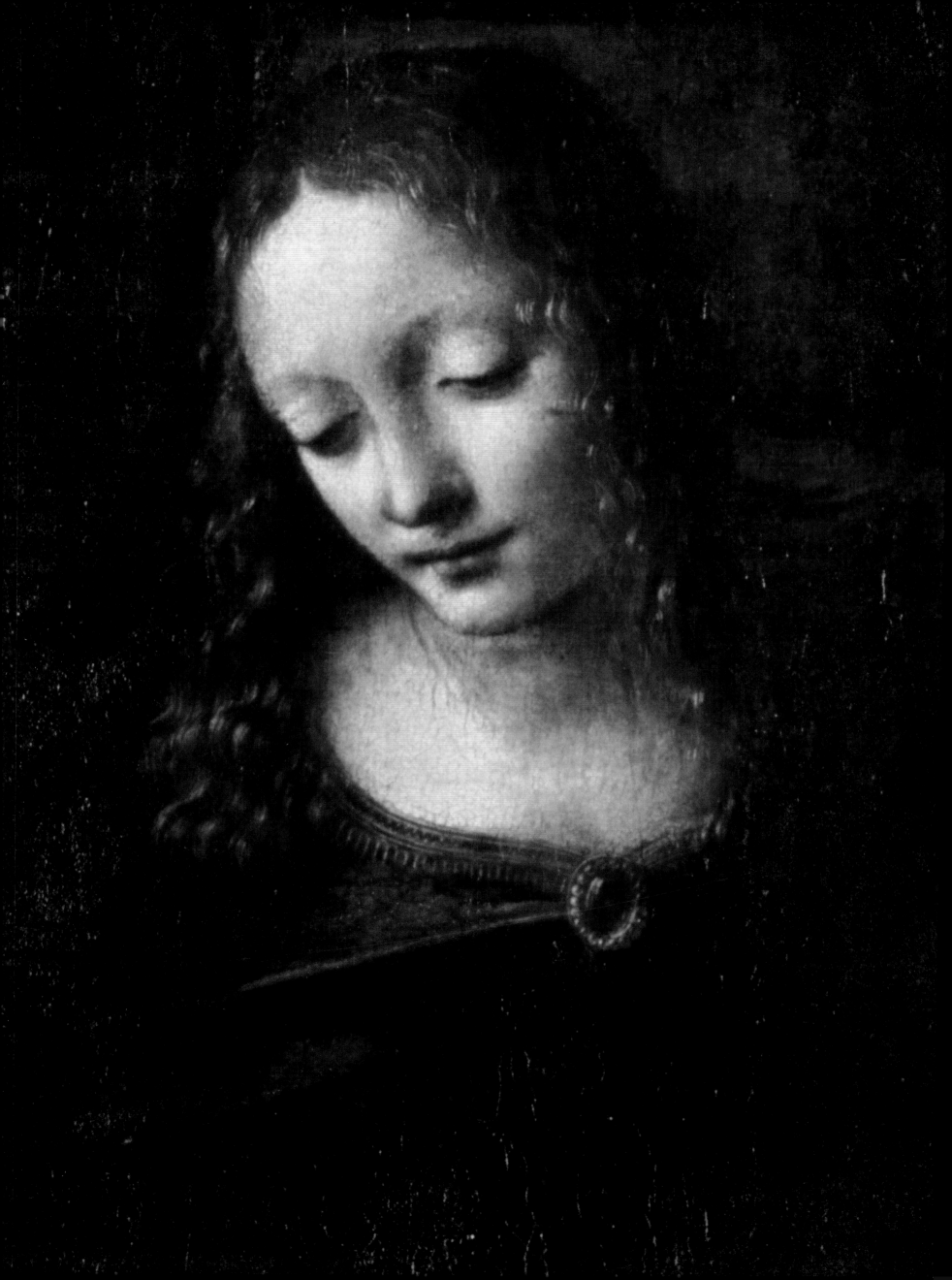

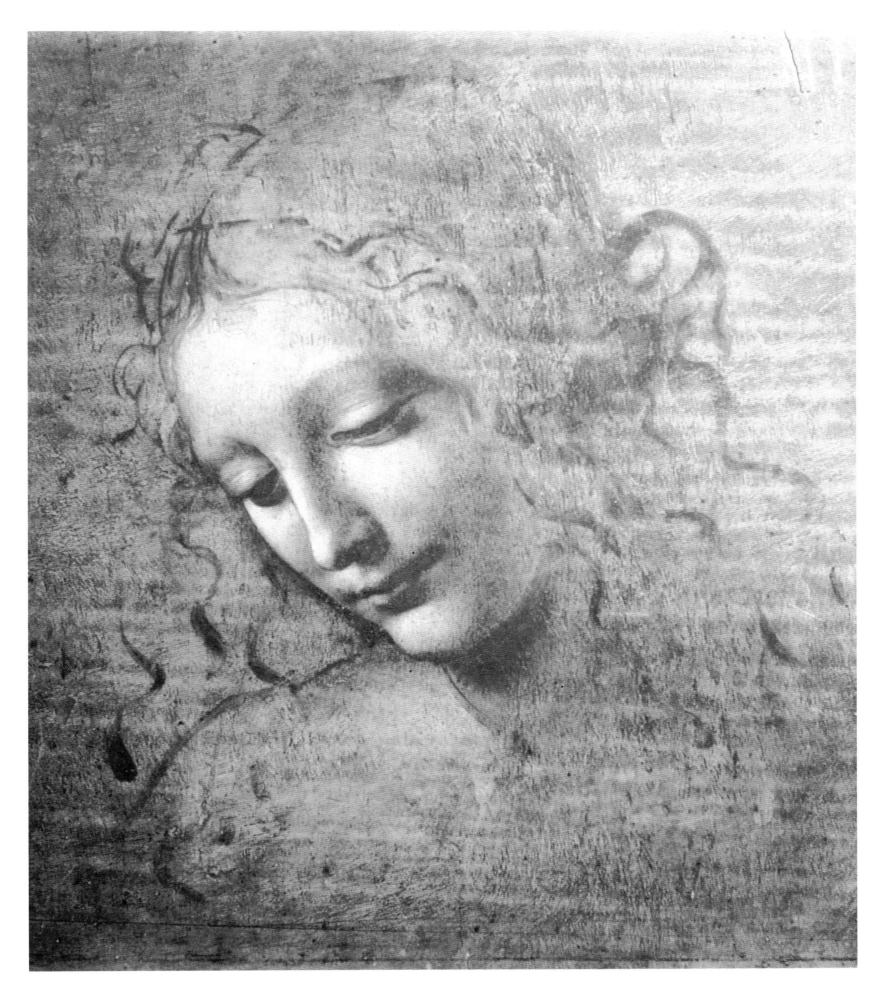

LEFT: Detail of the head of the Virgin from the Louvre *Madonna of the Rocks*.

ABOVE: *Head of a Young Woman*, attributed to Leonardo, 1480's?, drawing on board, 10⅝ × 8¼ (27 × 21 cm), National Gallery, Parma.

petition the Duke of Milan in 1493 or 1494 for an additional payment, since technically they had only received the initial payment of 100 lire between them. This claim was dismissed, however, as was their request that Leonardo's central panel be sold, although it is possible that the central panel was in fact sold and that the second version of the central panel was begun as a replacement in the 1490s.

In 1503 Ambrogio appealed again, this time to the King of France, but by this time Leonardo was no longer in Milan and the case was once again deferred. Then on 27 April 1506 the altarpiece was judged to be unfinished – this must have been the second version of the central panel – and, despite his absence from Milan, Leonardo was ordered to complete the painting within two years. For

43

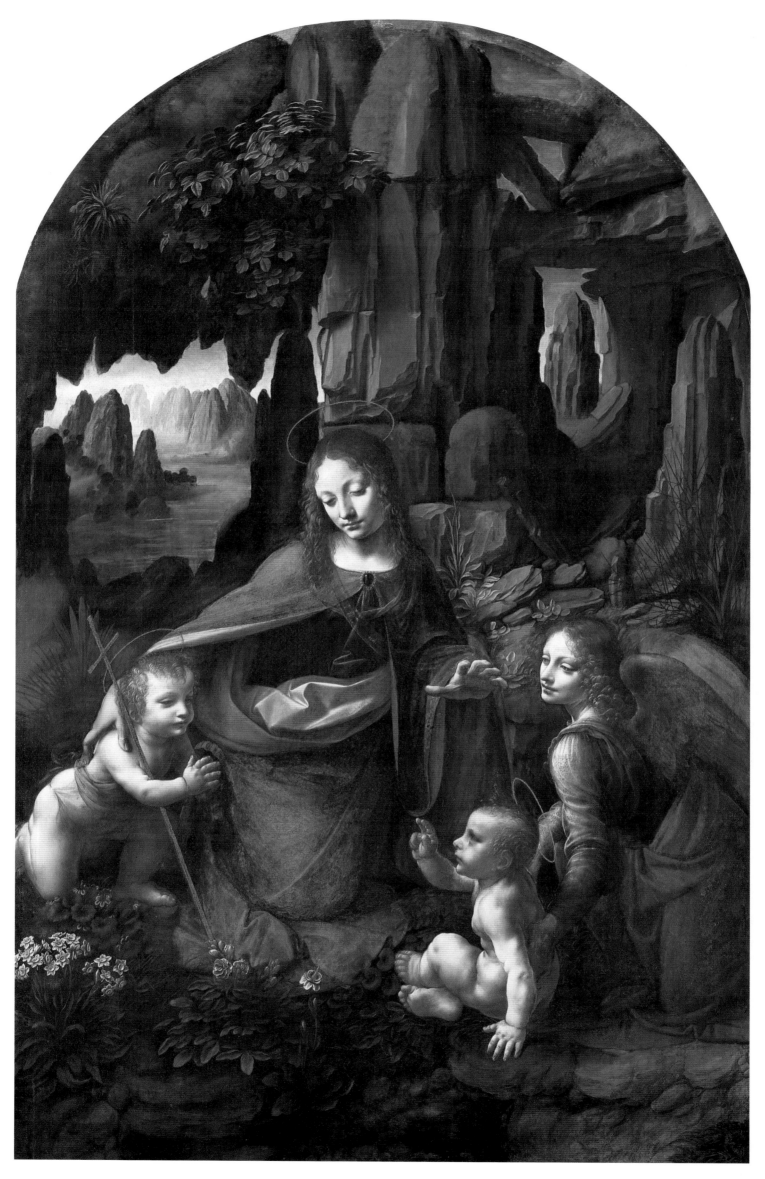

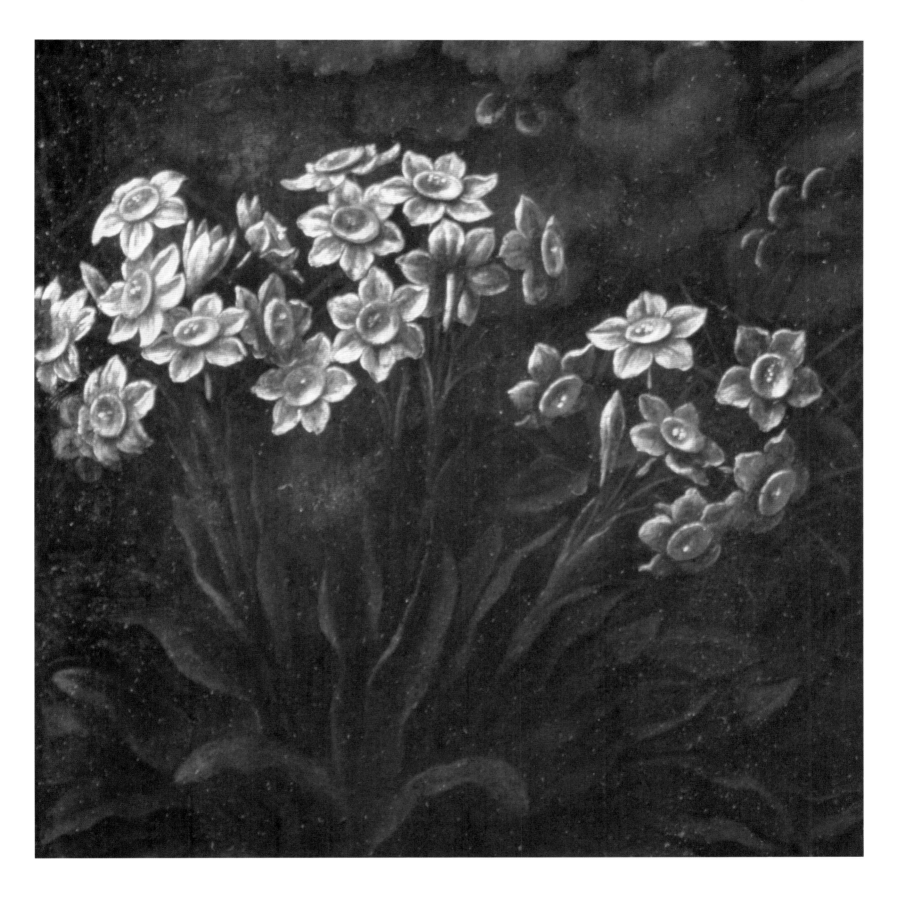

LEFT: *Madonna of the Rocks*, c.1506, oil on wood panel, 74⅝ × 47¼ inches (189.5 × 120 cm), Courtesy of the Trustees of the National Gallery, London. This is believed to be the second, later, version of the central panel of the altarpiece made for the Confraternity of the Immaculate Conception in Milan.

ABOVE: Detail of flowers from the London *Madonna of the Rocks*. Begun in the 1490s, this painting was completed by Leonardo and possibly Ambrogio da Predis or some other hand, who may have been responsible for minor details such as these flowers.

this work Leonardo was to receive 200 lire. Finally, on 18 August 1508, nearly 13 years late, the altarpiece was in place in San Francesco Grande.

Whatever the reasons for the two versions of the *Madonna of the Rocks*, the paintings are interesting in that neither version illustrates a specific incident in the Gospels and both are therefore open to a variety of interpretations. It is possible that the paintings show an incident popularized in the fifteenth century by the theologian Pietro Cavalca, relating to a meeting between the infants St John and Christ when the Holy Family were fleeing to Egypt. Certain elements do support this thesis: the angel could be the

Angel Uriel, who was reputed to be the protector of the child-hermit St John. There are also symbols that prefigure the Baptism, such as the pool of water in the foreground, and the Crucifixion, such as the sharp leaves of the iris which may allude to the 'swords of sorrow' which pierced the Virgin's heart.

The *Madonna* is, however, more than just an illustration of a story. In the fifteenth century, the cult of the Virgin was at its strongest and the doctrine of her own Immaculate Conception – for Christ to have been entirely immaculate, the Virgin must herself have been born of a virgin mother – was particularly popular. Not only are the symbols of the Vir-

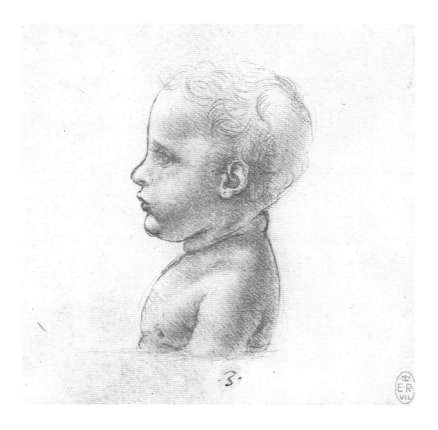

gin apparent in the paintings, for example the palm tree, but the *Song of Songs* was also a popular source of Marian iconography:

O my dove, in the cleft of the rocks,
in the covert of the cliff,
let me see your face.

It has been suggested that in these lines of verse lie the origins of the rocky landscape setting of the figures.

Furthermore, the *Madonna of the Rocks* was the earliest expression of a theory of painting that Leonardo was to explain in some detail in his notebooks. Briefly, Leonardo's thesis was that, in shadow, the individual quality of colors is lost; where an object is in shadow, it should not be differentiated from other objects of different colors. Only in bright light is the true color of an object seen. The result of this approach can be clearly seen in the *Madonna of the Rocks*, where it is tone rather than color that deter-

mines the three-dimensionality and relief of the painting.

While Leonardo worked sporadically on one or other version of the *Madonna of the Rocks* throughout the 1480s and 1490s, he was also busy with other projects. From the early period in Milan, around 1482 or 1483, date two paintings. One is the unfinished *Portrait of a Musician*, believed to represent Franchino Gaffurio, court musician, composer and music theorist at the Sforza court, and the only extant portrait of a male subject by Leonardo. The second painting, *Lady with an Ermine*, is a portrait of Cecilia Gallerani, one of Ludovico Sforza's mistresses. As well as being a writer and poet herself, Cecilia was a patron of the arts in her own right. She was Il Moro's mistress for some ten years until her marriage in 1491. Il Moro's court poet Bernardo Bellincioni described how, in Leonardo's portrait, Cecilia appears not to speak but to be

listening. This accurately describes the attitude of the sitter as she turns to her left to listen to an unseen speaker. This gesture of turning, and more specifically of turning to look over the shoulder, is one that Leonardo used increasingly to enhance the dynamics and movement of his paintings, and complements the swirling movements he used to depict forms, beginning with the drawings for the *Madonna and Child with Cat* (page 13) and culminating in the Deluge drawings from c.1513 (page 100).

A third painting, known as *La Belle Feronnière*, dating from c.1485, has often been suggested as the work not of Leonardo but of his pupil Giovanni Antonio Boltraffio (1467-1516). Further complicating matters is the name *La Belle Feronnière*; this was the nickname given to a mistress of Henri II of France, and the name seems to have been erroneously given to this painting. As well as the portrait of Cecilia Gallerani, however, Leonardo is known to have painted a portrait of another of Ludovico Sforza's mistresses; Lucrezia Crivelli succeeded Cecilia in the 1490s and it is possible the painting is of her likeness.

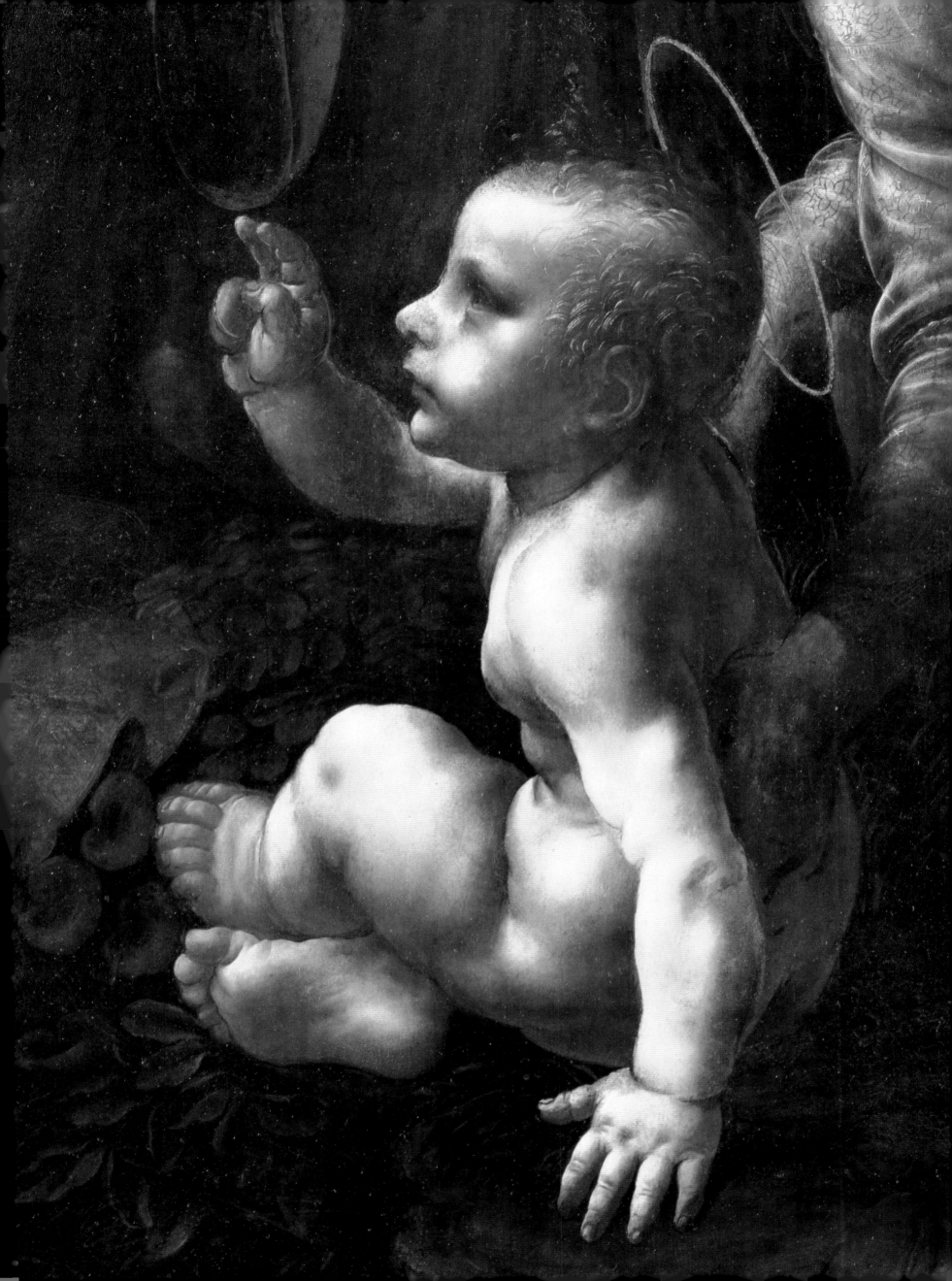

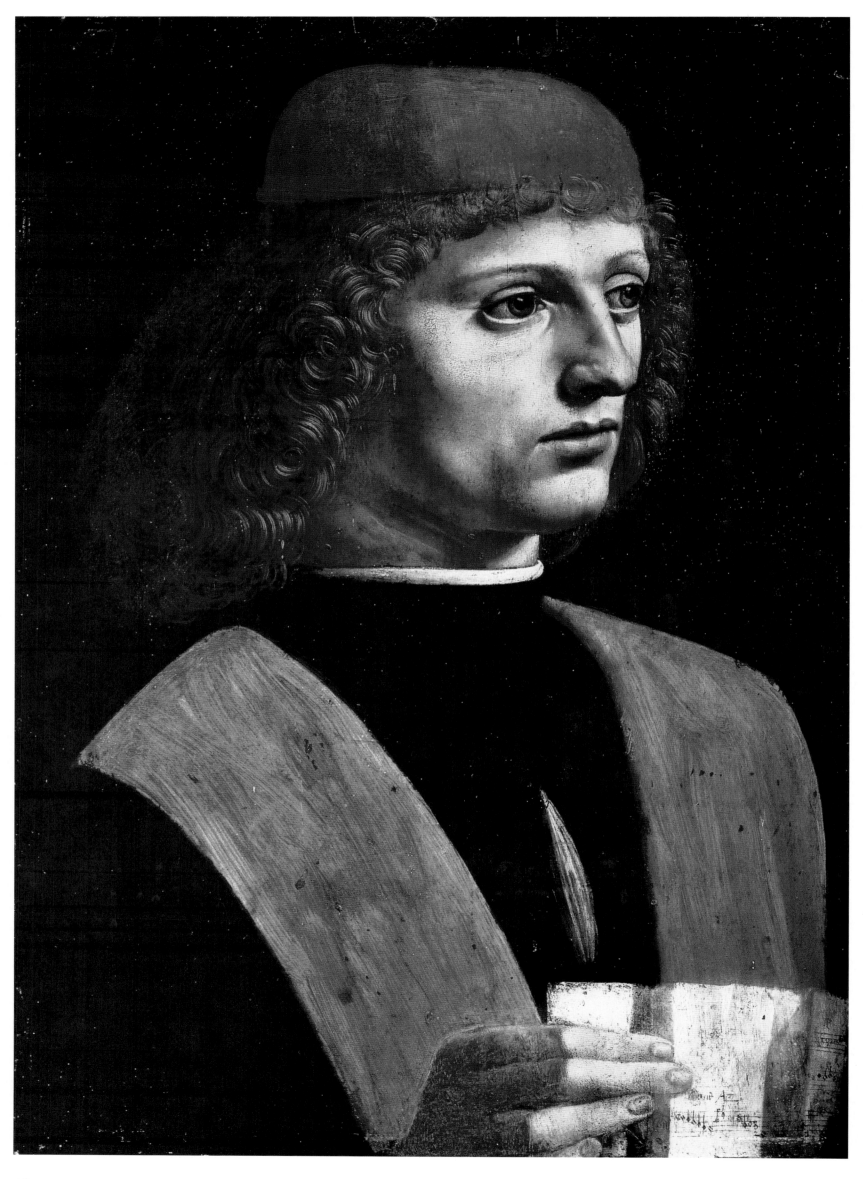

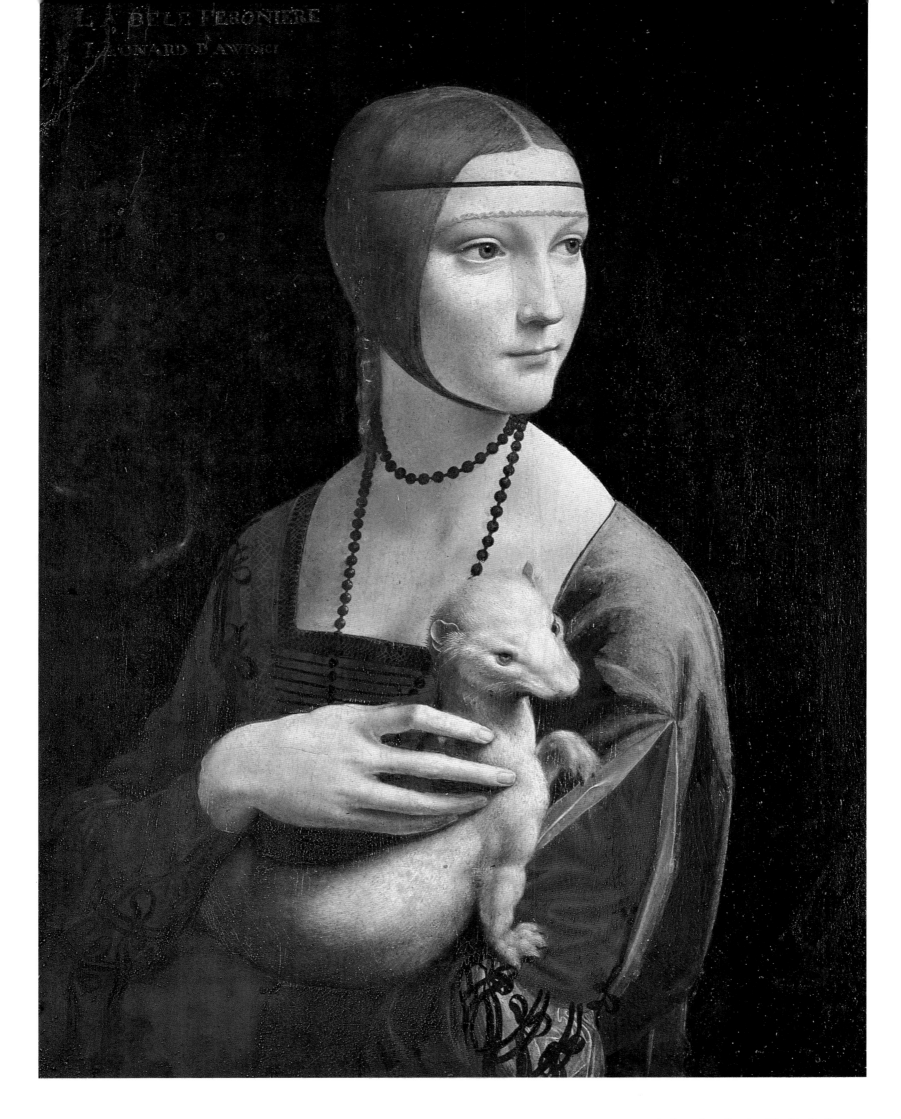

LEFT: *Portrait of a Musician*, c.1485, oil on wood panel, 17 × 12¼ inches (43 × 31 cm), Pinacoteca Ambrosiana, Milan. Possibly a portrait of Franchino Gaffurio (1451-1522), composer and musician to the Sforza court at Milan, this painting is Leonardo's only surviving secular representation of a male subject.

ABOVE: *Lady with an Ermine (Cecilia Gallerani)*, c.1485, oil on wood panel, 21¼ × 15⅜ inches (54 × 39 cm), Czartoryski Museum, Kraków. Cecilia was Ludovico Sforza's mistress for some ten years until her marriage in 1491. The ermine she holds functions both as a symbol of purity and as a pun on her name; in Greek the ermine is 'galay'.

49

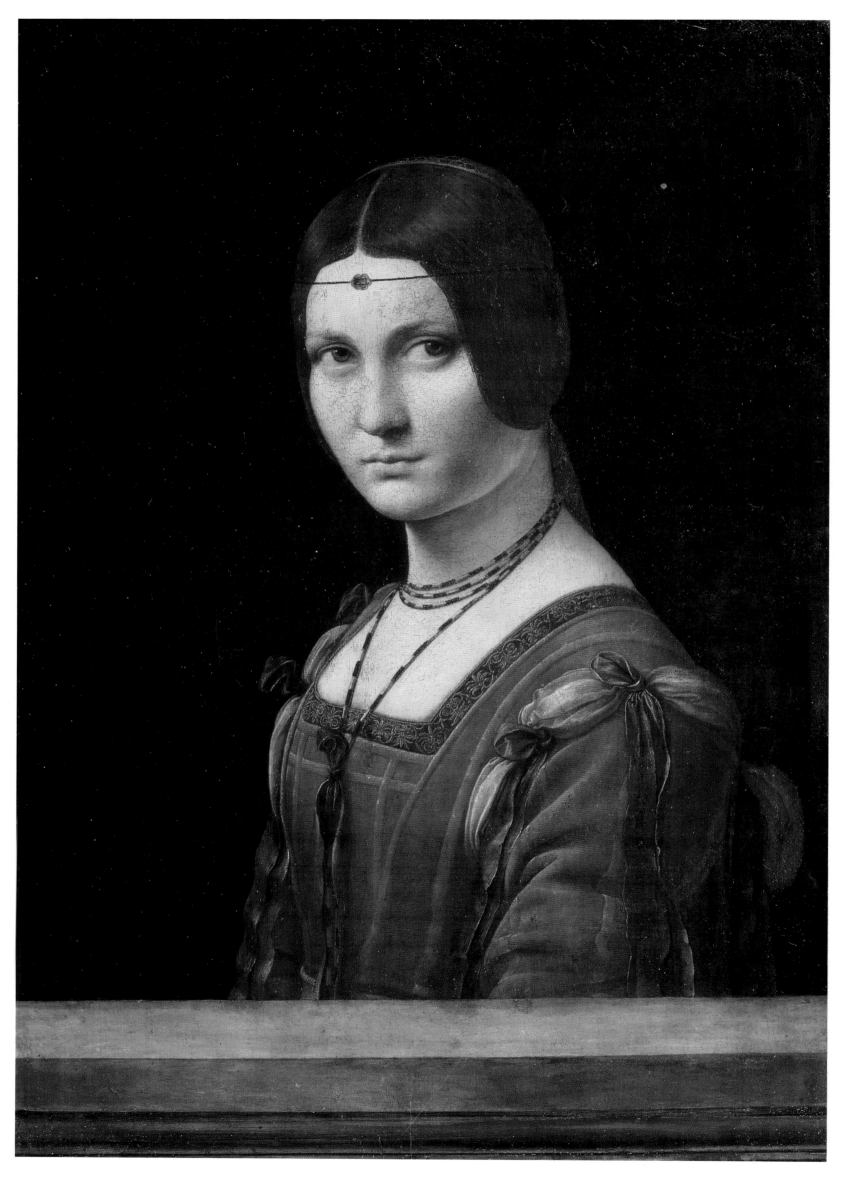

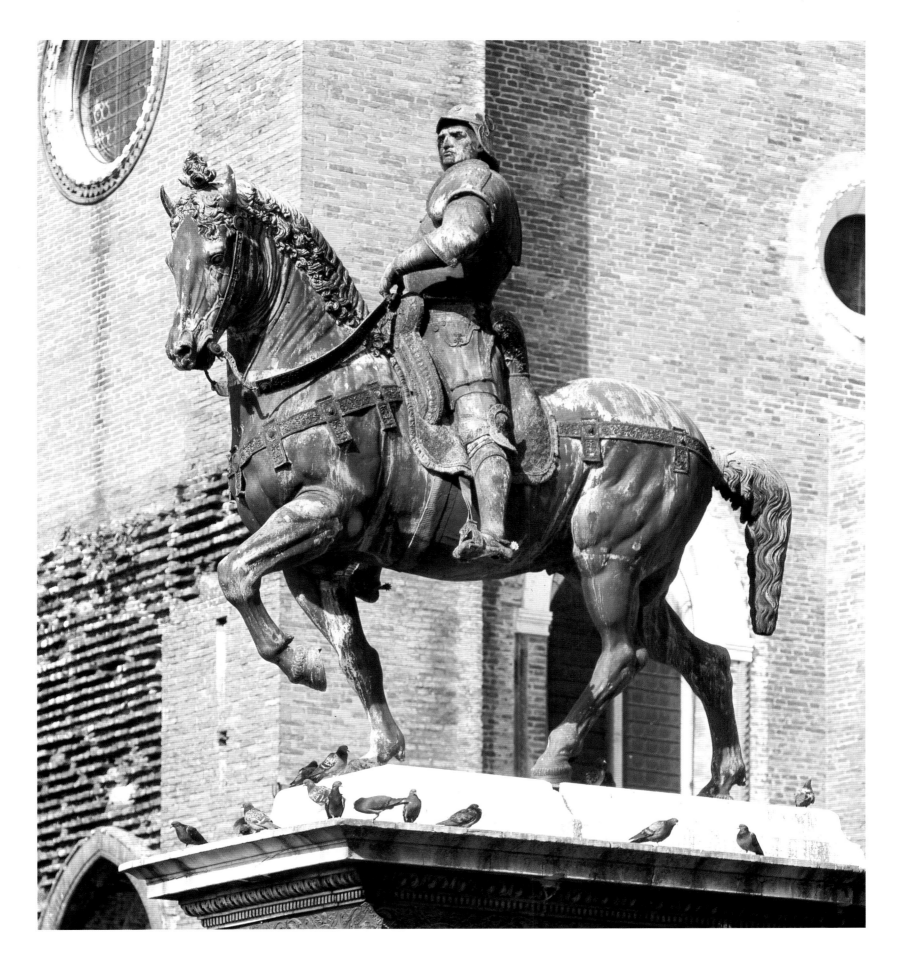

LEFT: *La Belle Ferronière*, c.1495, oil on wood panel, 24¾ × 17¾ inches (63 × 45 cm), Musée du Louvre, Paris. It has been suggested that this painting is not the work of Leonardo but is in fact by one of his pupils, Giovanni Boltraffio (1467-1516). Doubt also surrounds the identity of the sitter, who has been variously identified as Lucrezia Crivelli (Sforza's mistress in the 1490s) and La Belle Ferronière, a mistress of Henri II of France.

ABOVE: Verrocchio's Colleoni Monument in Venice. This work by his master may well have influenced Leonardo's own conception of the Sforza and Trivulzio equestrian statues.

These were not the only projects to occupy Leonardo in the early part of his stay in Milan. Around 1483 he began work on a bronze equestrian statue of Francesco Sforza, a project that would occupy him for 16 years. During his apprenticeship to Verrocchio, Leonardo had assisted his master on the Colleone monument in Venice and so the job of designing, casting and erecting the bronze horseman in Milan fell to the Florentine 'engineer'. As part of his campaign to establish his claims as Duke of

Milan and to aggrandize the Sforza clan in general, Ludovico planned the monument to celebrate his father Francesco, who had been the first Sforza to rule the city. In his introductory letter to Ludovico, Leonardo had said that he could undertake the work on the bronze, but the first real indication we have of his actually working on the project comes in a letter of 1489 from the Florentine ambassador to Lorenzo de' Medici, in which he expressed his doubts about Leonardo's capabilities and asked

RIGHT: *Study of a Horseman on a Rearing Horse*, c.1490, silverpoint on blue prepared paper, Windsor Castle, Royal Library 12357. © 1994 Her Majesty The Queen. This is almost certainly an early study for the Sforza Monument.

BELOW: This sixteenth-century bronze *Rearing Horse*, height 8⅝ inches (22 cm), relates to Leonardo's early studies for the Sforza monument.

FAR RIGHT: *A Horse in Profile to the Right and Its Forelegs*, c.1497, silverpoint on blue prepared paper, 8½ × 6¼ inches (21.4 × 16 cm), Windsor Castle, Royal Library 12321. © Her Majesty The Queen. As well as studying horses for their anatomy and proportions, Leonardo made a number of sketches from life as preliminary studies for the Sforza equestrian statue.

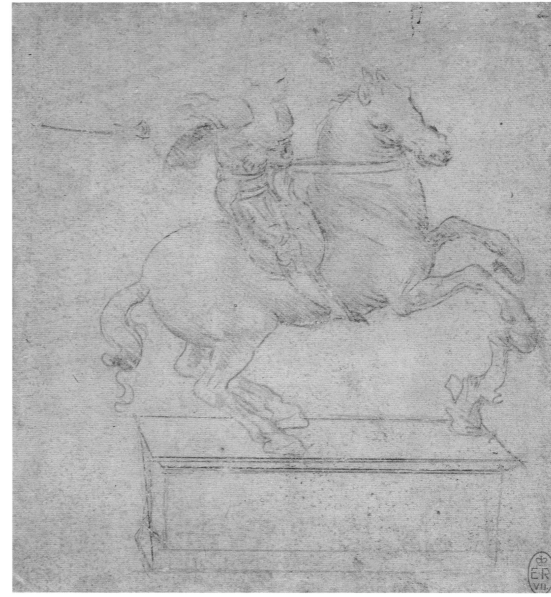

Lorenzo to recommend an alternative Florentine sculptor to do the work. Perhaps Leonardo was taking too long on the project, or maybe in the Ambassador's eyes he simply required technical assistance.

Leonardo's original ideas, judging from surviving drawings, seem to have been for a rearing horse, but by 1490 the decision was taken to portray a walking horse. Leonardo's own notes reveal that

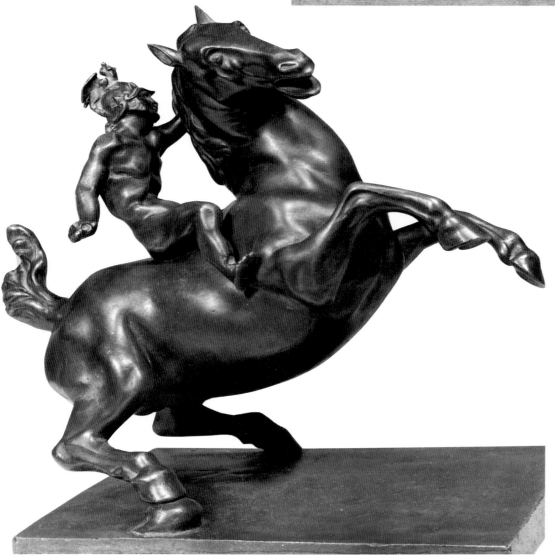

he made a great number of studies from life of some of Il Moro's horses and, throughout his career, he was to seek out the underlying proportions in his studies of plants, animals and humans. The final pose he adopted was of a high-stepping horse with one front leg raised, a pose similar to the equestrian statue of Marcus Aurelius in Rome. No doubt such classical allusions would have been highly attractive to the Sforza clan.

Ludovico Sforza was not a patient man, however; he wrote to Leonardo that the statue must be completed by November 1493 as he wanted it as a showpiece at the wedding of his illegitimate daughter Bianca to the Emperor Maximilian (whose first wife Margaret had died leaving huge debts, crippling the Medici bank in Bruges). Leonardo replied that while he could not guarantee the bronze, he could promise a clay model, three times life size (about 56 feet from hoof to the top of Francesco's head). Surprisingly he managed to keep his word, and the clay statue was erected in the courtyard of the Castello Sforzesco and was ceremonially unveiled during the wedding celebrations. This clay model was as far as the project was ever to get.

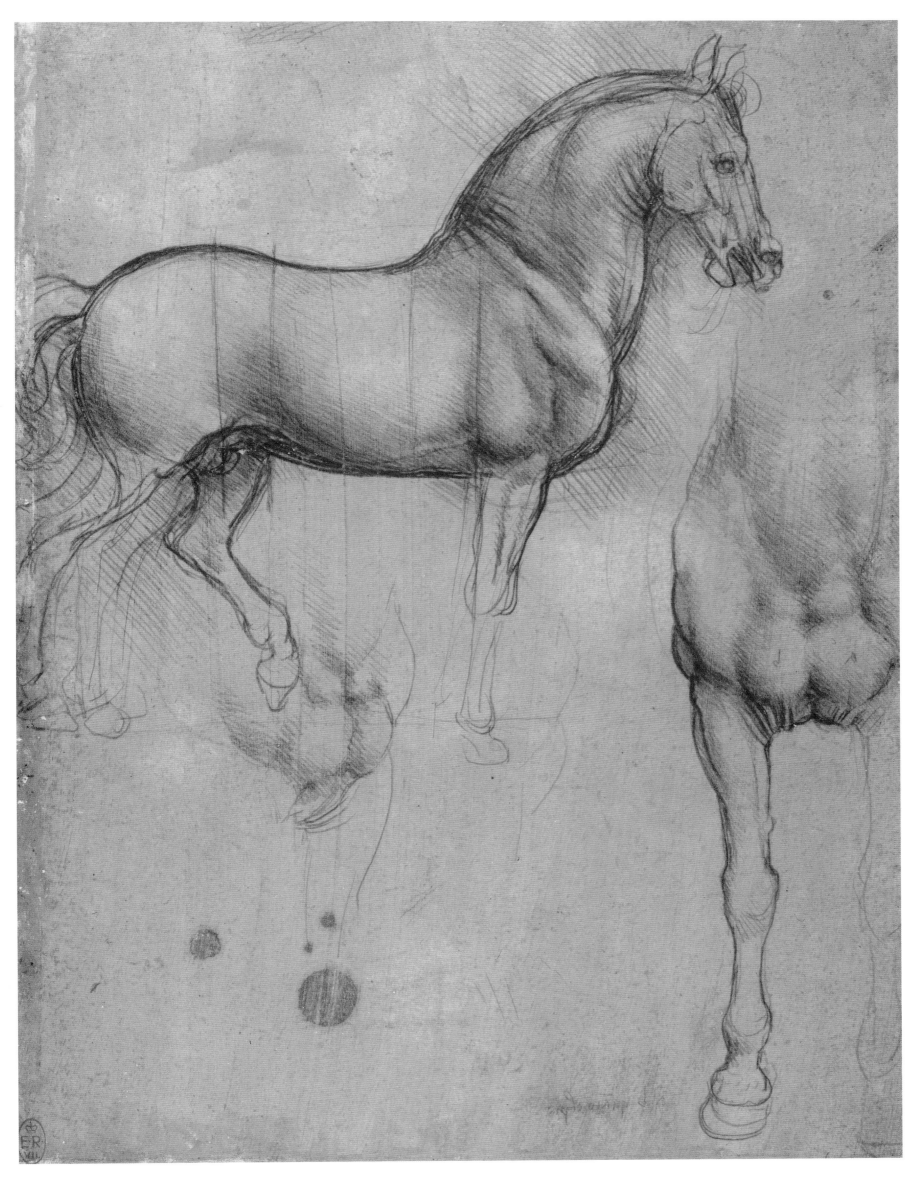

Other projects that occupied Leonardo in Milan included the construction of a model for the *triburio*, the central cupola planned for the dome of Milan Cathedral, for which a number of drawings exist. Ludovico also sent Leonardo to Pavia to restore the Sforza-Visconti castle. In the town that had been home to the poet Petrarch and to the explorer Christopher Columbus, Leonardo wrote his notes on optics which would, after his death, be turned into a treatise. Here he worked on the camera obscura to demonstrate his theory that all vision was determined by the angle at which light fell upon the eye.

Leonardo also proved to be adept at planning masques and devising stage machines for court occasions. For the wedding of Gian Galeazzo Sforza to Isabella of Aragon, scheduled for early 1489, Leonardo devised a portico covered in greenery to be erected in the castle courtyard: the countryside brought safely inside the Sforza Castle walls! A series of planned marriages serving to cement Milan's political alliances culminated in 1491 with Ludovico's own marriage to Beatrice d'Este, the sister of the aesthete Isabella who had herself married into the

LEFT: *Study for the Triburio of Milan Cathedral*, c.1487, pen and ink, Biblioteca Ambrosiana, Milan. Between 1487 and 1488 Leonardo was working on a model for the *triburio*, or central cupola, planned for the dome of Milan Cathedral. Along with a wooden model, Leonardo submitted a letter to the works department in which he compared the building in need of repairs to a sick body and the architect to a doctor.

BELOW: *A Scythed Chariot, Armored Vehicle and a Partisan*, c.1485-88, pen, ink and wash, 6⅞ × 9⅝ inches (17.3 × 24.6 cm), courtesy of the Trustees of the British Museum, London. One of Leonardo's most famous designs for machines of war, this shows two views of the armored vehicle, one without its roof, the other complete with gun barrels projecting outward.

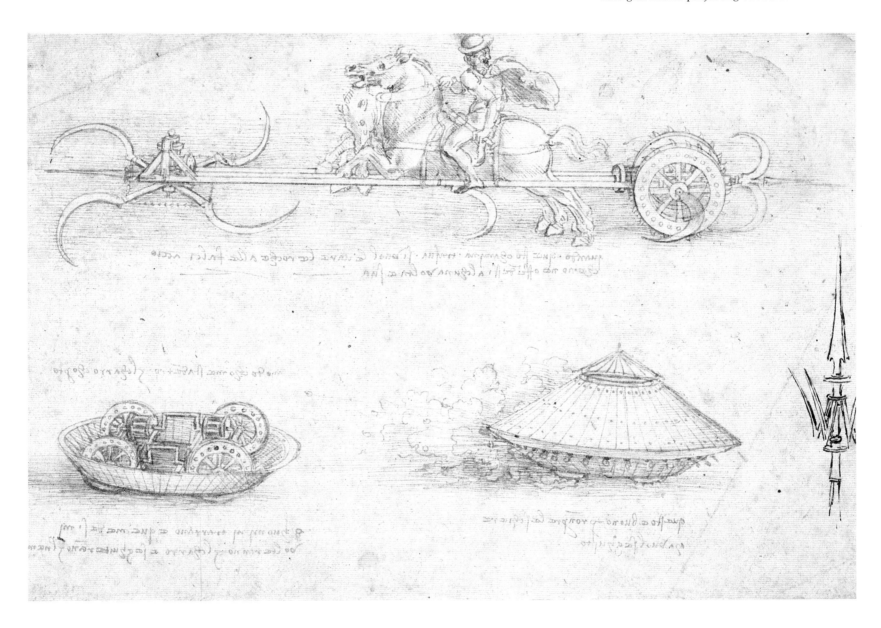

Gonzaga family who ruled Mantua. To celebrate the union of Il Moro and Beatrice, Leonardo staged a pageant sponsored by Galeazzo di Sanseverino (Ludovico's son-in-law and a captain in the Milanese army).

Leonardo seems to have found favor with Ludovico for this type of work, but it appears from his notebooks that Leonardo had projects in mind that should have been of greater interest to the Duke. In 1485 he had produced his first designs for a flying machine, recom- mending in his notebooks that for safety's sake the test flight should be carried out over water. The same year he watched the eclipse of the sun and devised a method of observing such phenomena without injuring the eye. When Leonardo wrote to Ludovico offering his services and writing of his many talents, the list of skills which he offered included 30 of a technical nature and only three artistic. In an age of transition from the crossbow to the cannon, Leonardo has left us a wealth of designs for machines and weapons, as well as maps and studies of human anatomy. It appears, however, that Ludovico Sforza chose not to make use of any of Leonardo's 'inventions'. In his letter Leonardo claimed he could make cannons and mortars that were both beautiful and different from those already in use. The chief limitations of Renaissance firearms were their slow rate of fire and their inaccuracy. One of Leonardo's solutions was to devise a series of light cannon or *scoppietti* in a fan pattern. He seems to have had a particu-

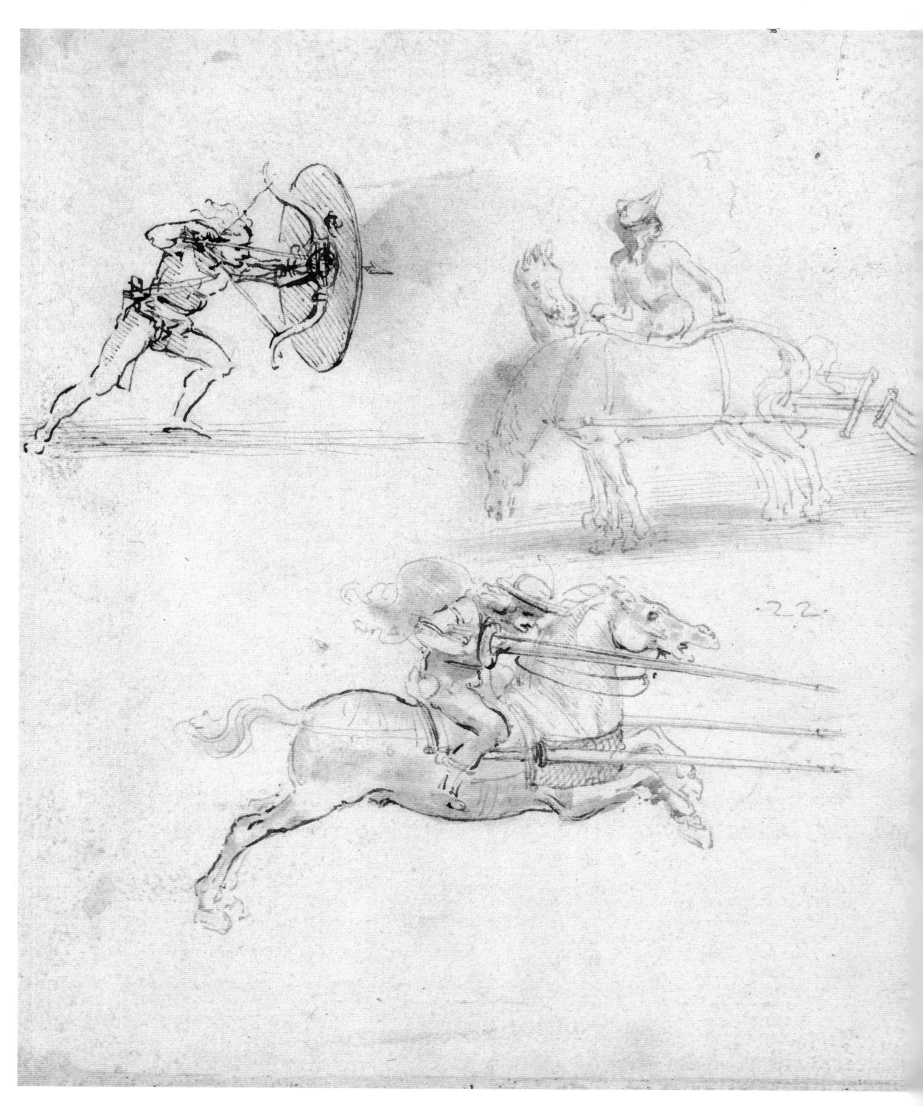

lar interest in designs that multiplied a single force; almost 10 years after he had arrived in Milan he made a sketch depicting a mounted warrior carrying not one but three lances, two of which were attached to the rider's saddle.

The most famous of Leonardo's 'war machine' drawings is the *Scythed Chariot, Armored Vehicle and a Partisan* from c.1487. The scythed chariot was probably inspired by descriptions of antique war machines, such as the one reputedly driven by the Celtic leader Queen Boudicca. The drawing shows two views of the armored tank. One, like a turtle rolled on to its back, shows the arrangement inside designed to carry eight men. The other view, with its roof in place and guns poking out, is completed with a cloud of dust which Leonardo claimed was useful for breaking up enemy ranks.

Leonardo's designs for weapons can be divided into three broad categories: catapults (ballista) like the *Giant Crossbow on Wheels* of c.1485-88; cannon, like the drawing of *A Large Cannon being Raised on to a Gun Carriage (Artillery Park)* (c.1485-88), the various water-borne mortars and those with explosive, shrapnel-spreading projectiles; and muskets (arquebus), the matchlock-firing mechanisms for which are described in drawings from 1495. The demand for increased fire power led Leonardo to even grander schemes, such as the design for a treadmill-powered crossbow, a sort of huge machine gun where the archer is perched inside a big treadmill, which is turned by the foot power of soldiers placed on the outer rim of the wheel for added leverage. These soldiers are hopefully protected from enemy fire by a pivoted shield of wooden planks. For a man who professed a hatred of war, guns and artillery were to be a constant area of study for Leonardo.

Little escaped Leonardo's observation, no matter how mundane. In addition to weapons of war he turned his hand to devising labor-saving devices like the *De-*

BELOW: *A Giant Crossbow on Wheels*, c.1485-88, pen, ink and wash, 7⅞ × 10⅝ inches (20.2 × 27.25 cm), Bibilioteca Ambrosiana, Milan. This huge ballista has some advanced design features, including a laminated bow for extra flexibility and a worm and gear mechanism for drawing back the bow, which is shown in detail in the right-hand corner. The two left-hand drawings are designs for the release mechanism; the upper drawing shows a spring device operated by a hammer blow, while the lower one shows a lever action device.

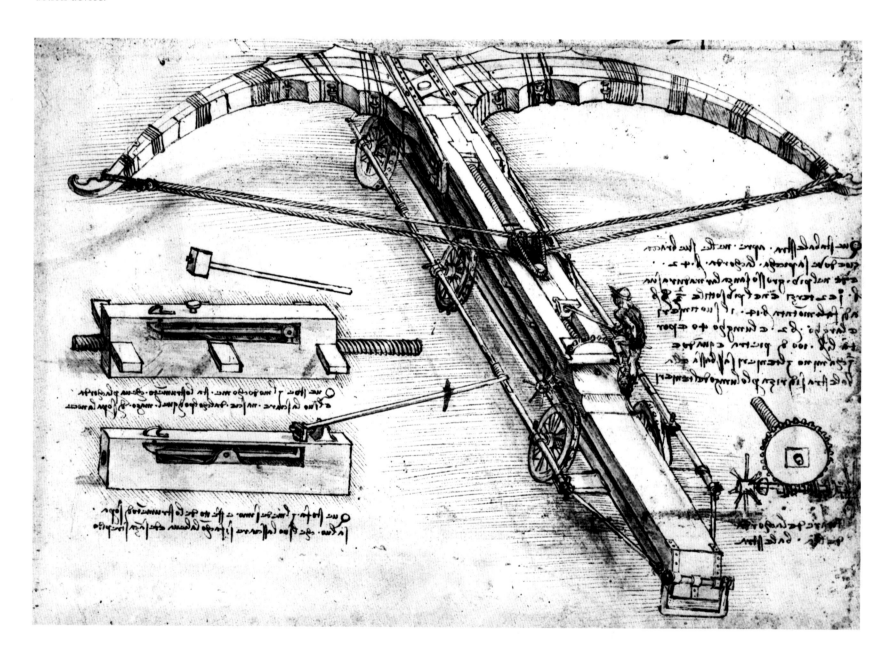

sign for a Napping Machine for producing a constant level of nap on cloth, thereby replacing tedious handwork with a mechanized process. One of his earliest designs was for a file or rasp marker, a machine designed to strike the teeth of the file evenly on the face of metal blanks. Once started, the machine required no human intervention apart from re-cranking the weight to its start position. There are also drawings in which Leonardo studied the problem of translating rotary motion into reciprocating or piston-like action and vice versa; he designed a windlass for lifting heavy loads. In this drawing Leonardo shows us two views of the device, one assembled, the other an exploded view of the mechanism. Another drawing shows a machine for boring holes; until the late seventeenth century, when cast iron piping began to be used for water mains, logs with holes bored through their centers served this function. What is inventive about Leonardo's machine is the set of adjustable chucks which would ensure that the axis of the logs remained in the center of the machine, whatever the diameter of the logs.

Although the most grandiose schemes and designs never left Leonardo's notebooks, he did understand fully the impact that such machines and technology would have on society. He expressed some of the resulting fears in his *Prophecies*, riddles devised to be solved at court parties. In the guise of clever word games,

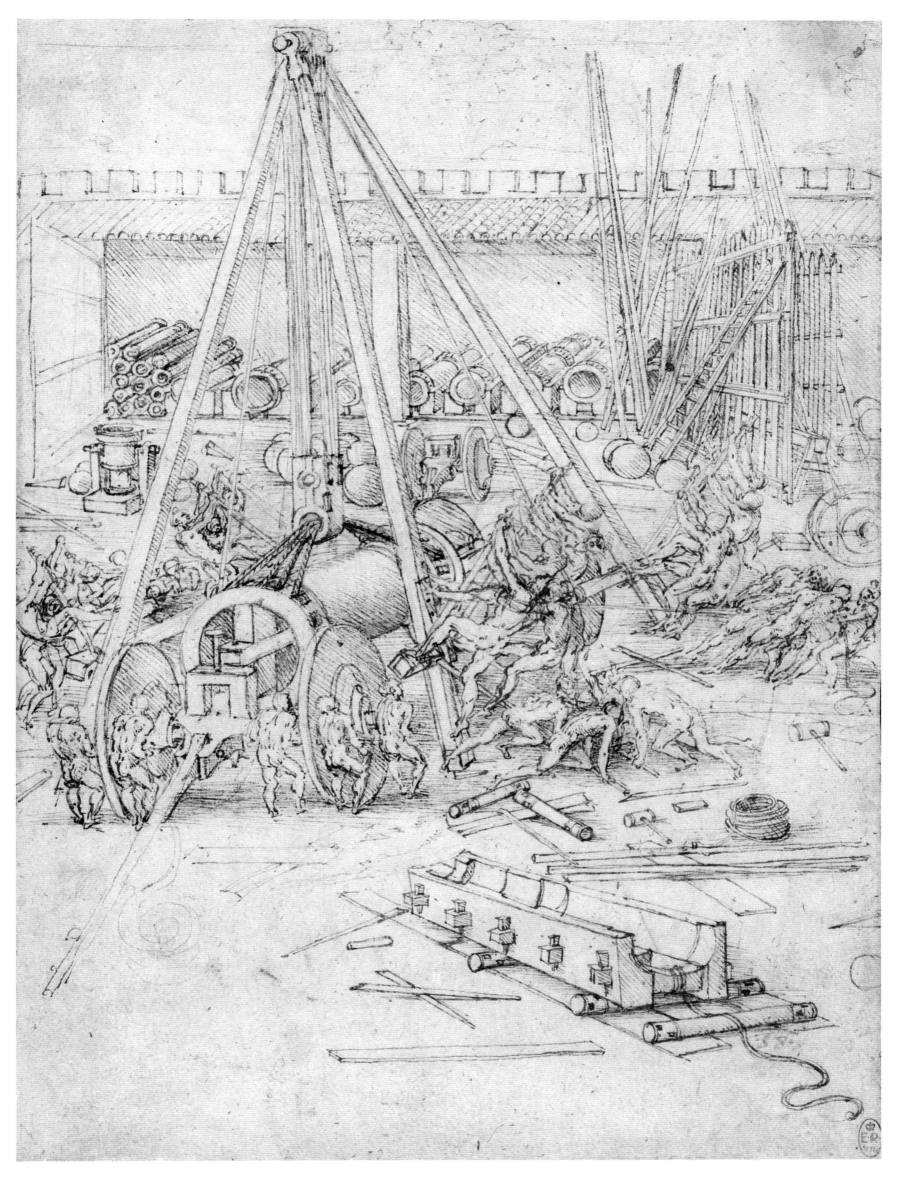

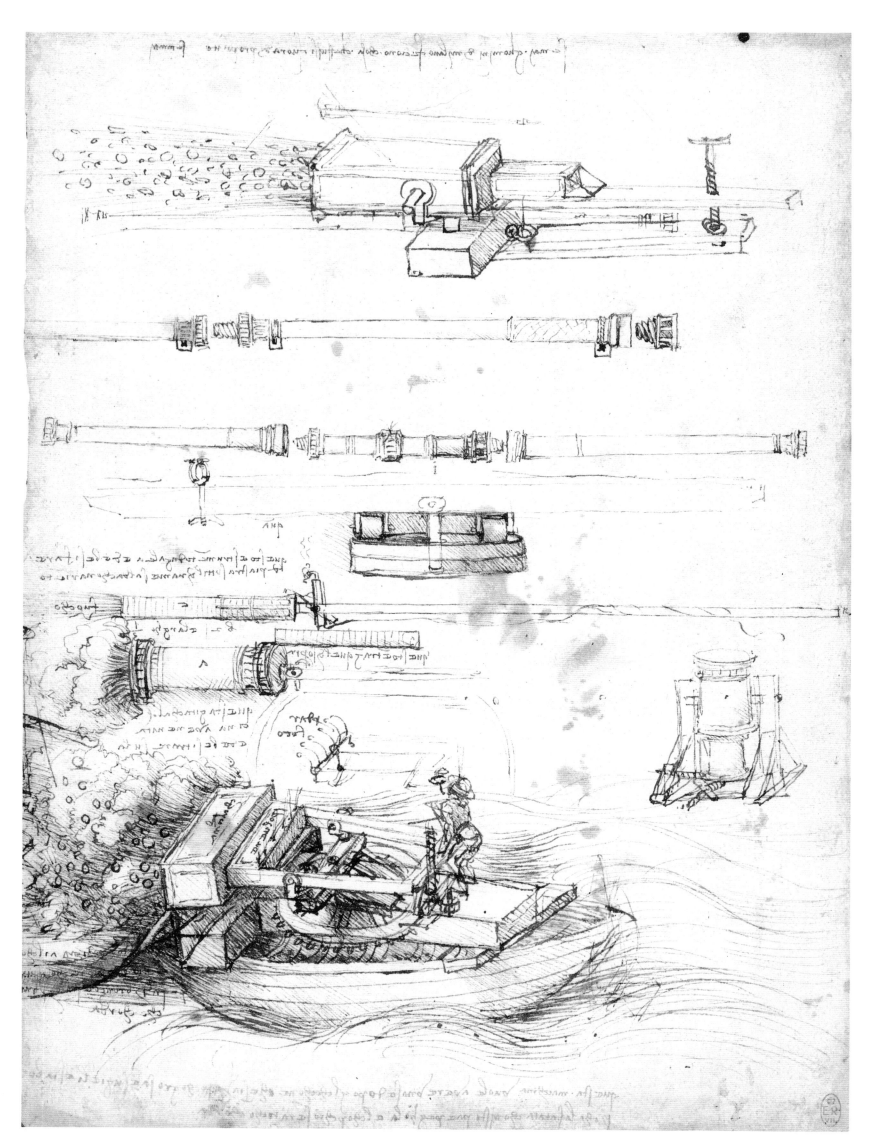

LEFT: *Studies of Mortars, One Firing from a Boat and of Cannon*, c.1485-88, pen and ink, 11⅛ × 8⅝ inches (28.2 × 20.5 cm), Windsor Castle Royal Library 12652r. © 1994 Her Majesty The Queen. These drawings support the claims that Leonardo made in his letter of introduction to Ludovico Sforza that he could make both offensive and defensive weapons, for land or sea. The cannon at the top was designed to hurl small stones or to shoot salvos of 'Greek fire' – incendiary shells. At the foot of the drawing, the cannon is shown mounted on to a boat. At the very top of the page are the words in Leonardo's mirror handwriting: 'If ever the men of Milan did anything which was beyond the requirements or never' – words generally interpreted as frustration with his Milanese employers' unwillingness to put any of his ideas into action.

BELOW: *Treadmill-powered Crossbow*, c.1485-88, Biblioteca Ambrosiana, Milan. The archer is suspended out of range of enemy fire in the middle of the huge treadmill, which is turned by the footpower of soldiers on the outer rim, who in turn are protected by the pivoted shield of wooden planks.

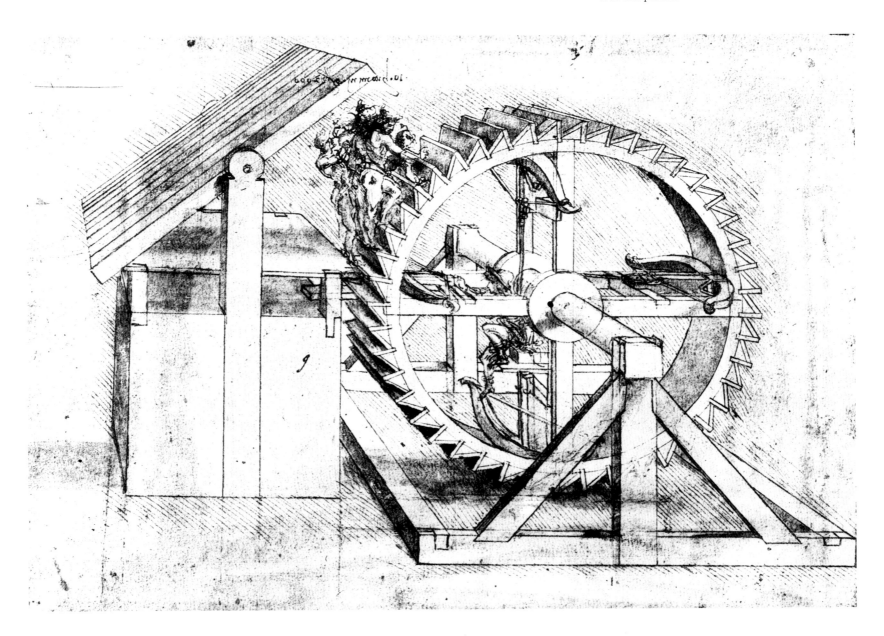

Leonardo not only pointed out the problems of his own era but commented on humanity in general, comments that regrettably hold true five hundred years later:

Creatures will be seen upon the earth who will always be fighting one another . . . there will be no bounds to their malice, by their fierce limbs a great number of trees of the immense forest of the world shall be laid to the ground.

The outbreak of plague in Milan in 1483 and again in 1486 may have inspired Leonardo to draw up his plans for the remodeling of the city. His plans called for a city built on two levels: the lower streets were set aside for use by carts, animals and the lower classes of citizens, while the upper level was to be a promenade with hanging gardens for the pleasure of the wealthy and noble. Archways and unobstructed views of the sky provided light and ventilation to the lower level, and every hundred meters or so a staircase connected the two levels.

Leonardo had also observed that the Milanese were in the habit of leaving their garbage in corners; to overcome this, he planned his staircases as spirals! All of these schemes, including weapons, machines, underground sewage systems, running water supplies, a clean air project for Milan for circulating fresh air by windmills and many others, were dismissed by Ludovico Sforza. Furthermore the Duke failed at times to pay Leonardo the money due to him for other commissions, but was content for Leonardo to

BELOW: *The Firing Mechanism of a Gun,* c.1485-88, Codex Madrid I. f.18v, Biblioteca Nacional, Madrid. These drawings show Leonardo's ideas for improving the matchlock-firing mechanism of a gun. The mechanism shown simultaneously opens the powder chamber and sets fire to the touch hole.

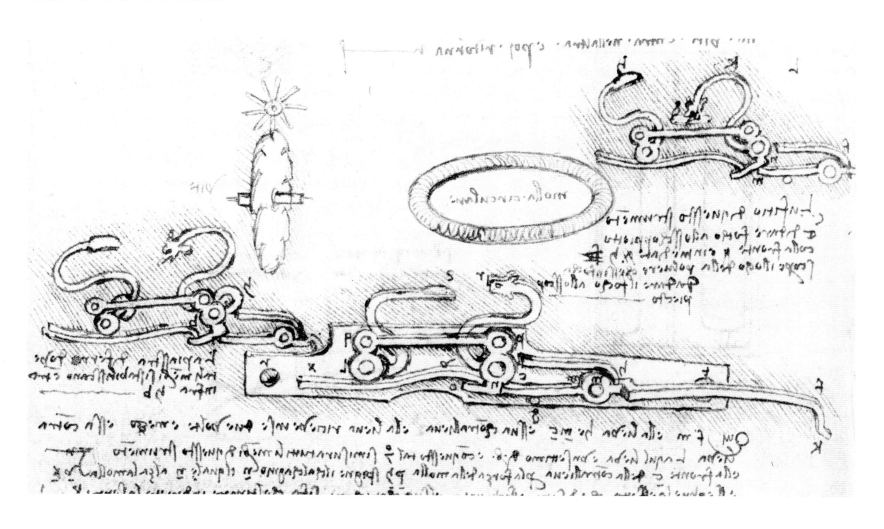

design his pageants and courtly diversions.

Ludovico did, however, have more immediate concerns. When he sent his niece Bianca off with a dowry of 400,000 ducats to marry the Emperor Maximilian – money the Emperor badly needed – Ludovico was buying Imperial protection. He had heard that his sister-in-law Isabella d'Este in Mantua was urging her grandfather the King of Naples to challenge Ludovico's right to the dukedom of Milan. In a counter-move, Ludovico contacted the French king Charles VIII and promised him support for his own claim to Naples. Ludovico began to arm, and the bronze that had been set aside for the casting of the equestrian statue of his father was now diverted to Ludovico's father-in-law Ercole d'Este in Ferrara,

where it was made into cannons. Things were looking pretty bleak for Il Moro: few trusted him and he was already suspected of plotting to kill his nephew Gian Galeazzo, the rightful duke. While the French king was grateful for the support in claiming Naples, Ludovico did not realize that his French ally also had his eye on the throne of Milan. By October 1494, Gian Galeazzo was dead. Undaunted by the ensuing rumors of murder, Ludovico proclaimed himself Duke of Milan and continued with his magnificent patronage of the arts. In charge of court culture was Leonardo.

In 1491 Ludovico had sent Leonardo to divert the River Ticino from its natural course in order to irrigate the surrounding fields. There Leonardo met the nobleman Giovanni Melzi, who had a villa at

Vaprio on the River Adda. Leonardo soon became one of Melzi's household and is believed to have completed *The Madonna of the Rocks* (page 40) while staying at Melzi's villa.

Ludovico, who took great care in promoting cultural life, did not neglect his own spiritual well-being. For some time he had been asking Leonardo to paint a *Last Supper* for the Dominican monastery in Milan, Santa Maria delle Grazie, which Ludovico had adopted as his 'court church'. The first notes on the design of the painting in Leonardo's manuscripts are dated between 1494 and 1495. At Ludovico's instruction, the east end of the church was reconstructed during the 1490s by Donato Bramante (1444-1514), later to be the architect of St Peter's in Rome. Using a plan similar to those

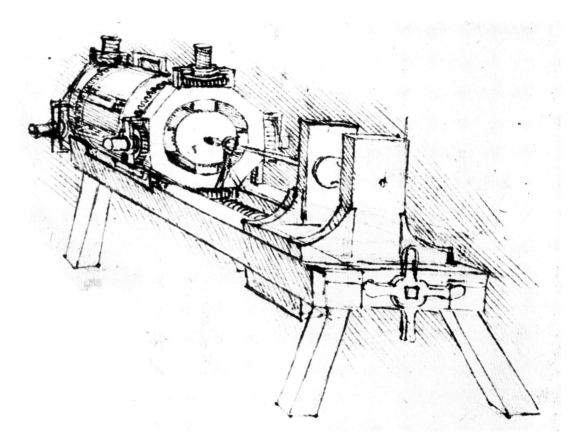

RIGHT: Resembling a modern lathe, this machine was devised for drilling wooden water pipes, which were widely used until the introduction of lead and, later, cast iron piping. A set of adjustable chucks ensures the drill bores precisely through the center of the log, no matter what its diameter. Biblioteca Ambrosiana, Milan.

BELOW: *Design for a Napping Machine*, c.1497, pen and ink, Biblioteca Ambrosiana, Milan. The tedious job of cutting the excess hair from the surface of newly woven cloth with hand-held shears could have been replaced altogether by this machine. As well as saving both time and labor costs, the machine would have produced a constant level of nap.

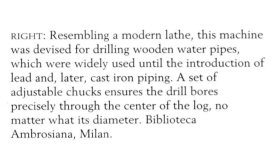

RIGHT: *Two Designs for a Domed Church with Surrounding Cupolas*, c.1488-89, pen and ink, 9 × 6¼ inches (23 × 16 cm), Bibliothèque de l'Institut de France, Paris. Centralized church designs were particularly favored by Renaissance architects and theorists because of their classical origins. This drawing dates from the period when Leonardo was involved in the project for the domed crossing for Milan Cathedral.

BELOW: *Design for a Multi-leveled Town*, c.1488, pen and ink, Bibliothèque de l'Institut de France, Paris. The outbreak of plague in Milan in 1483 may have inspired Leonardo to draw up plans for a remodeled city. His plan called for streets on two levels, the lower ones for carts and lower class citizens, the upper levels for hanging gardens and promenades for the noble Milanese. Every hundred meters or so a spiral staircase would link the two levels, and archways would provide light and ventilation to the lower streets.

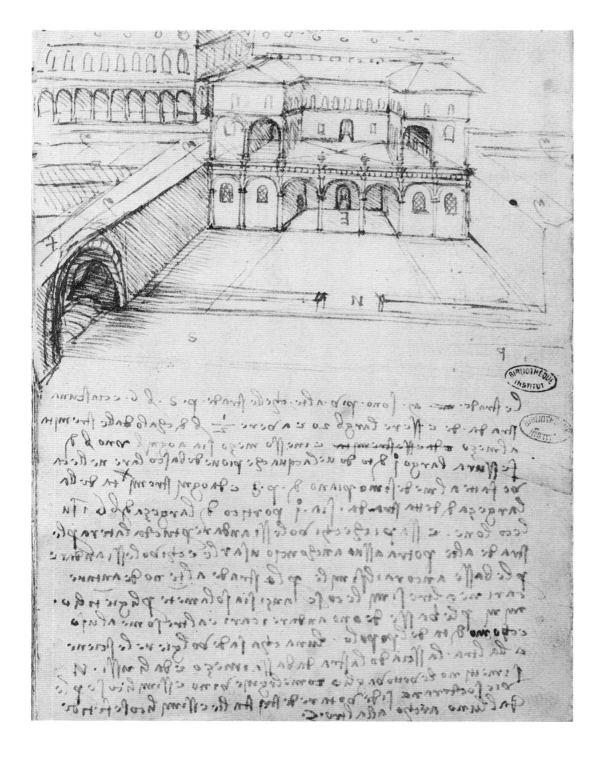

which Leonardo had worked out in 1488-89 in his notebooks for centrally planned churches, Bramante constructed a massive centralized space based on simple geometric forms. Ludovico intended the church as a family mausoleum and a dynastical memorial to the Sforzas. Piously, every Tuesday and Thursday, Ludovico dined in the refectory with the abbot and it was for the end wall of this room, facing the abbot's table, that he commissioned the *Last Supper*. Leonardo began working on the painting in 1496.

As the painting developed it created astonishment; the poet Boccaccio's brother, Matteo Bandello, who was receiving instruction at the monastery where his uncle was a prior, wrote a unique contemporary description of Leonardo at work on the *Last Supper* in 1497:

Many a time I have seen Leonardo go early in the morning to work on the platform before the *Last Supper*; and there he would stay from sunrise to darkness, never laying down the brush . . . Then three or four days would pass without his touching the work, yet each day he would spend several hours examining it and criticizing the figures to himself. I have also seen him, as the caprice or fancy took him, set out at midday from the Corte Vecchia, where he was at work on the clay model of the colossal horse, and go straight to the Grazie; on having mounted the scaffolding take up his brush and add one or two more touches to one of the figures and then abruptly part and go elsewhere.

This description offers us an insight into Leonardo's working method and how he could be distracted during periods of contemplation. the *Last Supper* was Leonardo's first wall painting and, because of the large scale and the nature of the wall surface, it was not practicable for him to work in oil paints, which would have allowed him to make alterations as he went along. The *buon fresco* method with which he would have

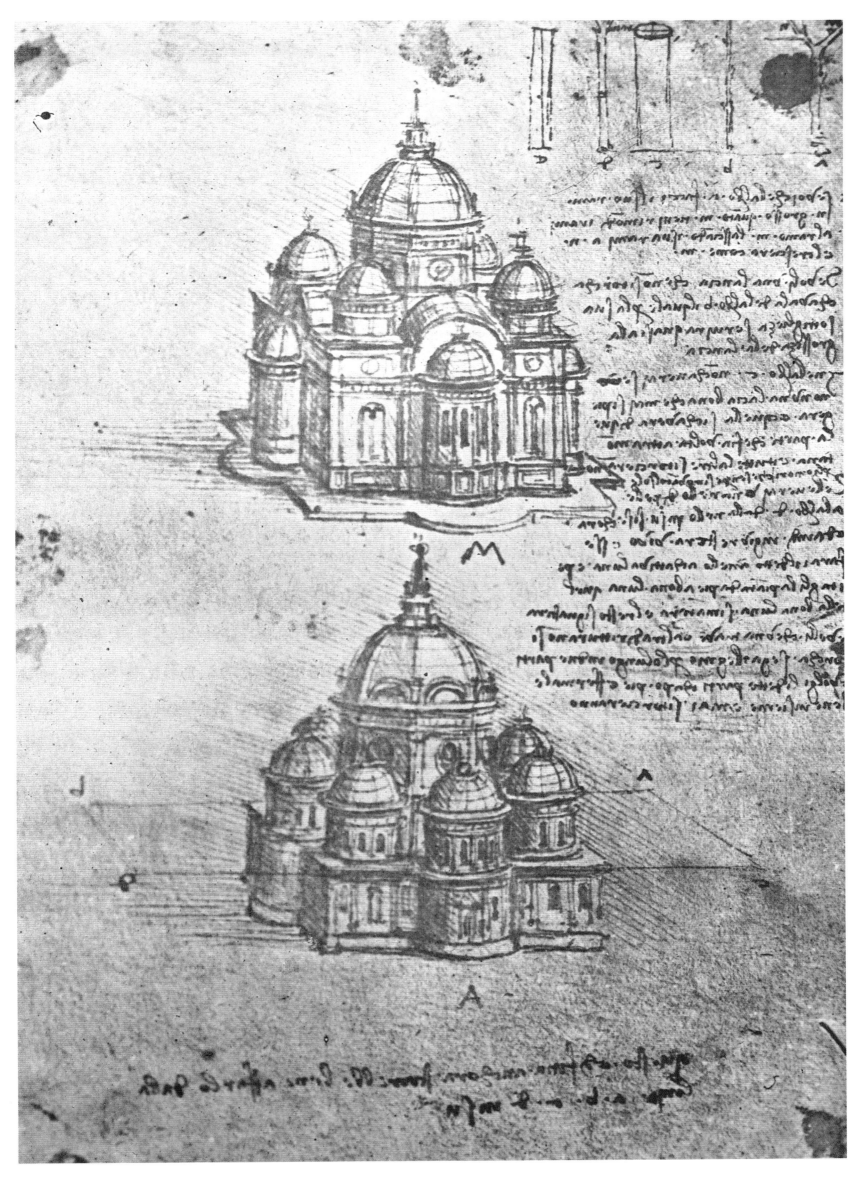

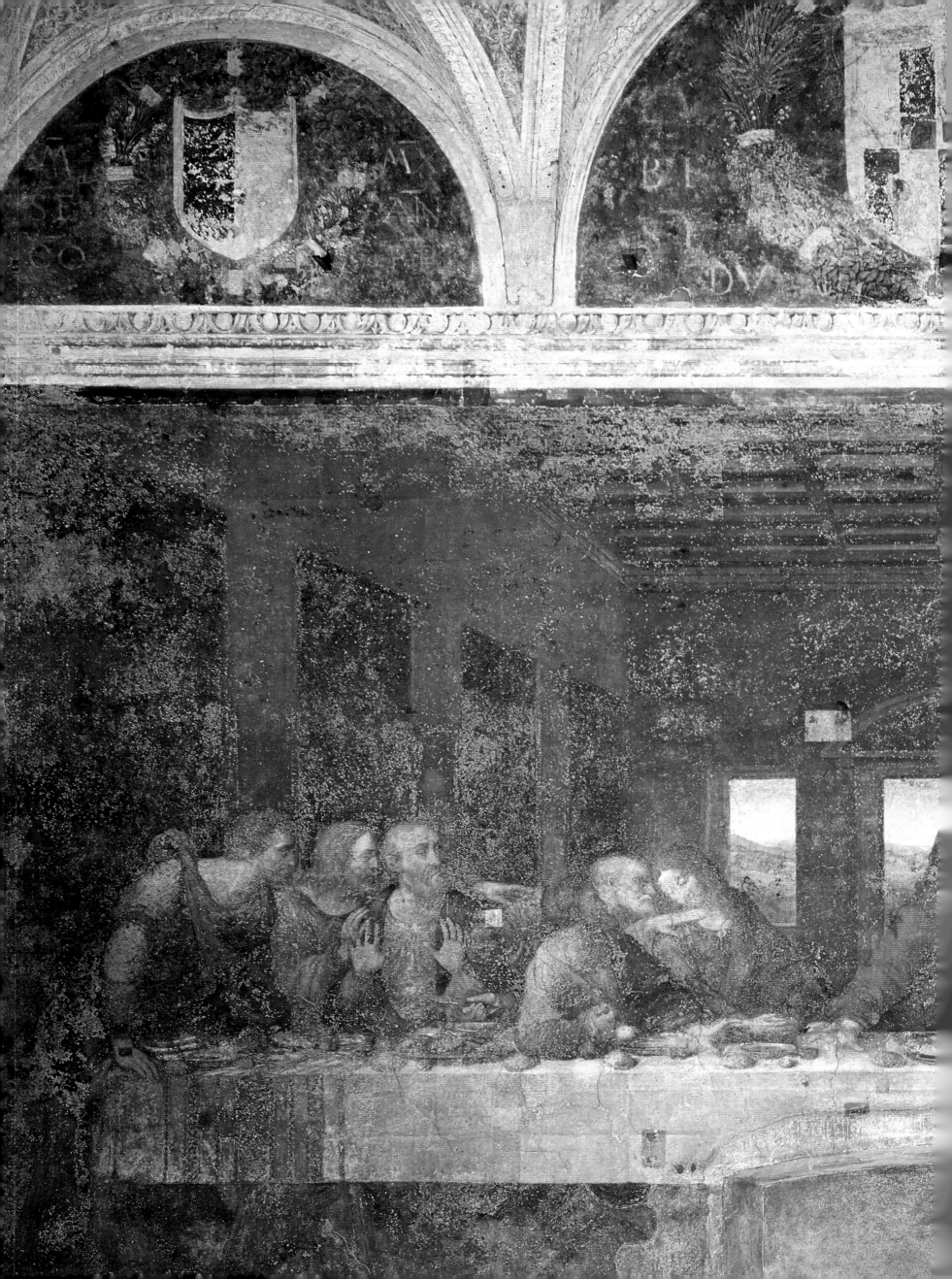

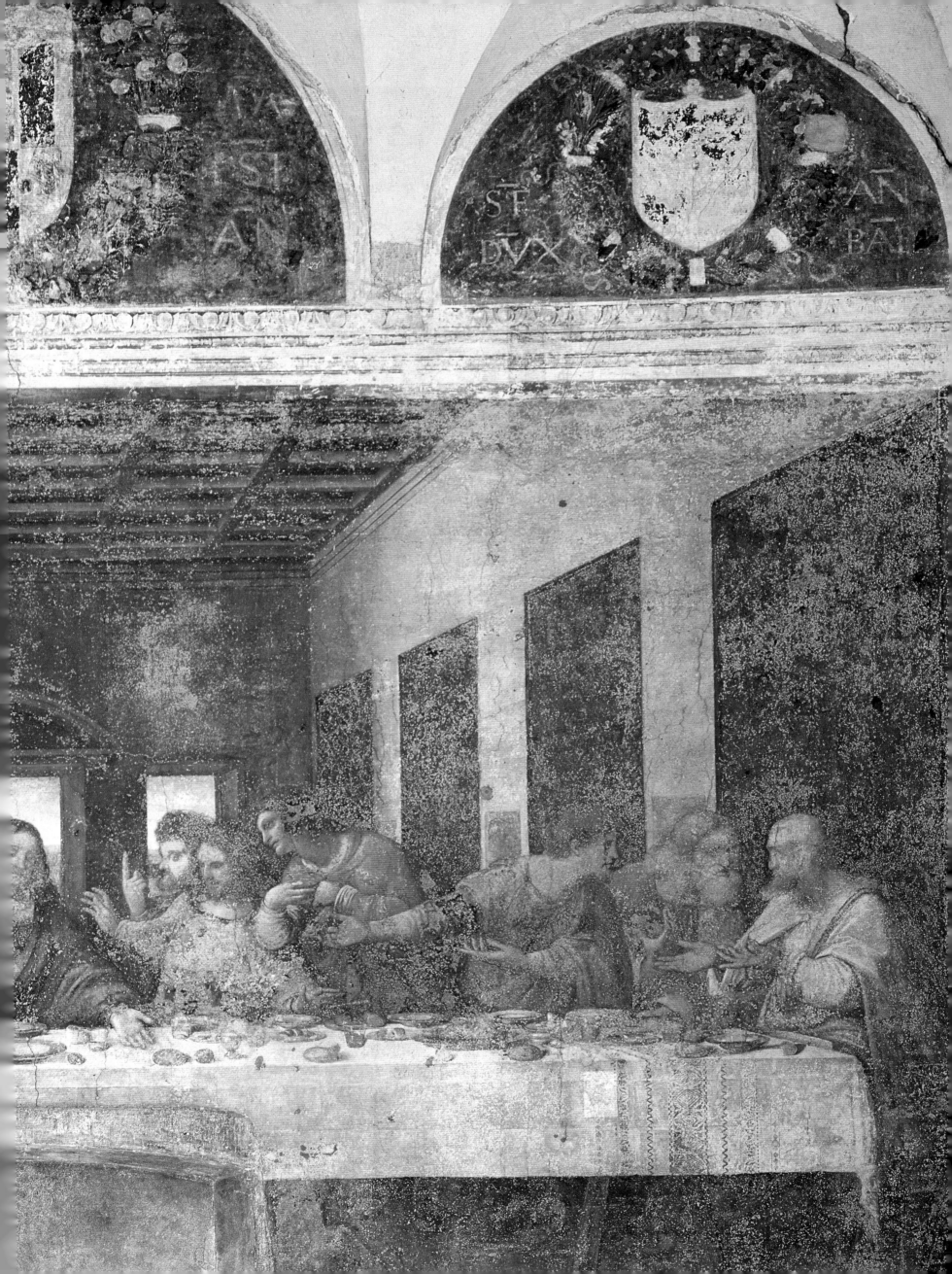

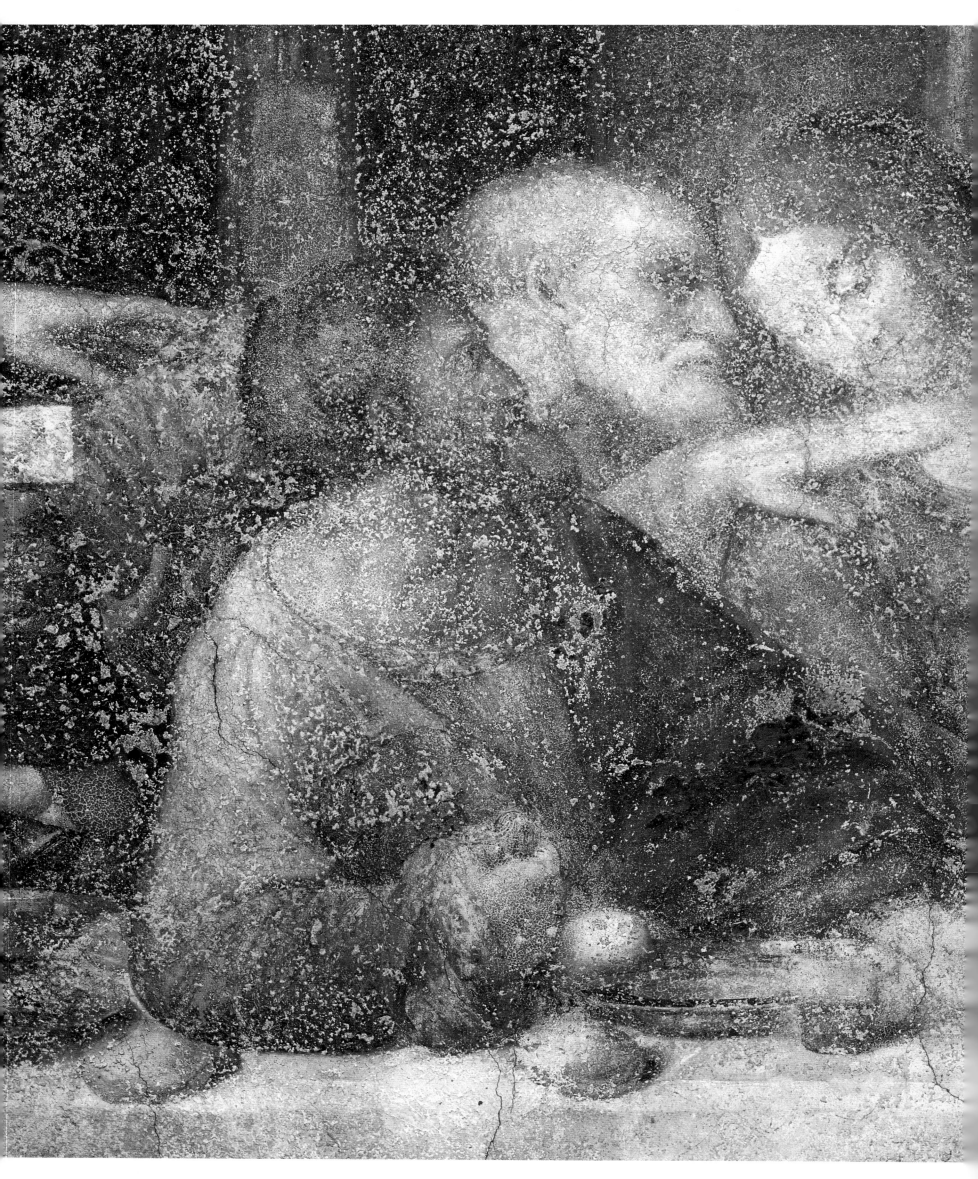

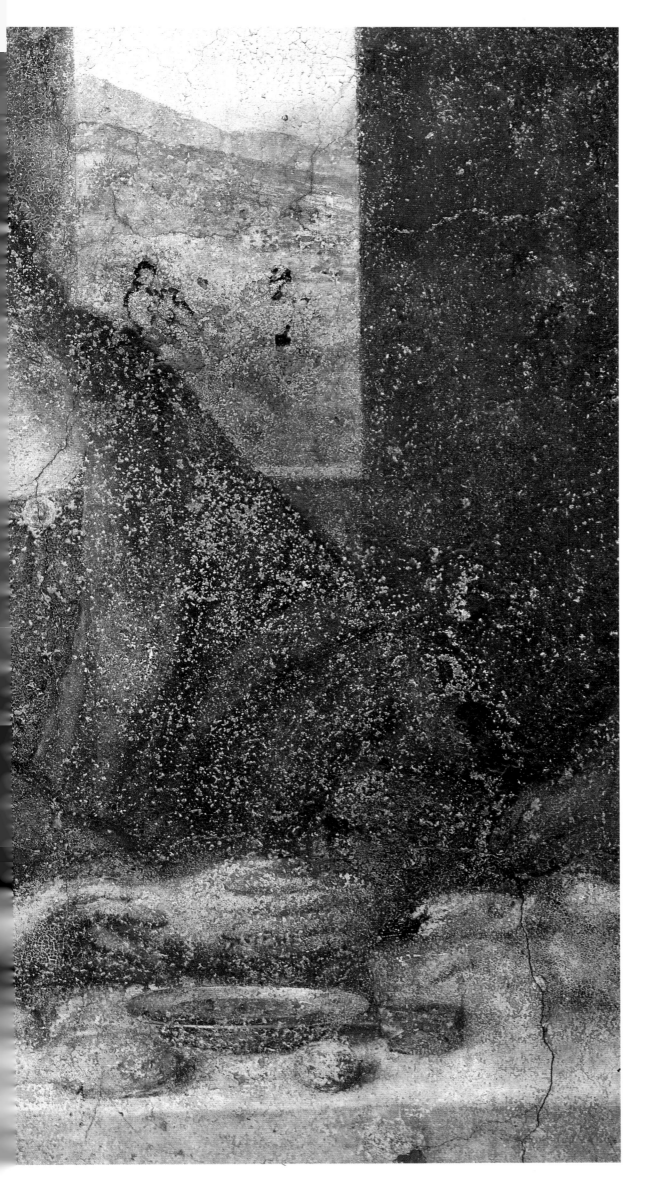

PREVIOUS PAGES: *Last Supper*, 1495-97, tempera on gesso, pitch and mastic, 15 feet 1 inch × 28 feet 10½ inches (460 × 880 cm), S Maria delle Grazie, Milan.

LEFT: Detail from the *Last Supper* showing, from the left, St Peter, Judas (in front) and St John and revealing the extent to which the painting has suffered from decay.

been familiar from his early years in Florence, although the most obvious choice for largescale wall paintings, allowed no changes to be made and was unsuitable from an artistic point of view. Leonardo therefore developed his own medium of tempera on stone. This required a strong base of gesso, pitch and mastic to seal the wall against damp and to provide an even ground for the paint. Unfortunately this medium proved unstable and, as a result, the paint began to detach from the ground within a few years of completion.

By 1556, when Vasari visited the monastery, the *Last Supper* had decayed so extensively that he described the painting as no more than a 'mass of blobs'. Apart from the 'natural' decay, further damage was to occur. The first damage was caused when a doorway was cut through the lower part of the table cloth in 1652 and, although this was subsequently filled in, the damage is still clearly visible. Throughout the eighteenth and nineteenth centuries, restoration attempts were made. The first of these was undertaken in 1726 by Michelangelo Bellotti, who mistakenly believed that Leonardo had worked in oils and therefore retouched the areas laid bare by paint loss and gave the finished restoration a heavy coat of oil varnish. Unfortunately, Bellotti did not take account of the humidity, one of the main problems that had caused much of the original decay.

In 1770 a second painter, Giuseppi Mazza, was called in by the monks. In addition to scraping off Bellotti's retouching, Mazza seems to have repainted more extensively than required. A third scheme in 1821 by Stefano Barezzi attempted to move the entire painting to a more stable environment. Barezzi had been very successful in detaching frescoes in one piece. These consist of two substantial layers of plaster, the *intonaco*, a rough base later applied to a wall on to which a sketch of the painting would be

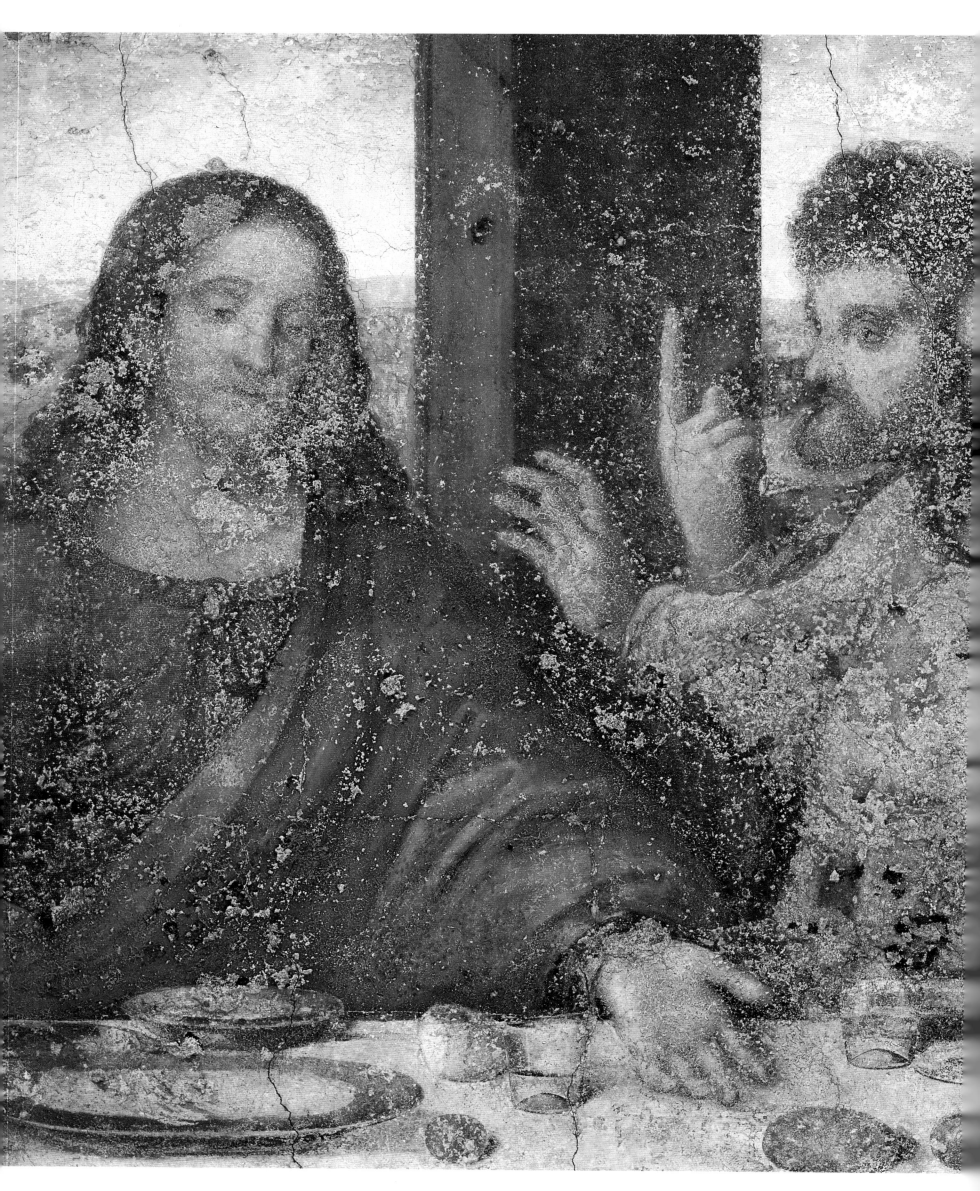

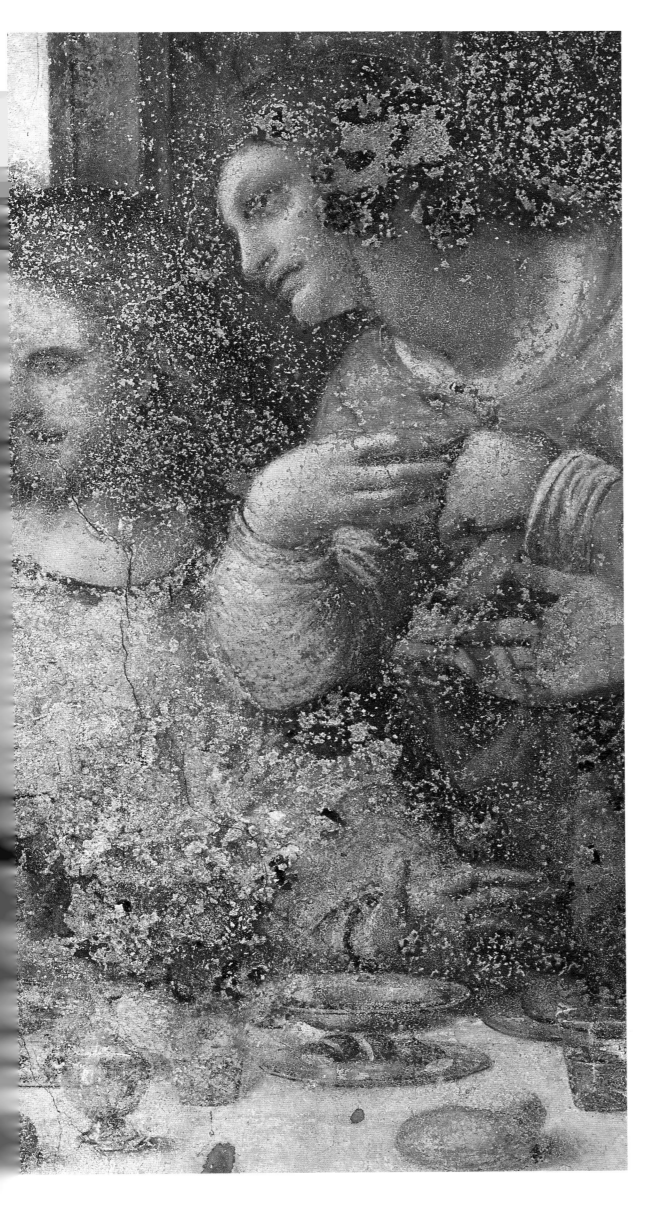

made, and the *arriccio*, a much finer layer applied over the *intonaco* in *giornate*, sections which corresponded to a day's work. In *buon fresco* the *arriccio* plaster would be painted on while still wet. Because the two layers were different textures, it was quite easy to separate one layer from the other. Leonardo's technique on the *Last Supper* was quite different, however, and the unfortunate Barezzi only discovered this after he had managed to damage a sizeable portion of the tablecloth and one of Christ's hands.

Over-zealous painter-restorers have not been the only culprits; Milan's strategic importance in European affairs saw the city frequently involved in wars. In 1796 Napoleon's troops entered the city and, despite his personal orders to the contrary, the refectory was used as a barn, arsenal and billet for troops and prisoners. The worst damage, however, occurred quite recently, in August 1943, when the roof and one of the supporting walls of the refectory were completely destroyed by a bomb. Fortunately a steel framework filled with sandbags had been erected beforehand to protect the painting. Modern science has yet to halt the decay still being caused by humidity, but until it decays completely, the *Last Supper* can still be seen in the setting for which it was intended.

The painting does seem to have been jinxed right from the start. In the New Year of 1497, Beatrice d'Este, the pregnant wife of Ludovico Sforza, was celebrating by dancing and drinking. The next day she miscarried and was dead. For many superstitious Milanese, her death and Leonardo's *Last Supper* were linked. In the early stages of the development of the painting scheme, the *Last Supper* had accompanied a *Crucifixion* by Montorfano, which included donor portraits of Ludovico, Beatrice and their two children. This painting was subsequently painted over and Beatrice's death was seen as a portent of evil things to come for the Sforzas and for Milan.

By the time Leonardo painted the *Cenacolo* or *Last Supper*, it was already a commonplace subject for wall paintings in the refectories of monasteries. Traditionally it formed one of the many scenes in fresco cycles of Christ's life, but by the middle of the fifteenth century, the Last Supper had become popular as an individual scene. Leonardo would have seen many of these *Cenacoli* in his youth, in particular Taddeo Gaddi's version of 1350 in the monastery of Santa Croce in Florence and Andrea del Castagno's version of 1450 in San Apollonia. Both of these show the room in which the last supper is taking place. In another example, this time by Leonardo's fellow student in Verrocchio's workshop, Domenico Ghirlandaio, in the monastery of Ognissanti in Florence, the room is represented as though it were an extension of the actual room on the wall of which the painting had been made. It is this approach that Leonardo also adopted in his *Last Supper*.

The composition of the *Last Supper* is less simple than it seems. The symmetrical disposition of the disciples on either side of Christ could have been boring. The setting too is unreservedly symmetrical, with its three windows, the center one framing Christ's head. Yet there is little that is bland about the arrangement of the disciples themselves. They are arranged in two groups of three on either side of Christ. In the first group to the left are Bartholomew, James the Less and Andrew. The next group comprises Judas, Peter and John. To the right of Christ are Thomas, with his finger raised, James the Elder, with outstretched arms, and Philip. The outside group comprises Simon, Jude and Matthew, who sweeps around them in disbelief. Because of the compositional restraint, the viewer's attention is concentrated on the reactions of the disciples to the news that one of them will betray Christ. In quiet calm contrast, Christ gestures to the bread and wine.

ABOVE AND RIGHT: The decorative scheme of the ceiling and part of the lower walls of the Sala delle Asse in the Castello Sforzesco in Milan. This work was only re-discovered at the end of the nineteenth century and has also been heavily restored. Nevertheless, the interest in natural forms and the intertwining of the foliage are typically Leonardoesque features.

If the *Last Supper* is the best known commission, and the only complete, if somewhat battered, example of Leonardo's great group compositions, from the 18 or so years he spent at Ludovico's court in Milan, then the *Sala delle Asse* (Room of the Boards) must be the least well known. The room formed the introduction to a suite of private rooms for Ludovico and Beatrice. She died in 1497 and the decorative scheme of the rooms was probably influenced by this event. This painted decoration was only discovered at the end of the nineteenth century and, because the rooms have been heavily restored, it is hard to determine exactly how much was by Leonardo's hand and how much was the work of his pupils. We do know from documentary evidence that Leonardo worked on the ceiling. There are also two studies of interlaces in the Codex Atlanticus which might have been intended for floor decorations; one of them represents a detail of the motif and is pricked for transfer in the actual size for a tile design.

Such interlacing motifs first began to fascinate Leonardo in Florence, with Verrocchio's work on the Medici tomb in San Lorenzo and his own drawings of female heads with their elaborately braided hairstyles. The characteristic knots appear throughout Leonardo's manuscripts and drawings, from the earliest sheets in around 1480 to the latest from around 1518. Some of these are details of dress, others appear as braided hair (as in the preparatory drawings for *Leda*) and they can also be seen in the *Battle of Anghiari*. Eventually these twisting motifs became associated with plants, water and smoke.

The *Sala delle Asse* is a large square room in the north tower of the castle. The decorative scheme was described in 1584 by Giovanni Paolo Lomazzo:

As for trees, a beautiful motif has been invented by Leonardo, that of making their branches interlace in bizarre groups.

There are about 18 paintings of tree trunks around the room, of which eight, those rising from the four corners and the four center points of the walls, stand in for columns and rise up to join at the middle of the ceiling with their branches constituting the ribs of a vault. Equally attractive and naturalistic is the foliage and the roots of the trees, which nestle among stonework at the base of the walls. The image of tree roots was in fact part of Ludovico Sforza's personal emblem and the whole scheme can therefore be read as a huge coat of arms.

The scheme goes further than simply commemorating Ludovico, however; it also celebrated his union with his late wife Beatrice d'Este. One of the features of the decoration is a gold cord which is entwined around the boughs. The device of interlocking gold thread was one which Beatrice had adopted from her sister Isabella, and which she had had worked into her clothes in the form of filigree or gilded knotting.

The confidence that the Sforzas had in a brilliant future for themselves and for Milan, a future which Ludovico believed he had secured by the marriage of Bianca to the Emperor Maximilian, soon proved to be misplaced. Ludovico was now going through hard times: all of Italy was uniting against him and his finances were stretched to the limit because of his need for more men and more bronze to cast cannons. He could not even afford to pay his servants. Some time between November 1497 and February 1498 Leonardo wrote to the Duke complaining of arrears in his salary. This letter has been torn down the middle, perhaps by the furious Il Moro himself, but in March 1499 the Duke did in fact pay Leonardo in full, and even gave him a vineyard as a bonus.

By this time Venice and France had formed an alliance against Ludovico and he now needed all the friends he could buy. By September, however, he was no longer Duke of Milan. He had taken the precaution of sending his family to safety in Innsbruck, under the protection of Maximilian, since the new French king Louis XII was laying claim to both Naples and Milan. Ludovico tried to play a double-bluff and invited Louis to Italy in the hope of saving Milan. The French forces under Trivulzio entered Milan on 28 September 1499, through the city gates opened by Ludovico's officers. Ludovico had joined his family, in the hope that he could re-enter the city with the aid of Swiss mercenaries. Meanwhile the Castello Sforzesco was flooded, the stores looted and Leonardo's great clay horse was destroyed by Gascon archers, who used it for target practice.

On 5 February 1500 Ludovico, backed by his hired army, re-entered Milan. When the ensuing battle began to go against him, he tried to escape disguised as a monk but was caught and taken prisoner, locked in an iron cage, and transported to Loches on the French frontier, where he was to remain until his death 10 years later.

As for Leonardo, he was lucky the Duke had paid him when he did. Long before the French arrived in Milan, he had left the city and was staying in the villa at Vaprio, where he taught his old friend Melzi's son Francesco. Only when he heard that Milan was secure in French hands and that further bloodshed was unlikely, did he return. There he met King Louis and his aide, Cesare Borgia, the son of Pope Alexander VI. Borgia was now in the position that Ludovico had occupied; he needed artists, scientists and thinkers, not only because they fascinated him, but because they gave him prestige. Borgia offered to take Leonardo on as his chief military engineer but he declined the offer and continued to Mantua and the court of Isabella d'Este.

Isabella had shown a great interest in Leonardo's work and had even borrowed the portrait of Cecilia Gallerani. The Duchess pampered Leonardo and he in turn promised her an oil painting but, like

BELOW: These studies of a woman's head and intricately dressed hair are believed to have been made for the lost painting of *Leda*. Twisting and interlacing motifs fascinated Leonardo and can be seen in his early drawings from around 1480 to the latest ones from around 1516, when they become associated with the movement of plants, water and smoke.

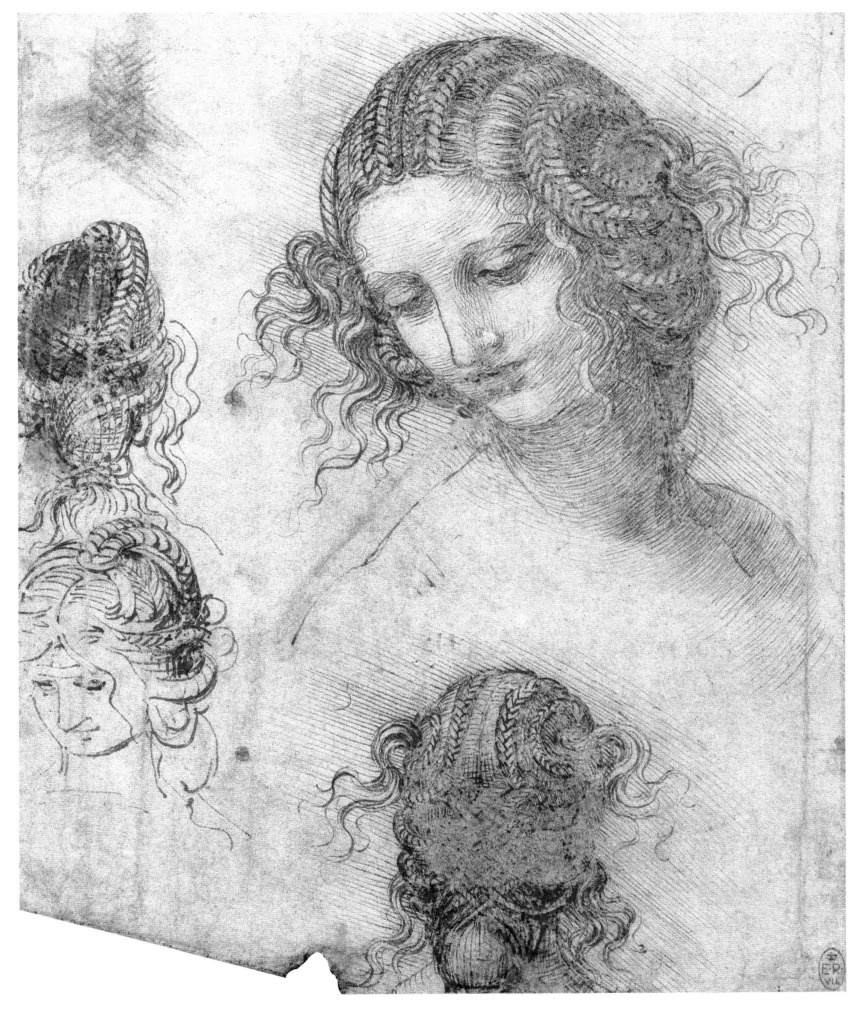

so many of his projects, Isabella's portrait never materialized. All that remains is a badly damaged drawing which may or may not be by Leonardo. It is pricked for transfer and shows Isabella's head in profile, with her body turned toward the viewer and her hands folded in front of her, a formula familiar to us from Leonardo's earlier female portraits.

By March 1500 Leonardo was on the move again, this time to Venice. La Serenissima then (as now) was in her glory. The Venetian Republic was probably the richest in all Italy, with an empire stretching down the Dalmation coast and including the island of Crete. The city's own small population of around 200,000 was augmented by nearly two million 'colonial' subjects. During the fifteenth century Venice had also produced some of the most magnificent art and architecture in Europe and had nursed ambitions for greater land-based power. Had the Church been less powerful and influential, Venice might have dominated much

of northern Italy. But above all else, Venice was 'foreign'. Surrounded by the impenetrable moat of the lagoon, which was navigable only by those who knew the safe routes through it, the Venetians were by nature suspicious of outsiders. A small army of private agents spied on newcomers and laws forbade Venetians to entertain foreigners in their homes. Leonardo, as a Florentine and thus a foreigner, would have found it very difficult indeed to find a patron in Venice to match Ludovico Sforza. He would instead have to earn his living, something he was not very good at doing.

The Turkish threat to Venice was one area that Leonardo appeared to try and exploit. The Battle of Lepanto in August 1499 had broken Turkish sea power, but Venice still feared an attack on the city by land. A fragment of a draft letter to the governing council of Venice details Leonardo's travels through the area under threat, the Isonza valley in Friuli, to the north of Venice, and outlines his

scheme to flood the area as a defensive measure. Other plans that he outlined involved designs for mine ships, ramming vessels and a submarine, all part of a system for destroying the Turkish fleet. Leonardo overlooked two things, however: firstly his schemes were costly, and secondly Venice already had a fleet and an arsenal which was a closed shop to outsiders, jobs being passed from father to son, and to the ideas of outsiders. The Venetian council did not even officially record Leonardo's visit to the city.

Nevertheless while he was there he seems to have become friendly with a number of people, including the printer Aldous and Cardinal Grimani, whose collection of Flemish paintings and Greek marble of *Leda* Leonardo saw and possibly sketched. He also met the Comte de Ligny, who offered him a position in France. This offer Leonardo turned down – at least for the time being – and one month after his arrival, he was on his way back to Florence.

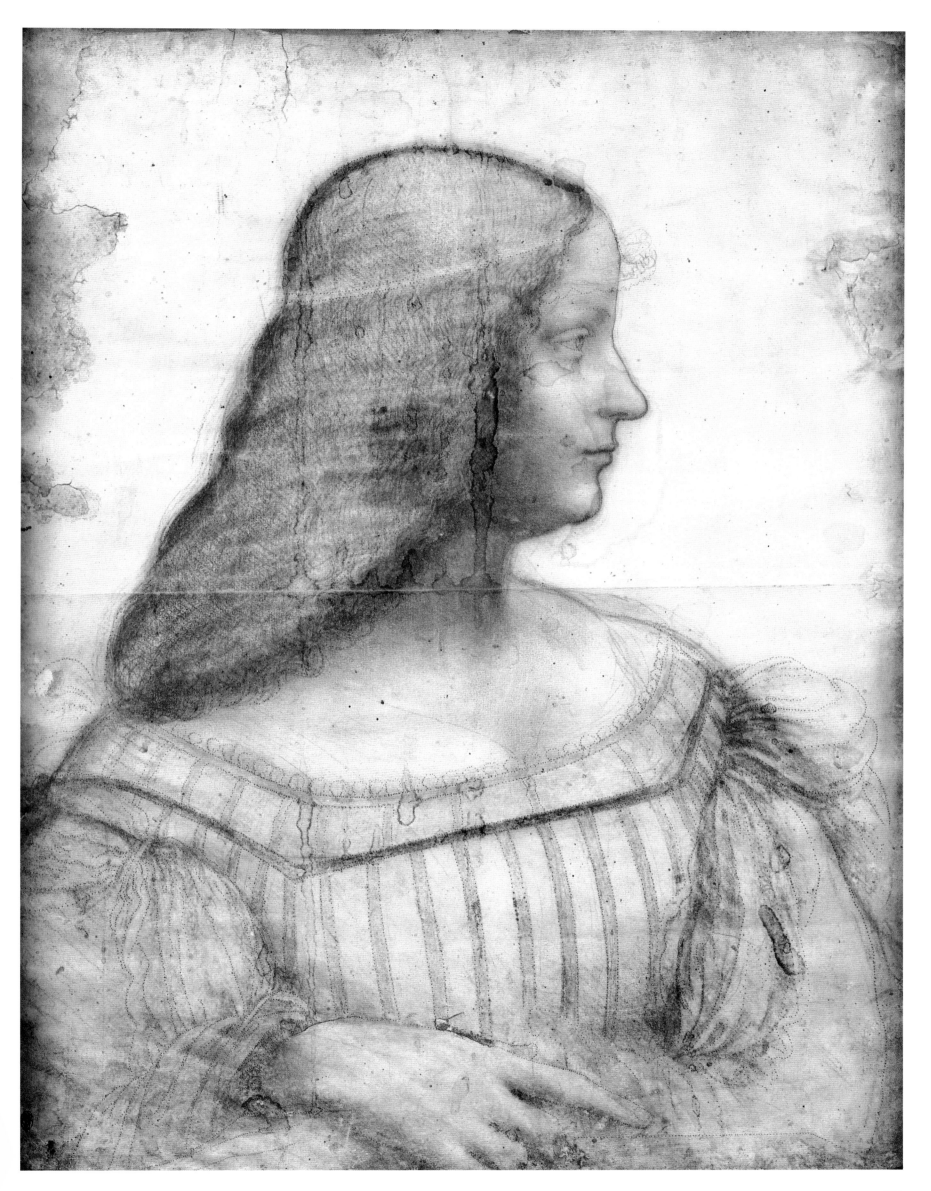

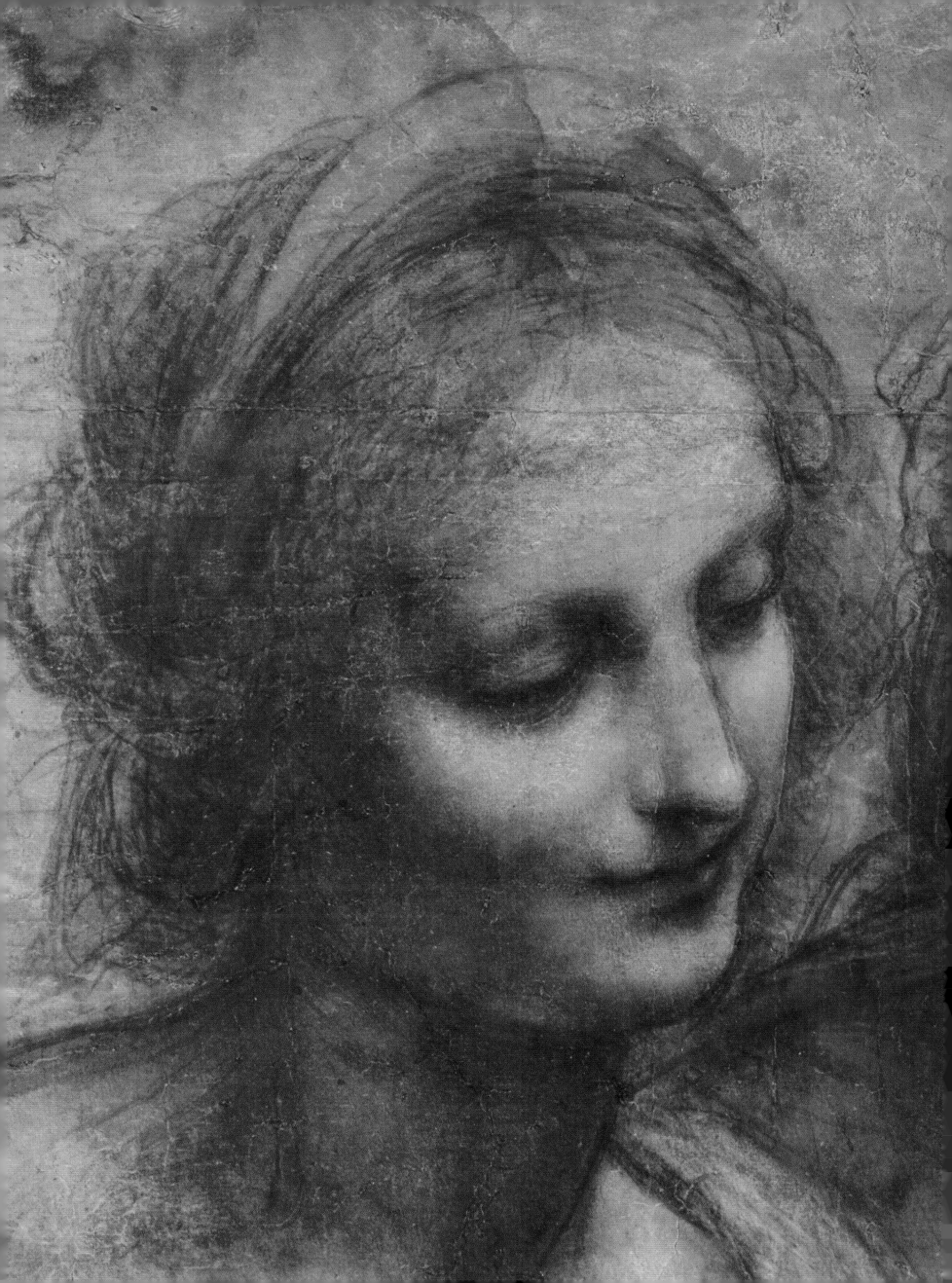

CHAPTER 3
Florence 1499–1506

During Leonardo's 18-year absence, the political and artistic climate of Florence had changed considerably. The Medici were no longer in power; following a few unsuccessful attempts to govern the city-state, Lorenzo de' Medici's son had drowned in the river Garigliano during military action. Medici rule had been replaced by a republic under the leadership of their most hated enemy, the stern, fanatical Dominican friar Girolamo Savonarola, who supervised a puritan regime in the bankrupt city. Even Botticelli became a supporter and destroyed all his early works, while Pico della Mirandola abandoned Neoplatonism and Boccaccio's books were burnt. Some of Leonardo's old friends were still alive but many of those who had made Florence the artistic and philosophical center of

Europe were dead: Ficino, Poliziano, Mirandola, the Pollaiuolo brothers, Domenico Ghirlandaio and above all, his old master Verrocchio.

It is possible that Leonardo was planning only an extended visit to Florence. In December 1499 he had lodged a letter of exchange for six hundred gold florins with the monastery of Santa Maria Novella in Florence. On his arrival in the city he cashed fifty of the florins; the transaction was dated 25 April 1500. With the Medici court dispersed, Leonardo had little chance of finding a new patron or attracting many commissions. Fortunately, Leonardo's father was now the procurator of the Servite monastery of the Annunciation, where the monks had already commissioned Filippino Lippi to complete two paintings for

the high altar of their church. While Vasari tells us that Lippi happily gave up the commission to Leonardo, it is more likely that Ser Piero used his influence to get the commission transferred to his son.

FACING PAGE: Detail of the head of the Virgin from the *Virgin and Child with St Anne and St John the Baptist* (page 84).

BELOW: A view of Florence by Leonardo's biographer, Giorgio Vasari, depicting the seige which led to the collapse of republican rule in the city in 1530. The city center is dominated by Brunelleschi's dome of the cathedral.

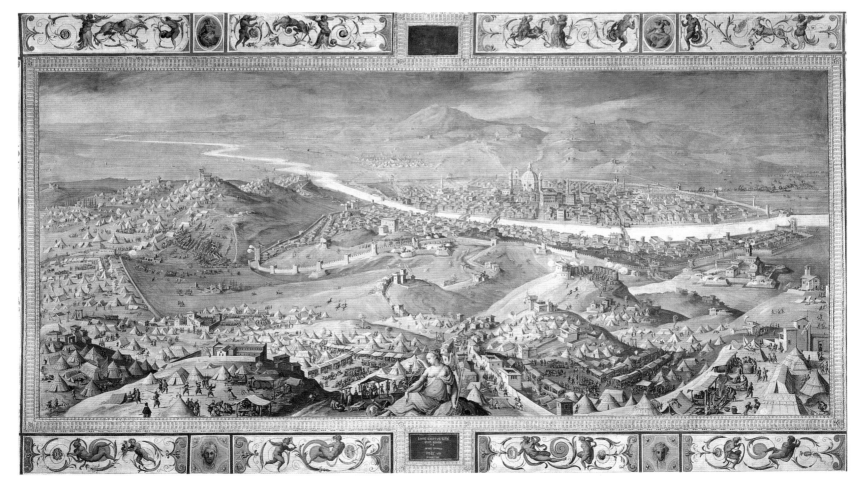

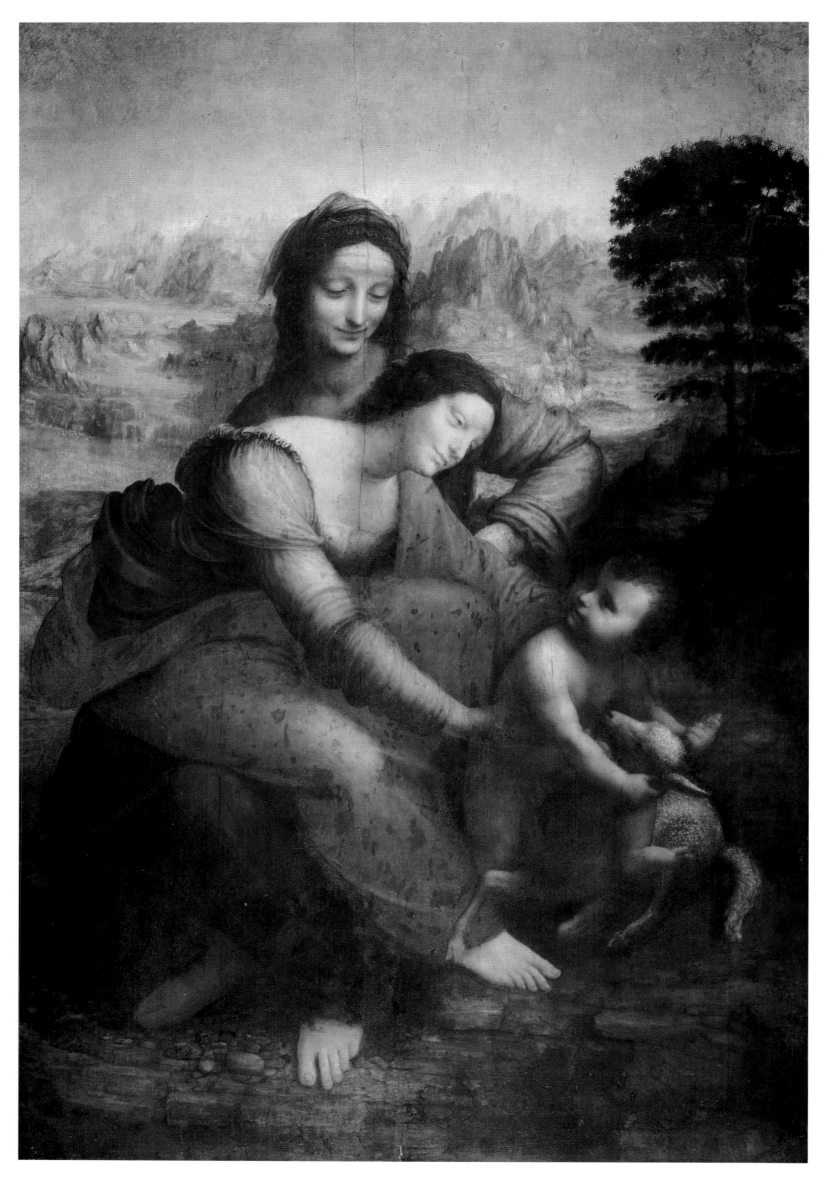

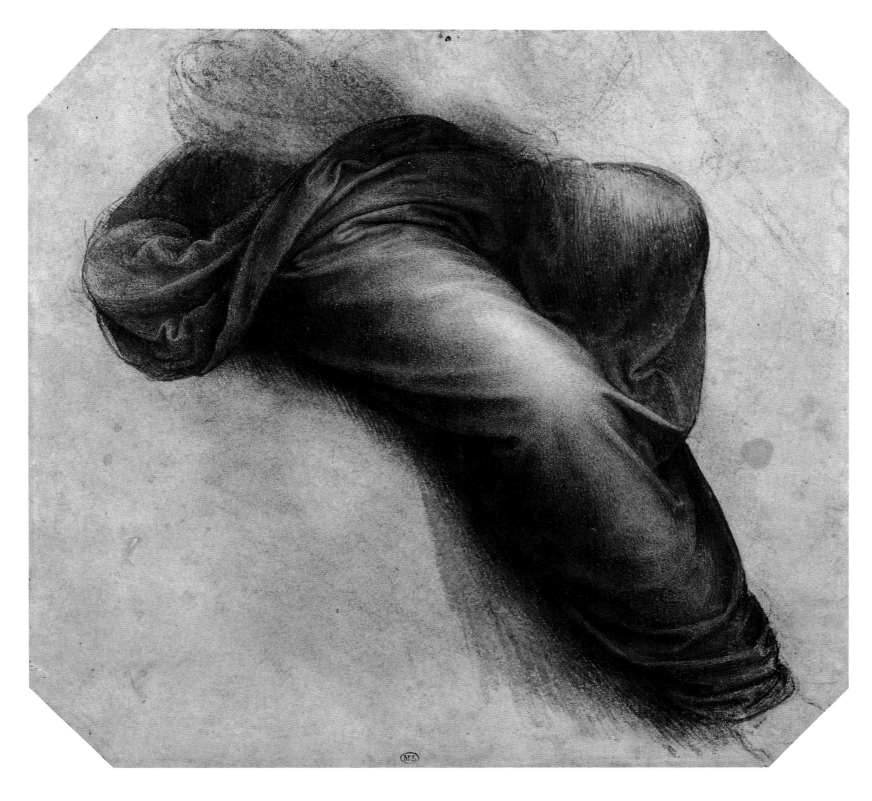

ABOVE: *Study of Drapery for the Virgin in the Virgin and Child with St Anne and a Lamb*, c.1508, black chalk and black wash heightened with white, 9 × 9⅝ inches (23 x 24.5 cm), Cabinet des Dessins, Musée du Louvre, Paris.

LEFT: *Virgin and Child with St Anne and a Lamb*, c.1508, oil on wood panel, 66⅛ × 44 inches (168 × 112 cm), Musée du Louvre, Paris.

In September 1500 Leonardo was hard at work, but not on the altarpiece. Isabella d'Este had written to Fra Pietro da Novellara, the Vicar-General of the Florentine Carmelites, in April 1501 enquiring about Leonardo's activities – no doubt she wanted to know when she was going to receive the finished portrait based on the cartoon – and asking Fra Pietro to persuade Leonardo to 'do a little Madonna, devout and sweet as is his wont.' Fra Pietro replied that as far as he knew, all Leonardo had done since his return to Florence was a study for the *Virgin and Child with St Anne* for the Servite monastery. Evidently Leonardo was spending much of his time studying geometry.

There are several cartoons and studies of the *Virgin and Child with St Anne*, at Windsor Castle, in the Louvre, in the Accademia in Venice and in the British Museum. The unfinished oil painting in the Louvre, *Virgin and Child with St Anne and a Lamb*, is usually dated around 1508-1510 but there is disagreement about Fra Pietro's description of the cartoon that he saw. He described the figures as turned to the left but it is unclear whether he meant his left or the sitter's left. He also described St Anne as preventing her daughter from discouraging the Christ Child as he grasps the lamb. The lamb is the sacrificial animal and the symbol of Christ's Passion, and St Anne's action of restraint thus signifies that the Church did not want to prevent the Passion. Matters are further complicated by the existence of a largescale cartoon, the *Virgin and Child with St Anne and St John the Baptist* in the National Gallery, London, which Vasari described and on which he said Leonardo was working as the basis for the altarpiece in

BELOW: *Study for the Virgin's Sleeve and Hand* for the *Virgin and Child with St Anne and a Lamb*, c.1508, black and red chalk, pen and ink, with washes of black, 3⅜ × 6¹¹⁄₁₆ inches (8.6 × 17 cm), Windsor Castle, Royal Library 12532. © 1994 Her Majesty The Queen.

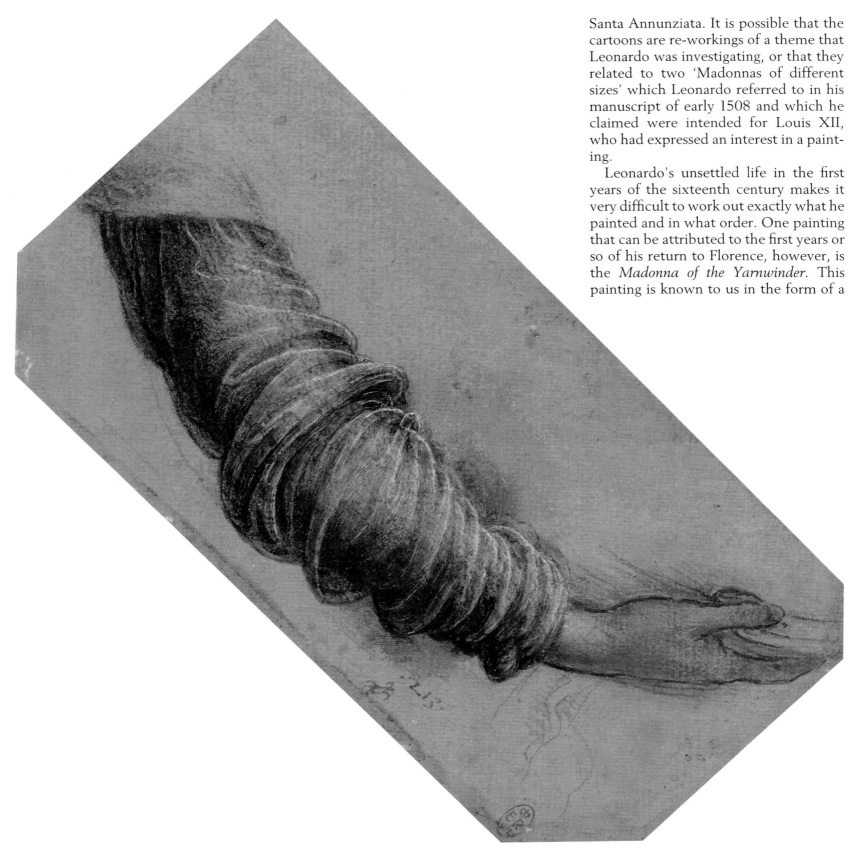

Santa Annunziata. It is possible that the cartoons are re-workings of a theme that Leonardo was investigating, or that they related to two 'Madonnas of different sizes' which Leonardo referred to in his manuscript of early 1508 and which he claimed were intended for Louis XII, who had expressed an interest in a painting.

Leonardo's unsettled life in the first years of the sixteenth century makes it very difficult to work out exactly what he painted and in what order. One painting that can be attributed to the first years or so of his return to Florence, however, is the *Madonna of the Yarnwinder*. This painting is known to us in the form of a

BELOW: *Studies for the Christ Child* in the *Virgin and Child with St Anne and a Lamb*, c.1505, red chalk, 11 × 8⅝ inches (28 × 22 cm), Galleria dell' Accademia, Venice.

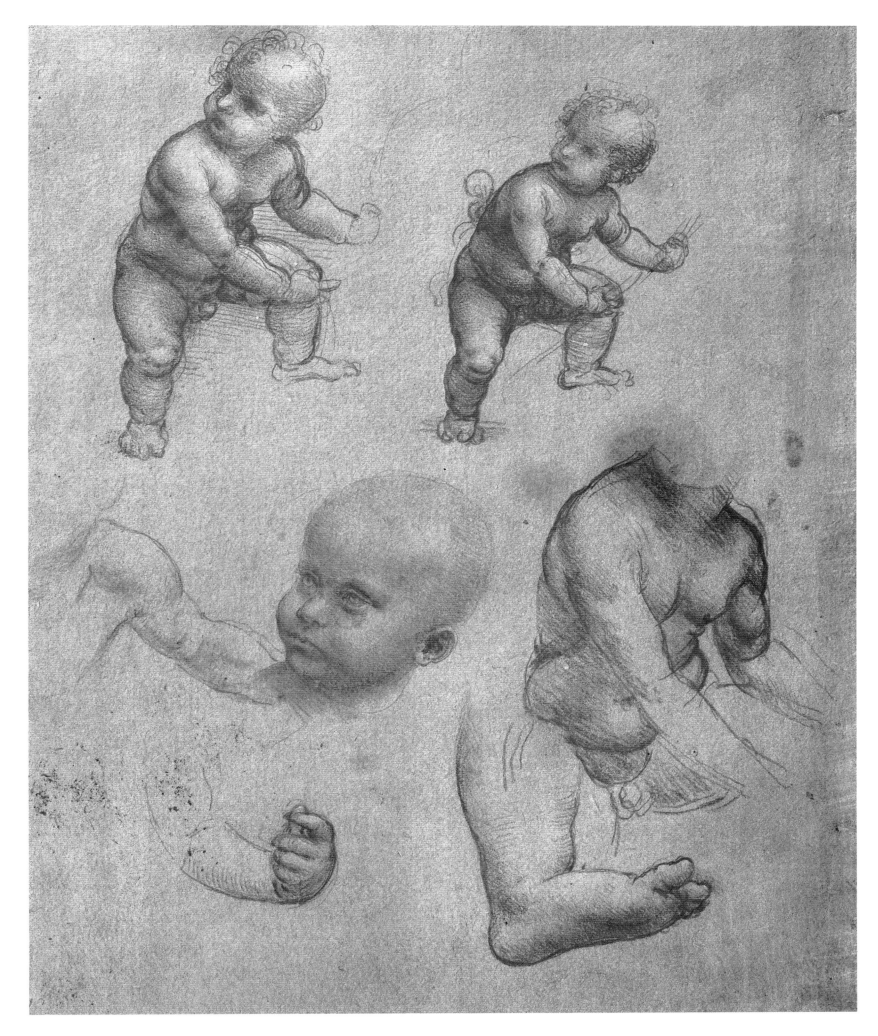

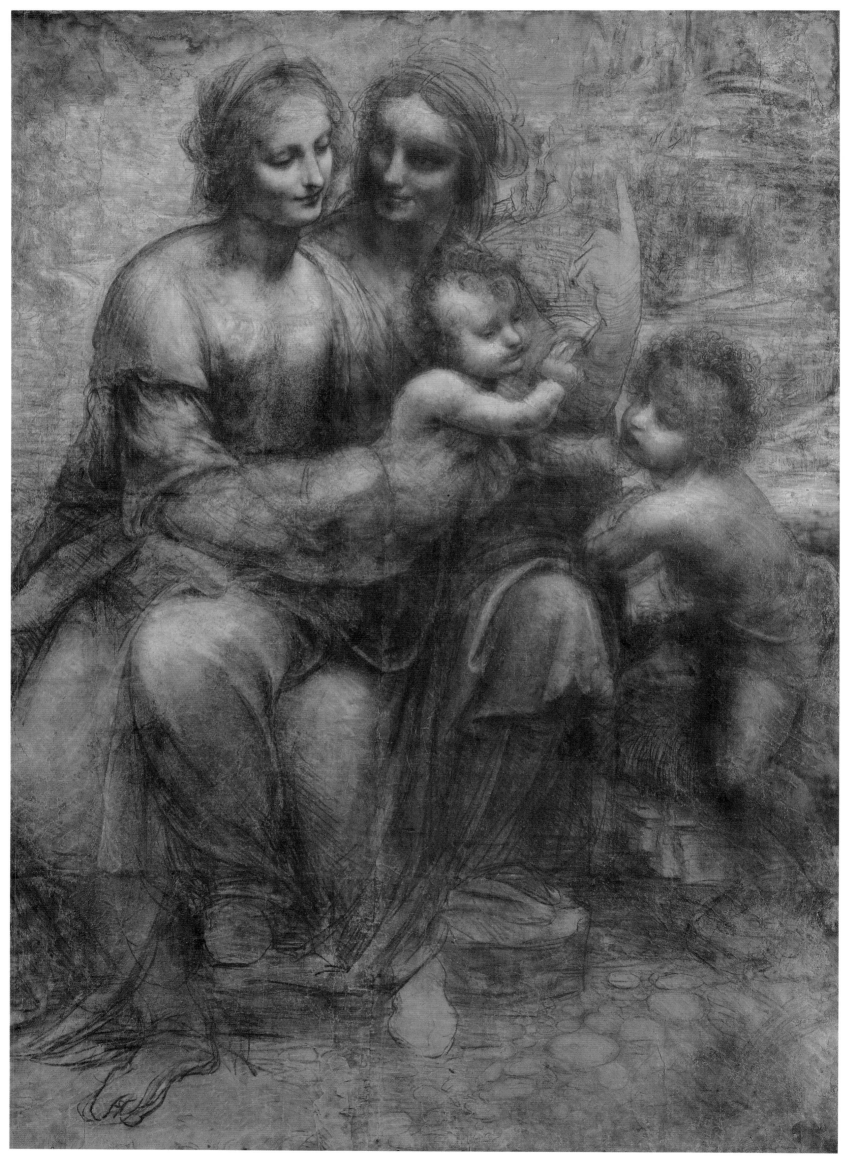

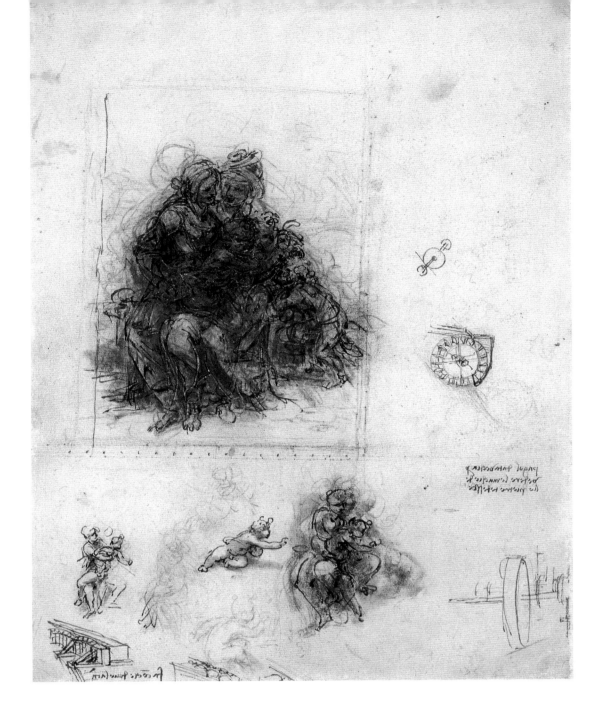

LEFT: *Virgin and Child with St Anne and St John the Baptist*, c.1505, 54¾ × 39¾ inches (139 × 101 cm), charcoal on brown paper heightened with white, National Gallery, London.

RIGHT: *Study for the Virgin and Child with St Anne*, c.1500-1505, pen, ink and wash over black chalk, 10¼ × 7¾ inches (26 × 19.7 cm), courtesy of the Trustees of the British Museum, London.

BELOW: Details of the heads of Christ (left) and St Anne (right) from the *Virgin and Child with St Anne and St John the Baptist.*

number of copies, the best of which Leonardo may well have had a hand in painting. It also conforms to the description of a small painting mentioned in Fra Pietro's letter to Isabella d'Este as having been executed for Florimund Robertet, Secretary of State to Louis XII of France. Fra Pietro describes how the Virgin is intent on spinning yarn but the child, whose feet rest on a basket of flax, takes hold of the yarnwinder and gazes intently at the four spokes which form the shape of a cross.

The records show that in July 1501 Leonardo signed a receipt for the rent of his vineyard outside Milan, and that Manfredo di Manfredi came to see him

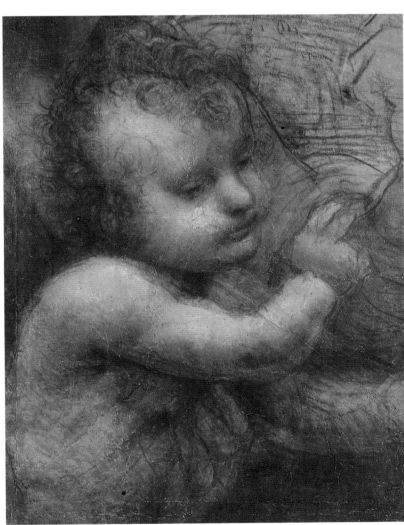

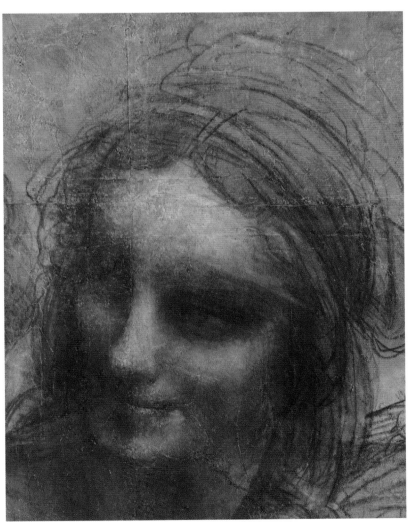

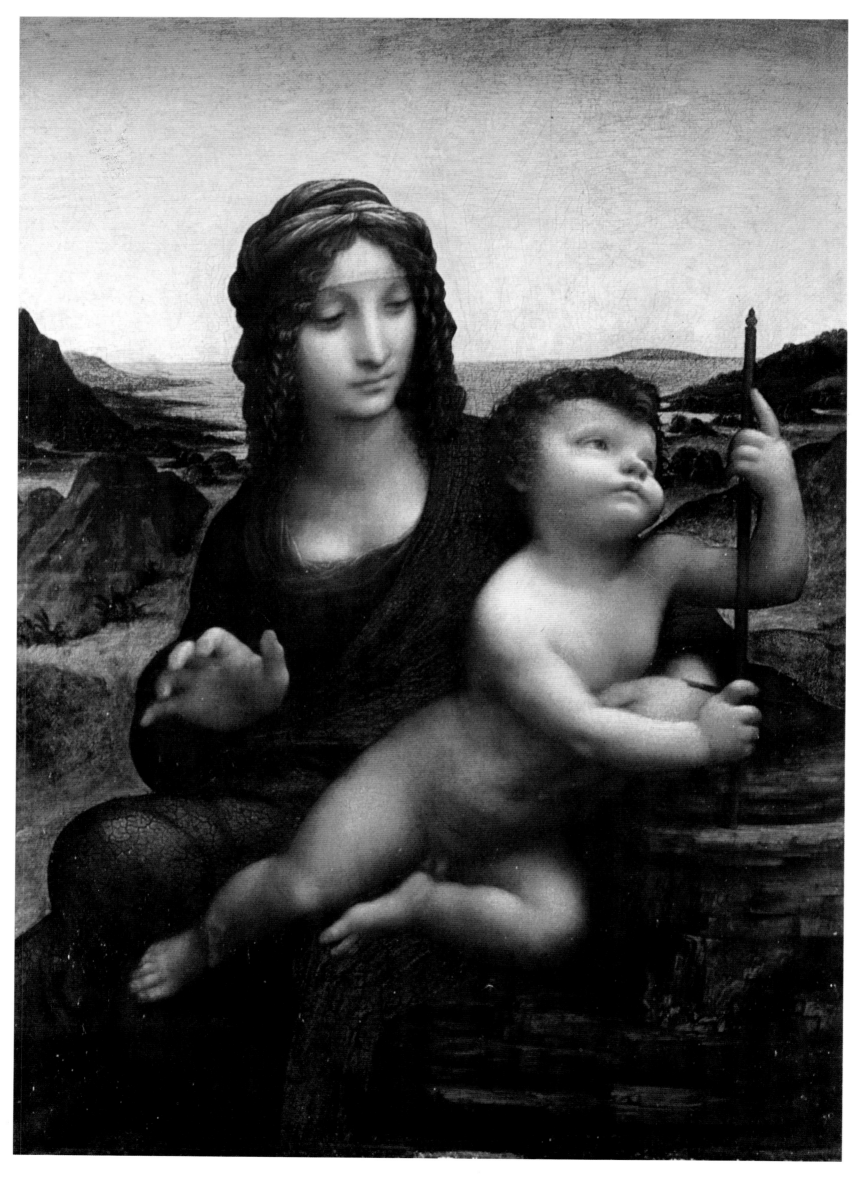

LEFT: *The Madonna of the Yarnwinder*, c.1501, oil on wood panel, 18¼ × 14¼ inches (46.4 × 36.2 cm), in the Collection of the Duke of Buccleuch and Queensberry KT, Drumlanrig Castle, Dumfriesshire. This painting is believed to have been produced for Florimund Robertet, Secretary of State to Louis XII of France. It conforms to a description by Fra Pietro da Novellarra in a letter to Isabella d'Este.

BELOW: *Bird's Eye View of Part of Tuscany*, c.1502-03, pen, ink and watercolor, 10⅞ × 15⅞ inches (27.5 × 40.1 cm), Windsor Castle Royal Library 12683. © 1944 Her Majesty The Queen. This map is believed to have been made for Leonardo's patron Cesare Borgia.

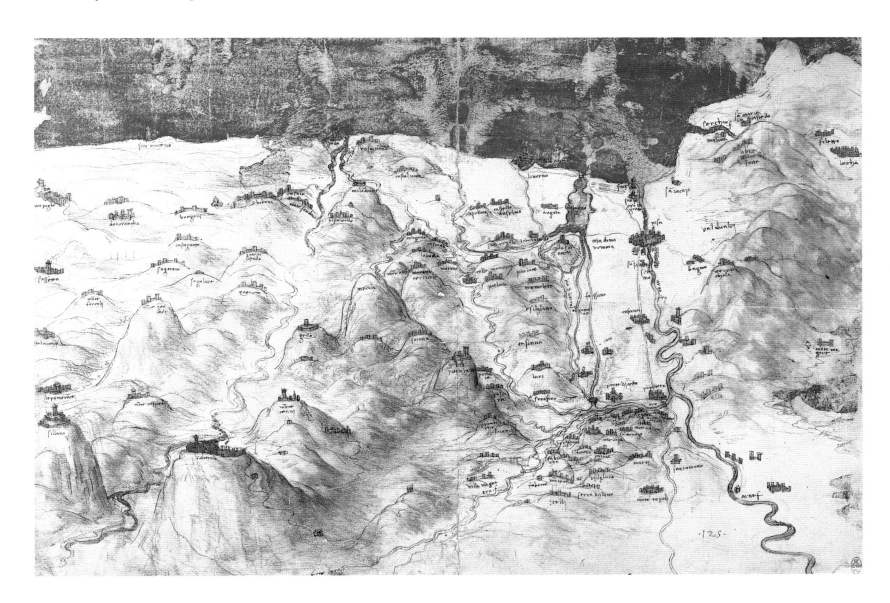

on Isabella d'Este's behalf. Despite her request, Leonardo neither returned to the court at Mantua, nor painted anything for the Duchess. In the following year, 1502, Leonardo was asked by Francesco Malatesta to appraise four jeweled vases that had once belonged to the Medici family and which were now being offered for sale. At this time Leonardo had found himself a new patron, Cesare Borgia, who employed him as his architect and chief engineer.

Cesare Borgia, like Ludovico Sforza, dreamed of ruling all Italy; his motto read 'Either Caesar or Nothing'. His father,

Pope Alexander VI, had made his son the Marshal of the Papal Troops and appointed him Duke of Romagna, thereby ousting the legitimate rulers of the area in the name of the Catholic Church. Florence was subdued by its powerful neighbor and a treaty named Cesare as 'Condottiere' of the Florentine Republic, a title that carried with it a handsome annual income of 30,000 gold ducats.

Borgia, with a mix of Arab and Castillian blood in his veins (and suffering from syphillis), had a reputation for intelligence, a foul temper and odd behavior;

he went to bed in the morning, breakfasted at four in the afternoon and walked about all day wearing a mask. His driving political ambitions also made him capable of murder; in his personal retinue Cesare maintained the services of a hired assassin called Grifonetto. He dispatched Paolo Orini and the Pope's favorite, Perrotta, and executed his own governor of Romagna, Don Ramiro del Lorqua, officially for being an extortionist but actually because he fell in love with Cesare's sister Lucrezia (herself no angel) who had just married. Later Cesare was to murder his brother-in-law as well.

BELOW: *Plan of Imola*, c.1502, pen, ink and watercolor, 17⅓ × 23⅔ inches (44 × 60.2 cm), Windsor Castle Royal Library 12284. © 1994 Her Majesty The Queen. Using a horizontally mounted and graduated surveying disc – possibly an astrolabe – Leonardo was able to record the radial angles of important features of the city when viewed from a high central vantage point. Faintly visible in places are the 64 equally spaced radiating lines, eight of which are drawn in bold and labeled according to the 'wind rose' – north, north-east, east and so on. In the map, every detail is color co-ordinated; the houses are pink, public squares are yellow and the streets are white.

RIGHT: *View of Chiana and Arezzo*, c.1500, black chalk, Windsor Castle Royal Library 12682. © 1994 Her Majesty The Queen. This map, possibly made for Cesare Borgia, appears to have been drawn from the air. In fact it was created using an imaginary perspective, combined with earlier views and studies that Leonardo had made of the region.

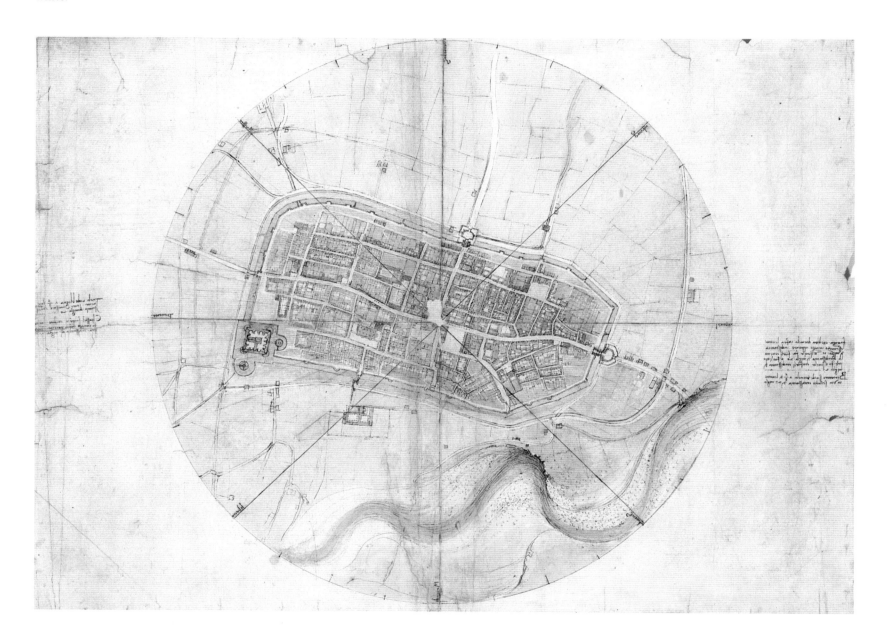

Busy creating his kingdom – the duchies of Faenza, Imola, Rimini, Pesaro and Urbino had already surrendered to him – Cesare was set to invade Umbria. Leonardo accompanied him on his military campaigns, producing maps and surveys. Cesare's chargé d'affaires, whose task as political observer was to report on the general situation, was Niccolò Macchiavelli, the first writer to develop a theory and program of political realism. His book *The Prince*, the main character of which was based on his employer, was

a sort of handbook on how to be successful in politics.

In the summer of 1502 Leonardo accompanied Cesare on his conquering mission through Emilia and the Marches, operating as the chief inspector of military buildings. Manuscript L in the Bibliothèque Nationale in Paris is Leonardo's diary of the journey and in it he records the stops in the region between Imola, Cesena, Rimini, Urbino and Pesaro. Apart from some sketches for the docks at Porto Cesenatico, we do not

have any further insight into Leonardo's official activities. He did, however, draw up the area of Borgia's military operations; part of a map of Tuscany and Romagna was made for Cesare, as was the magnificent circular *Plan of Imola* dated around 1502, an immensely accurate and beautiful plan in which every detail is pinpointed and color-coded. The houses are in pink, public squares in yellow, the streets in white. The castle is at the lower left and is surrounded by the blue moat. The notes at either side of the

plan, written very neatly but nevertheless in Leonardo's famous 'mirror handwriting' (from left to right with the letter forms reversed) refer to the geography, distance and bearings of Bologna and other cities of strategic importance or interest to Borgia.

From remarks he made in Manuscript L, we also learn that Leonardo visited the area of Piombino, part of Borgia's dominion at the northern end of the Tyrrhenian Sea. Iron ore from the island of Elba was unloaded in Piombino's fortified harbor, but the port was more important politically since the city occupied the central point between the bordering territories of the Papal States in the south, Lombardy and Genoa to the north, and Florence to the east. Following a long seige in 1501 Borgia succeeded in wresting Piombino from its ruler Jacopo IV Appiani. In 1502 Leonardo also made the map showing Arezzo and the valley of the Chiana, using an imaginary perspective that gives the illusion of an aerial view. But by the spring of 1503 Leonardo had given up his position with Borgia and returned to Florence. Pope Alexander VI had died and Cesare, back in Rome after an officers' rebellion against him, also fell ill – some say from poison – but he rallied

after being immersed in the steaming entrails of a mule. According to Macchiavelli, it was only because of his father's death and his own ill-health that Cesare was prevented from extending his rule throughout Italy. Ironically, had Cesare decided to launch a campaign against Tuscany, Florence might well have fallen, precisely because of Leonardo's mapmaking skills and the strategic engineering plans he had made for the Duke.

In Florence, Savonarola had been excommunicated and subsequently tried and burnt at the stake, but the system of government he had introduced, consisting of a chamber of 3000 enfranchized citizens, was to continue until 1512. This large council, the Signoria, needed a suitably large and magnificent meeting hall. In 1495 Antonio da Sangallo the Elder had designed a vast hall 178 feet long, 77 feet wide and 60 feet high. Having ousted the Medici, the new ruling Council needed to demonstrate its legitimacy and, hopefully, its expected longevity; the council hall became the vehicle for a decorative scheme demonstrating the virtues and achievements of republican power.

Filippino Lippi was commissioned to produce an altarpiece, depicting St Anne

accompanied by numerous saints who all had particular associations with Florence. Some time in the fall of 1503, Leonardo was commissioned to execute a larger wall painting depicting a scene from the *Battle of Anghiari*, while the young Michelangelo was asked to produce an accompanying scene of the *Battle of Cascina*. Both battles were famous Florentine victories; Michelangelo's subject showed an episode in the war against Pisa when bathing Florentine soldiers were ambushed and rushed for the weapons they had left on the river bank, while Leonardo's was the 1440 triumph over Milanese mercenaries.

Like so many of Leonardo's paintings, *The Battle of Anghiari* was never completed and what he did complete had been lost by around 1560. Although no original contract for the commission survives, we know that on 24 October 1503, Leonardo was given the keys to a large room in Santa Maria Novella in which to produce a full-size cartoon for the painting. By the time the contract was signed, around May 1504, he had been supplied with paper, other drawing materials, and scaffolding. Records show that the contract was witnessed by Macchiavelli, who, clearly aware of Leonardo's reputa-

RIGHT: Copy of the fight for the standard from the center of the *Battle of Anghiari*, c.1550, oil on wood panel, 6 × 8⅜ inches (15.1 × 21.3 cm), Palazzo Vecchio, Florence. One of the copies of Leonardo's painting, which was lost by 1560 when Giorgio Vasari frescoed the Sala del Consiglio.

BELOW: *Studies for the Central and Left Groups of the Battle of Anghiari*, c.1503-04, pen and ink, 5¾ × 6 inches (14.5 × 15.2 cm), Galleria dell' Accademia, Venice.

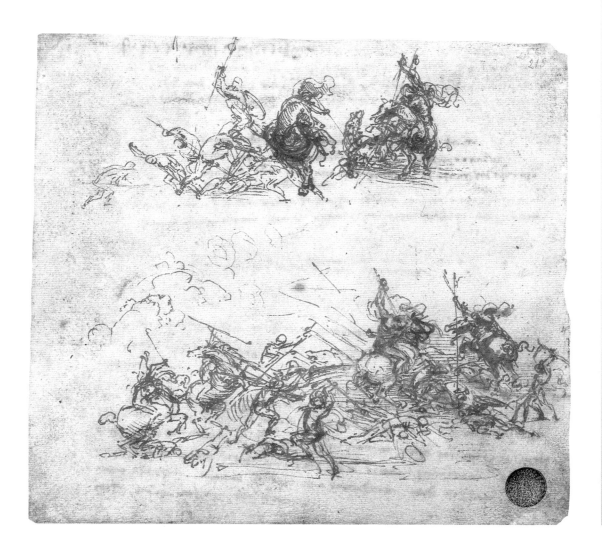

tion for not working to deadlines, stipulated that the cartoon must be complete by February 1505 or, failing that, Leonardo should have started painting the part of the cartoon that had been finished. If the latter was the case, the deadline would be extended.

Throughout 1504 and on past the deadline of February 1505, Leonardo continued to receive supplies for making whitewash, flour for sticking the cartoon to the wall, wall plaster, Greek pitch, linseed oil and Venetian sponges. These materials suggest that he intended to

paint the pitch over the smoother plaster base as a ground for oil-based paint. Much to the chagrin of the mayor of Florence, Piero Soderini, however, work on the *Battle of Anghiari* was abandoned in May 1506. Boards were erected to protect the painting in 1513, and several

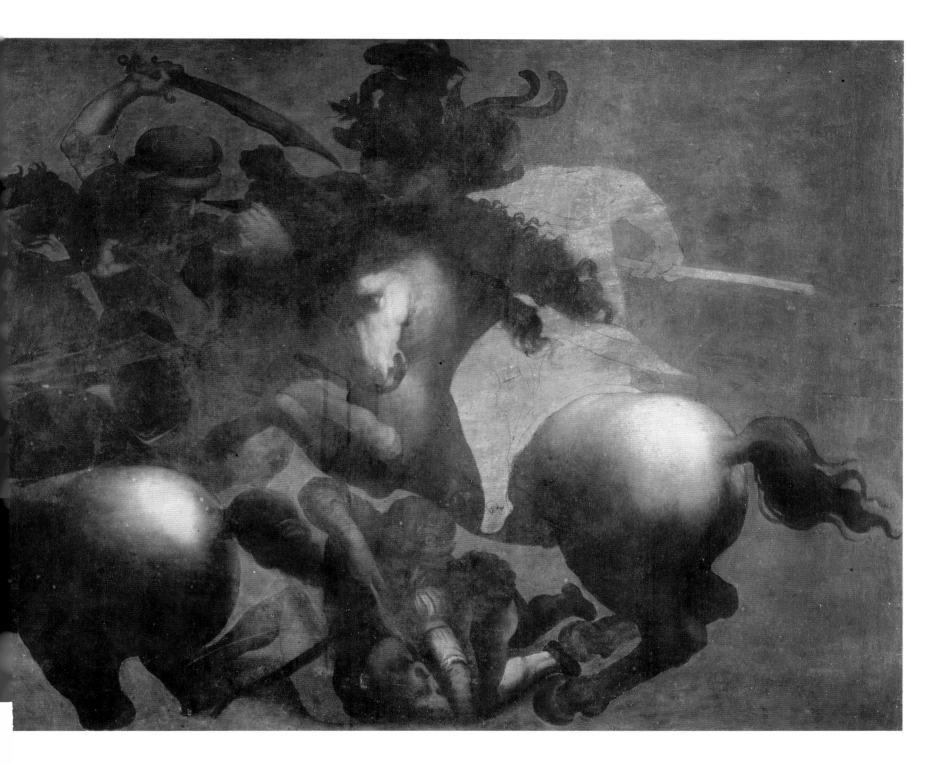

copies were made of it before it finally disappeared under Vasari's frescoes in 1560. It is only from these copies and some preparatory drawings that we know something about this lost work.

Leonardo's work on the *Battle of Anghiari* was no doubt interrupted by other pressing needs. In 1503 the Republic of Florence had once again embarked on a new campaign against its old enemy Pisa and between 24 and 26 July 1503 Leonardo was in the Florentine camp, where plans were being laid to divert the river Arno and cut off Pisa's access to the sea, thus starving the city into submission. One of the chief promoters of this scheme was the Florentine war minister, Macchiavelli. Leonardo must have had some knowledge of this plan, but whether he was actually involved in its implementation remains in doubt. In

ABOVE: A huge treadmill-powered digging machine designed by Leonardo, possibly in conjunction with his schemes to canalize the river Arno between Florence and the sea.

July 1503, at the order of the Council, Leonardo set off to inspect the trench-digging on the project. For well over a year the Arno plan was in action but the cost of manpower – which had been underestimated at 2000 men completing the work in 20 days – and the technical problems of securing the canal walls against collapse led to the scheme being abandoned in October 1504.

Leonardo himself had for many years had a strong interest in diverting the Arno, not for military purposes, but to make the river navigable between Florence and Pisa and thereby increase the volume of trade in Tuscany. He drew up maps showing the course of the river and schemes for its canalization on several occasions. Aware of the man-power required to effect such a scheme, Leonardo also designed a huge treadmill-powered digging machine.

When the plan to cut Pisa off from the sea collapsed (along with much of the canal itself), military activities were temporarily halted. The Signoria recalled its troops and instead planned to isolate Pisa through political channels. In 1504 Macchiavelli went to Piombino to treat with Jacopo IV Appiani, who had returned to power in the city after Borgia's fall. Macchiavelli had to win back Jacopo's trust and confidence in Florence – in 1499 Jacopo had been passed over in favor of Borgia for the position of Condottiere – in order to win his neutrality regarding Florence's hostilities with Pisa and Siena. Neutrality toward Pisa was easy; Jacopo still bore a grudge against the city for having ousted his family four generations earlier. In order to woo him into neutral-ity toward Siena, Leonardo was sent to Piombino in the fall of 1504 to advise Jacopo on fortifications for the city – a scheme Leonardo had originally devised for Cesare Borgia!

This information is of relatively recent origin, made available by the 're-dis-covery' of the Madrid Codices. These had been erroneously catalogued and then recorded as missing, but were found in 1965 on the shelves of the national Library in Madrid. In the Madrid Codex II, Leonardo drew up plans for the recon-struction of the harbor with a breakwater similar to ones devised by Francesco di Giorgio in his *Treatise of Architecture, Engineering and Military Art*, a copy of which Leonardo owned. From Giorgio, Leonardo also 'borrowed' schemes for citadels with rounded towers and thick inclined walls, well suited to deflecting mortar bombardments. In his sketches of fortresses, Leonardo also drew in cannons on top of the walls; he was one of the first military architects to do so. Many of his sketches also show cannons in towers and diagrams which plot the line of fire. Although it is not known whether any actual construction was carried out at Piombino, the tower of the main gate of the city is still known today as 'Leonardo's Tower'.

Despite his efforts, Leonardo found himself out of favor with the Florentines: he had failed to complete *The Battle of Anghiari*; and the plan for diverting the Arno had drained the treasury and some of the collapsed canal had flooded, caus-ing a swampland and resulting in an out-break of malaria which claimed the lives of many Florentines. In addition Leonardo had led a somewhat 'aristo-cratic' lifestyle in a very puritan city, and to cap it all his father died in 1504 and he became entangled in a lawsuit with his step-brothers over shares in the family property. Leonardo stood accused of betraying Florence by his earlier associa-tion with Borgia and of practicing magic, an accusation no doubt fueled by further allegations of homosexuality. At this time, only Isabella d'Este continued to offer her support but, for reasons known only to Leonardo, he chose to avoid her. When Isabella visited Florence, Leonardo went into hiding in Fiesole!

BELOW: *Head of a Man Shouting*, c.1505, red chalk, 9 × 7⅓ inches (22.7 × 18.6 cm), Museum of Fine Arts, Budapest. This drawing is a preparatory study for the unfinished, and now lost, painting of the *Battle of Anghiari*.

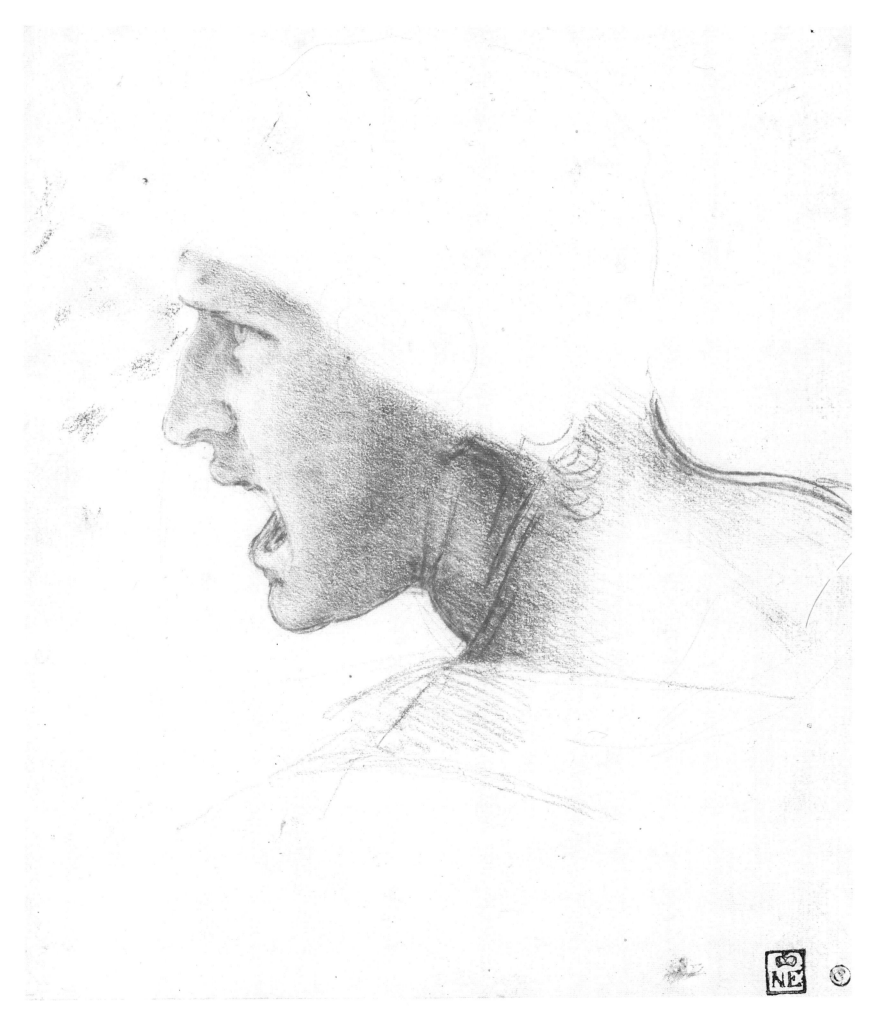

CHAPTER 4
Rome and France, 1506–19

In the spring of 1506, at the request of Charles d'Amboise, Lord of Clairmont-sur-Loire, and Governor of Milan in the name of Charles XII, Leonardo was back in that city. He had been granted three months leave by the Signoria, but he returned to Florence only in the fall of 1507 to end the legal battle with his family and to settle with the friars of San Francesco over the disputed commission for the *Madonna of the Rocks*. Once all litigation was complete, he returned to the French court at Milan, where he stayed until 1512. Joining him in Milan as his pupils were Francesco Melzi (the son of his old friend from Vaprio), Giovanni Boltraffio and Gian Giacomo Caprotti do Ornone, nick-named 'Salai' or 'little devil'. Salai had been part of Leonardo's 'household' since 1491 and was employed as a household servant and occasional model. Beautiful (according to Vasari), obstinate, greedy, a liar and a thief, Salai was also a talented artist and a faithful companion to Leonardo, staying with his master until he died. In Milan Salai was known as the painter Andrea Salaino.

On 27 May 1507 Louis XII made his official entry into Milan, and once again it fell to Leonardo to devise the official celebrations. According to Vasari he designed a vast lion 'which came forward several paces and then opened its breast which was full of lilies.'

FAR LEFT: *The Proportions of the Human Head*, silverpoint on blue prepared paper, 8¾ × 6 inches (21.3 × 15.3 cm), Windsor Castle Royal Library 12601. © 1994 Her Majesty The Queen. In his measured drawings Leonardo was attempting to divine the fundamental rules of proportion in nature, and as such these drawings are often much closer to his mathematical studies than to his anatomical drawings.

BELOW: Detail of the hands of the *Mona Lisa*.

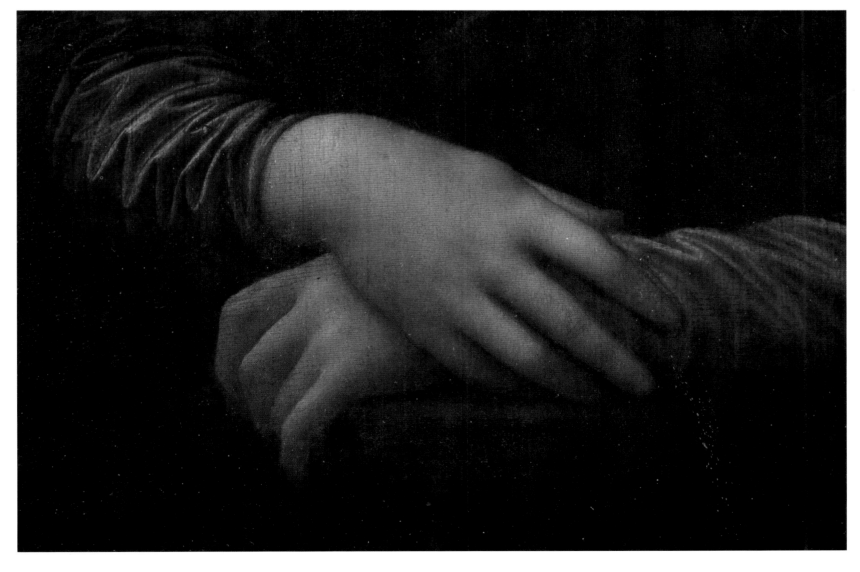

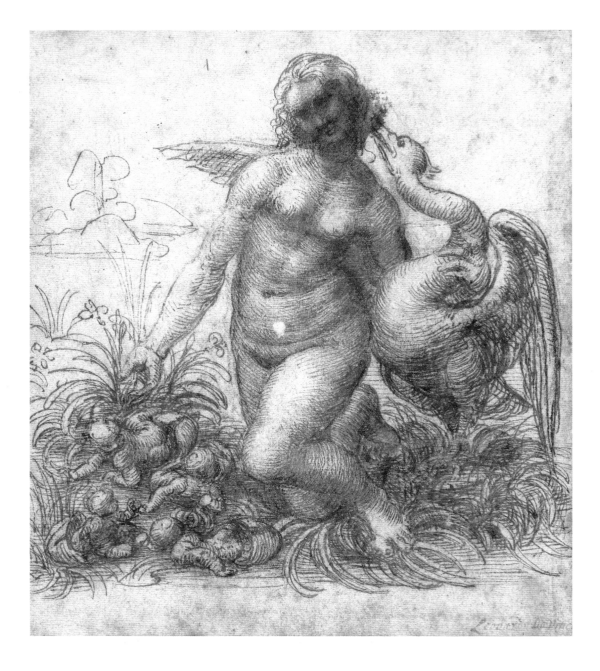

For some years Leonardo had also been working on what was to become the most famous portrait in the history of painting, the *Mona Lisa*. Mona or Madonna Lisa Gheraditi was identified by Vasari as the model. She came from a noble Neapolitan family and in 1495, aged about 17 or 18, she married a Florentine silk merchant, Francesco di Bartolomeo di Zanobi del Giacondo (hence the painting's other title *La Giaconda*). Francesco was about 20 years older than Lisa. She was his second wife, his first, Camilla Rucellai (whose family were also traders in silk) having died in childbirth.

It is very likely that Vasari's identification was based on a misinterpretation, as Anonimo Gaddiano recorded that Leonardo painted Francesco del Giacondo and not his wife. Other inconclusive evidence in documents of various dates has linked the woman in the painting with both Isabella d'Este (which seems unlikely given Leonardo's efforts to avoid her) and the Duchess of Burgundy, the wife of Louis XII. Since Louis was in effect Leonardo's patron, this thesis is not unreasonable. Whoever the portrait represents, Leonardo spent around four years on it. He took the portrait with

him to Milan and it is unlikely that any money passed between him and Giacondo, which suggests that the *Mona Lisa* may not have been a commission at all, but a single painting in which Leonardo worked out all that he had been trying to achieve in his portraits of women, including those of angels, saints and Madonnas.

The presentation and setting of the figure in the *Mona Lisa* is highly original and, although the panel has been trimmed at the sides, we can see enough of the balustrade to recognize that the figure is seated on a balcony with a landscape vista behind her. Such an image was almost totally unprecedented in Florentine portraiture. Even Leonardo's previous female portraits, such as those of Cecilia Gallerani and Ginevra de' Benci, had no such background, or just a glimpse, as through a small window, of such a scene. In the *Mona Lisa* the background is no longer merely a decorative backdrop. The treatment of the figure and the landscape are a reflexion of Leonardo's twin areas of study in the early years of the sixteenth century, the anatomy of the human body, and the movement and development of land-

scapes through geological and meteorological changes. The twisting flow of drapery and head veil echoes the action of the flowing water, while the spiralling curls of her hair are reflected in the pattern of the waterfall. But the reason for the *Mona Lisa*'s fame rests less on this novelty than on the famous 'Giaconda Smile'. The key to the painting's success is the very ambiguity of her expression, and the question of whether or not Mona Lisa is smiling. Whatever our interpretation, we remain transfixed by her gaze.

At this time Leonardo was working on some of the finest botanical drawings ever produced. The majority of the extant studies are related to the years 1508 and after, when Leonardo seems to have been working on the *Mona Lisa* and on variations on the theme of Leda and the Swan, depicting a standing Leda and a kneeling Leda. The story of Leda tells how Jupiter, disguised as a swan, fathered four children: Castor, Pollux, Clytemnestra and Helen, who were all hatched from eggs. The painting of *Leda* is known only from drawings and from sixteenth-century copies of the work. The earliest studies for the painting date from around 1504 (the same time that Leonardo was working on the *Battle of Anghiari*). These, and subsequent studies up to around 1506, developed the theme of Leda kneeling with one arm around the swan. The kneeling Leda had classical precedents in a type of kneeling Venus. Some time around 1507-8 Leonardo transformed Leda into a standing figure and we can assume that this pose became the basis for the painting, since the best copies of the work use this format.

The Rotterdam *Leda* includes a drawing of the plant *Sparganum erectum*, which is also seen in the study *Flowering Rushes*. In the Chatsworth *Leda*, a highly finished drawing of the kneeling Leda, Leonardo included both this elegant marsh plant and a spiralling plant, *Ornithogalum umbrellatum*, at Leda's feet. The study of this plant, the *Star of Bethlehem*,

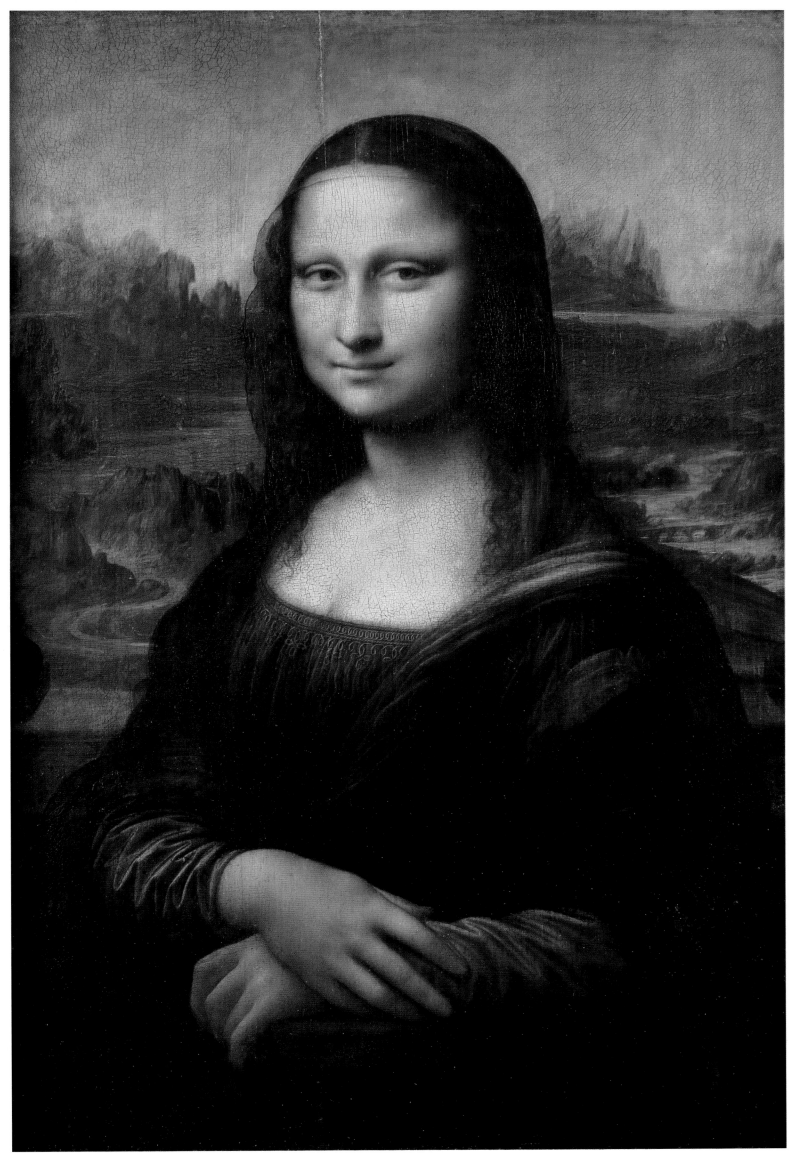

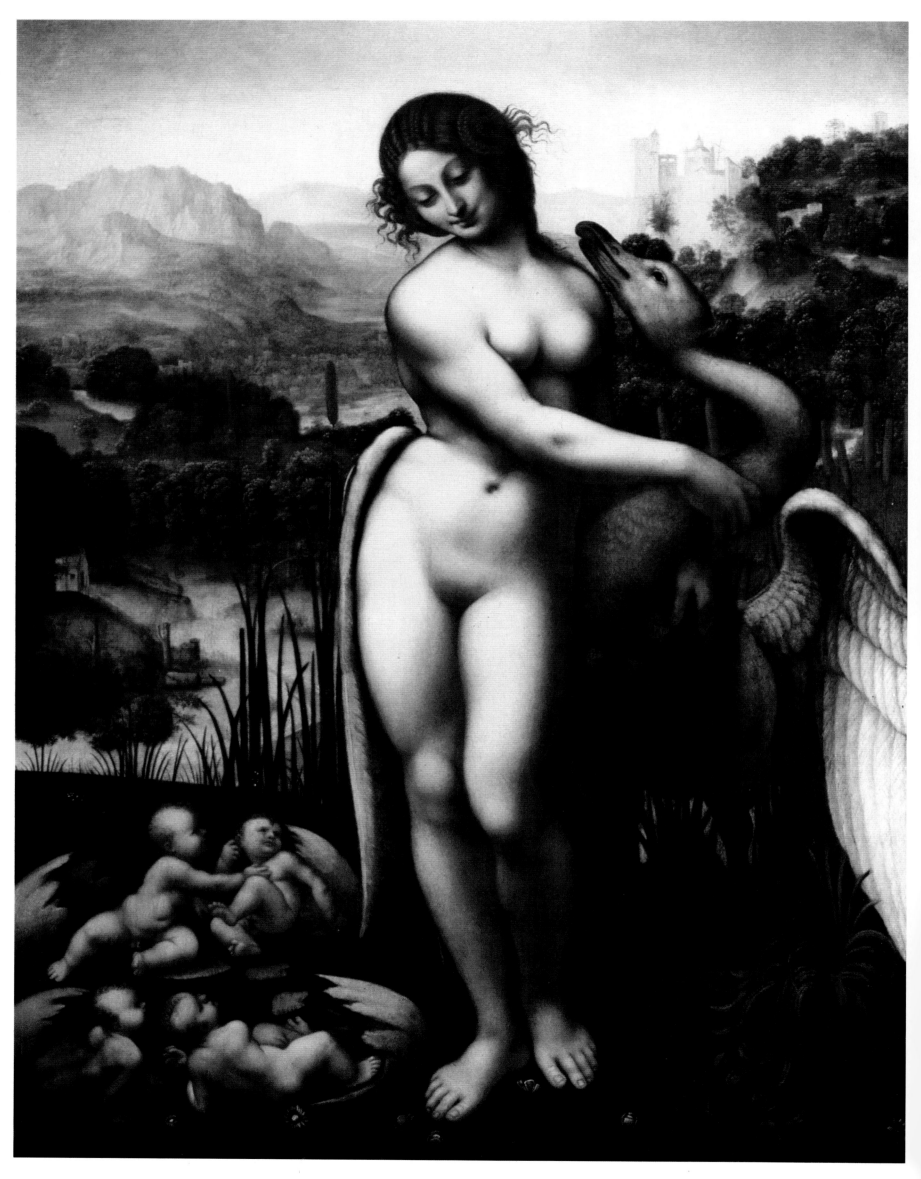

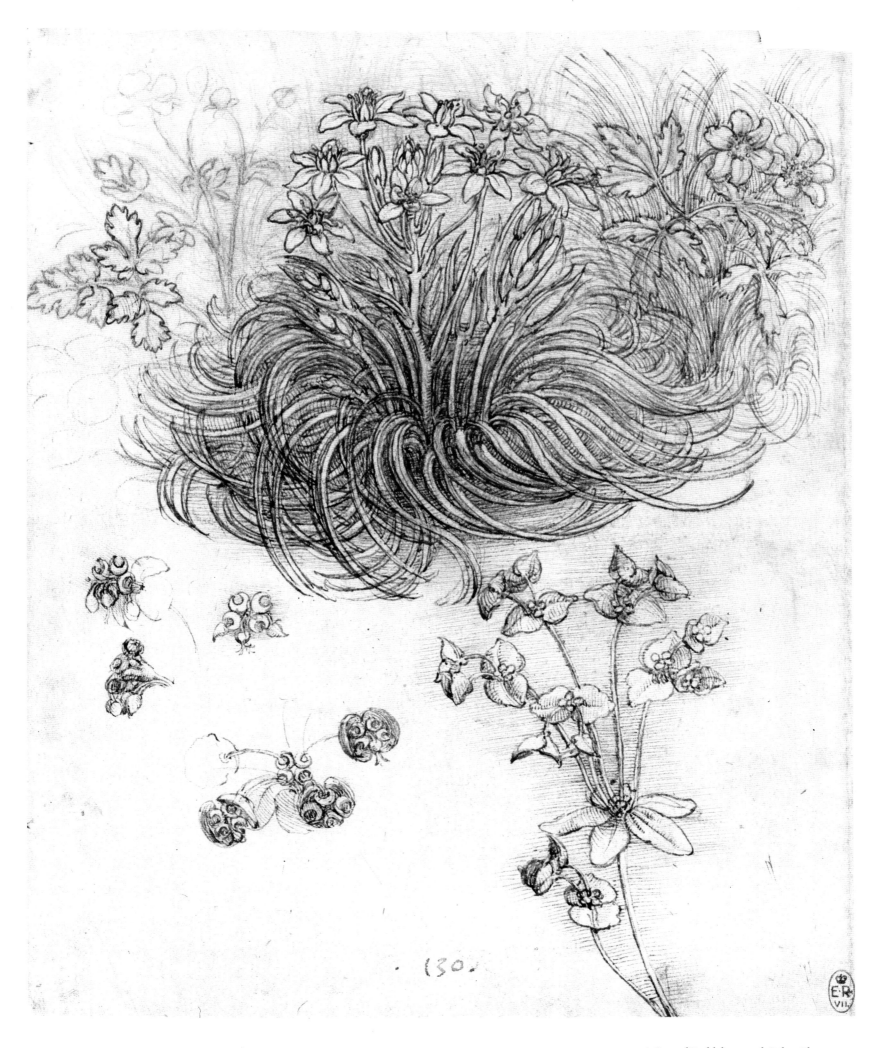

. 130.

LEFT: School of Leonardo, *Leda*, oil on wood panel, 38 × 29 inches (96.5 × 73.7 cm), Collection of the Earl of Pembroke, Wilton House Trust, Salisbury, Wiltshire. Most of the finest copies of Leonardo's *Leda* depict a standing figure, so we can assume that after making studies of a kneeling Leda (page 95), Leonardo settled on this scheme.

ABOVE: *A Star of Bethlehem and Other Plants*, c.1505-08, red chalk, pen and ink, 7¾ × 6 inches (19.8 × 16 cm), Windsor Castle Royal Library 12424. © 1994 Her Majesty The Queen. Possibly Leonardo's most famous botanical study, this is a highly finished drawing of the same plant that appears at Leda's feet in the Chatsworth *Leda* (page 95) and to the bottom right in the Pembroke *Leda* (left).

99

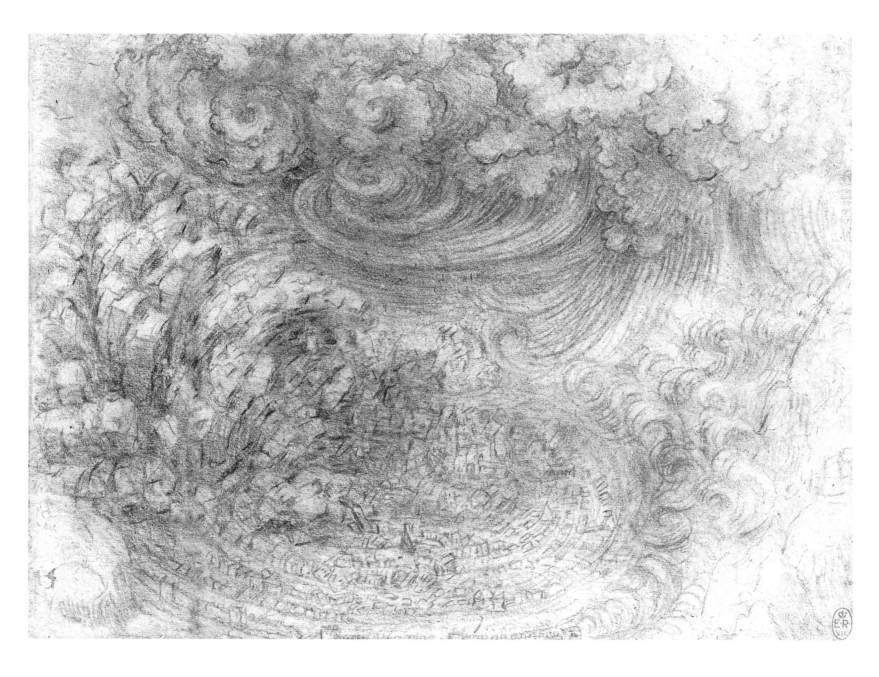

in red chalk, pen and ink, is probably Leonardo's best known botanical drawing, as well as being the most spectacular; there are in fact three different species of plant depicted on this page. It has been suggested by botanists that in its leaf formation the 'star of Bethlehem' does not have such a pronounced spiral arrangement. Its appearance was most likely due to Leonardo's method of observation and analysis, which, as in some of his anatomical studies, tended to result in an emphasis on the underlying structure of things and the patterns that these structures produced. Nevertheless, while he was aware of the iconography of plants and flowers in paintings, Leonardo also ensured that any plant life appeared in its proper 'ecological' setting; while the plants and flowers carry symbolic meaning, they are also true to nature.

The spiraling form that is evident in the ringlets of the *Mona Lisa* and in the drawing of the *Star of Bethlehem*, and the energies embodied in such spirals, were an area of interest to which Leonardo often returned. We can see them in his studies of water, in cloud formations, in the *Deluge* drawings, and in the braided hair of the *Leda* herself. The sheer number of drawings of landscapes and plants testifies to the passionate interest with which Leonardo observed nature. In addition to recording the slight variations within families of trees, Leonardo laid the basis for a theory of landscape in his *Treatise on Painting*. For Leonardo a landscape, as a work of art, had to be not merely decorative but also to correspond to something actual and true. His manuscripts reveal his interest in the changing appearance of trees under different lighting conditions, as well as in their growth patterns, and he excelled, in both his paintings and drawings, in modeling forms by gradations of light and dark.

Some of the botanical studies are also related to architectural forms, such as arches and vaults. The grass *Coix Lachryma-Jobi* was a relatively new plant to Europe when Leonardo made his study of it, *A Long-stemmed Plant*, and we can see a similar shape in his studies for churches and in the *triburio* for Milan Cathedral. At the same time this study of grass also explores the theme of reproduction that can be seen in other drawings of seeding, flowering and fruiting plants. Some of the drawings which at first sight appear to be purely botanical

ABOVE: *Deluge*, c.1513, black chalk, 6½ × 8¼ inches (16.3 × 21 cm), Windsor Castle Royal Library 12378. © 1994 Her Majesty The Queen. The spiralling forms evident in Leonardo's studies of braided hair and plant forms appear again in his cloud and water formations.

RIGHT: *Studies of Water Formations*, c.1507-09, pen and ink, 11½ × 8 inches (29 × 20.2 cm), Windsor Castle Royal Library 12660v. © 1994 Her Majesty The Queen.

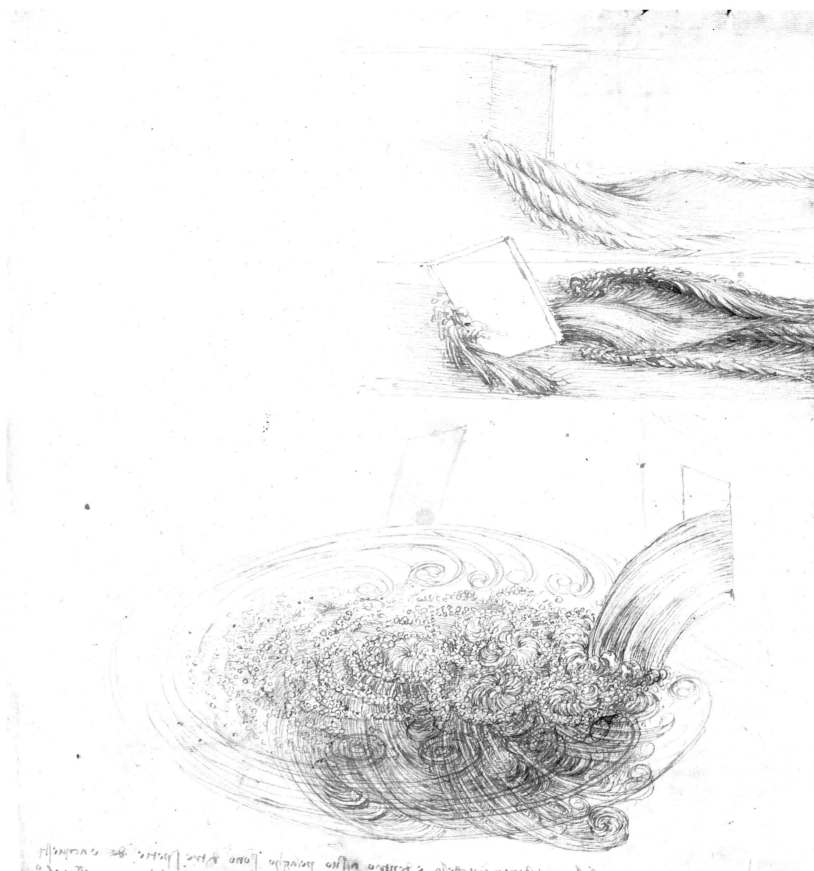

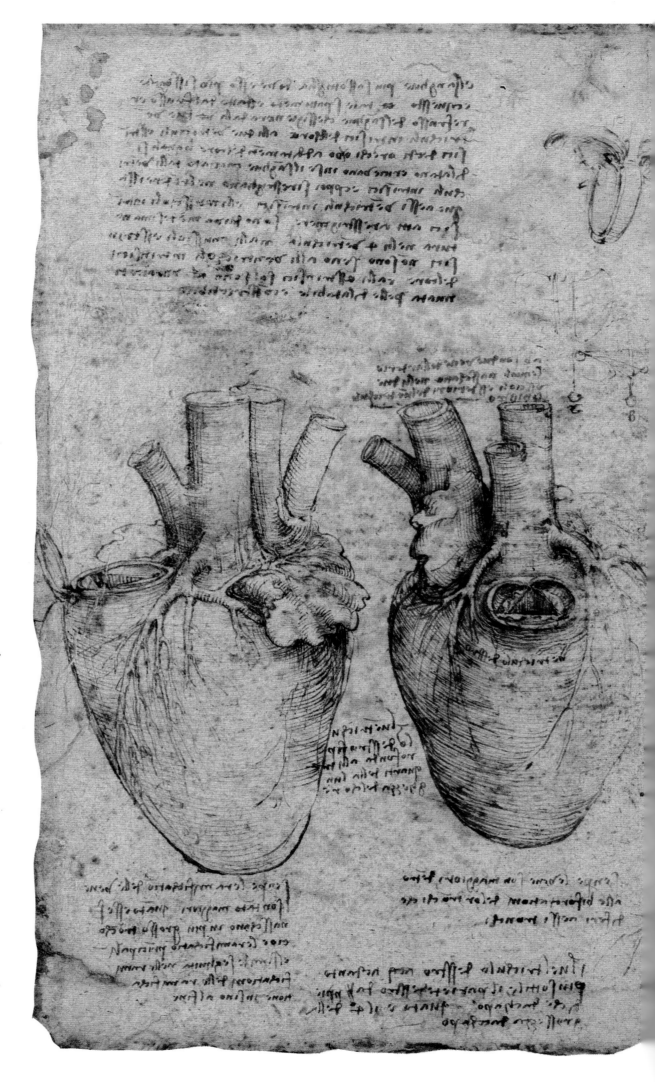

RIGHT: *Drawings of the Heart*, c.1513, pen and ink on blue paper, Windsor Castle Royal Library 19074r. © 1994 Her Majesty The Queen. The circulatory system was described in detail by Leonardo in over 50 drawings of the heart. Early drawings show it with two ventricals while later studies, no doubt informed by his dissections, show the four chambers of the heart in minute detail, but Leonardo did not fully understand the connection between the circulation of the blood and the pumping action of the heart itself.

studies are in fact related to motifs that appear in paintings. *Oak Leaves with Acorns and Dyer's Greenwood* comes from a group of studies in the Royal Collection at Windsor related to the lost *Leda* painting. The oak also appears as a motif in the lunette garlands of *The Last Supper* and in *St John-Bacchus*.

The large number of different studies of plants gives credence to the belief that Leonardo was planning a book on the subject. Had he produced one, it would have been the first of its kind, since the notes that accompany the drawings make no mention of any medicinal properties the plants have. Instead of producing a traditional 'herbal', he was studying and drawing plants in the manner of a true botanist, revealing the qualities of each plant for no other purpose than that of understanding its structure, growth, flowering and reproductive patterns.

Both *Leda* and the *Mona Lisa* represent ideas that Leonardo had formulated earlier in Florence. While there he was deeply involved in anatomical and geological studies, which were then worked on over a number of years up to and even perhaps after 1516, when he left Italy for France. The first date in Leonardo's notebooks on the subject of anatomy comes from April 1489; presumably he was undertaking illegal dissections, a practice strictly forbidden by papal decree. It is possible that rumors of this secret work were spread abroad in Florence, leading to the accusations of his being a heretic and of 'making magic'.

The majority of Leonardo's anatomical drawings, including the famous studies of the heart and of embryoes, were in fact carried out during the second period in Milan, between 1506 and 1513. These studies gained impetus from a particular dissection that had taken place in Florence in the winter of 1507-8, carried out on the body of an old man, the 'centenarian'. Leonardo believed that the old man's death was brought about by the failure of the blood to maintain a supply

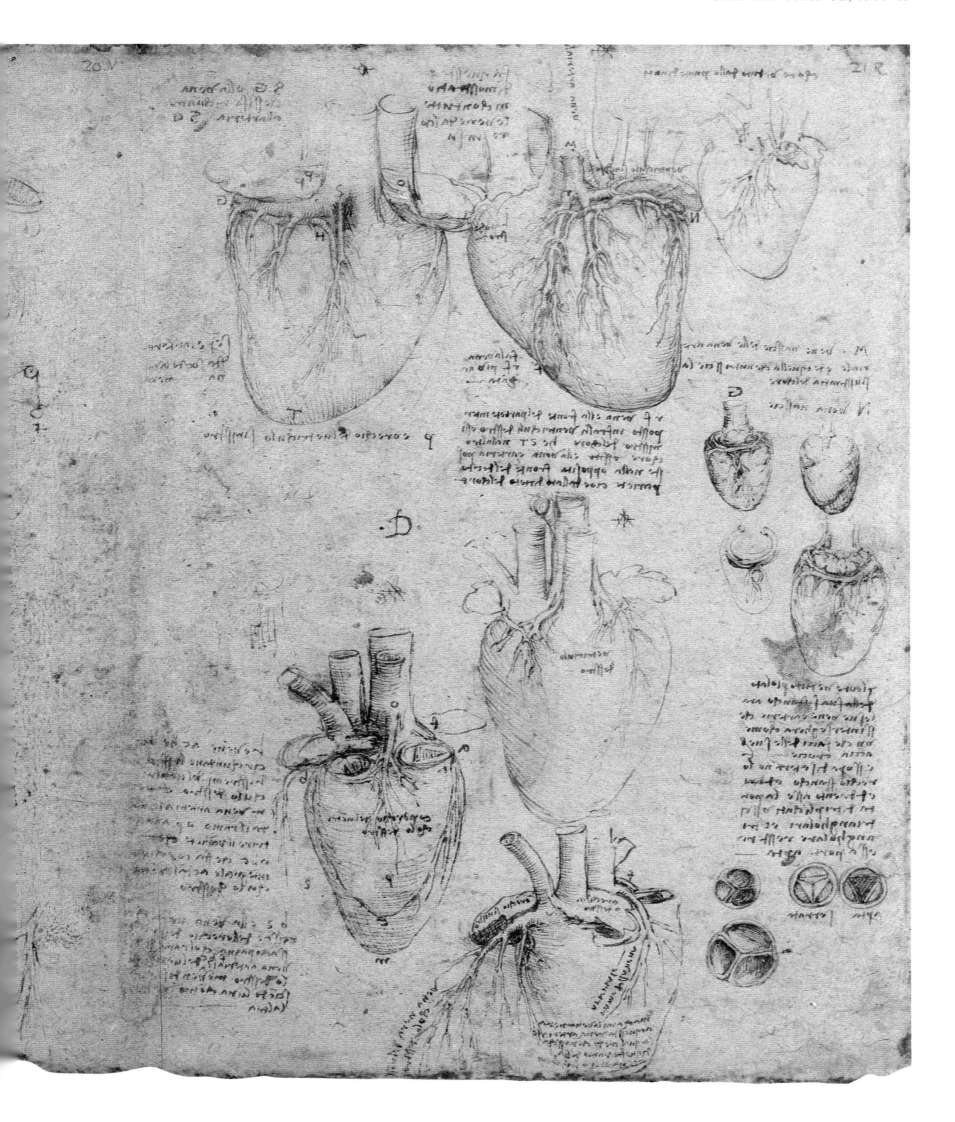

RIGHT: *Study of the Vulva*, c.1513, pen and ink, Windsor Castle Royal Library 190995. © 1994. Majesty The Queen.

FAR RIGHT: *Dissection of the Principal Organs of a Woman*, c.1510, pen, ink and wash over black chalk, 18½ × 13 inches (47 × 32.8 cm), Windsor Castle Royal Library 12281r. © 1994 Her Majesty The Queen. In the accompanying notes to this drawing, Leonardo wrote of a planned series of works, beginning with a study of the formation of the child in the womb, and followed by a discussion of digestion, reproduction and the blood vessels, as well as the cycles of life and death within the human body.

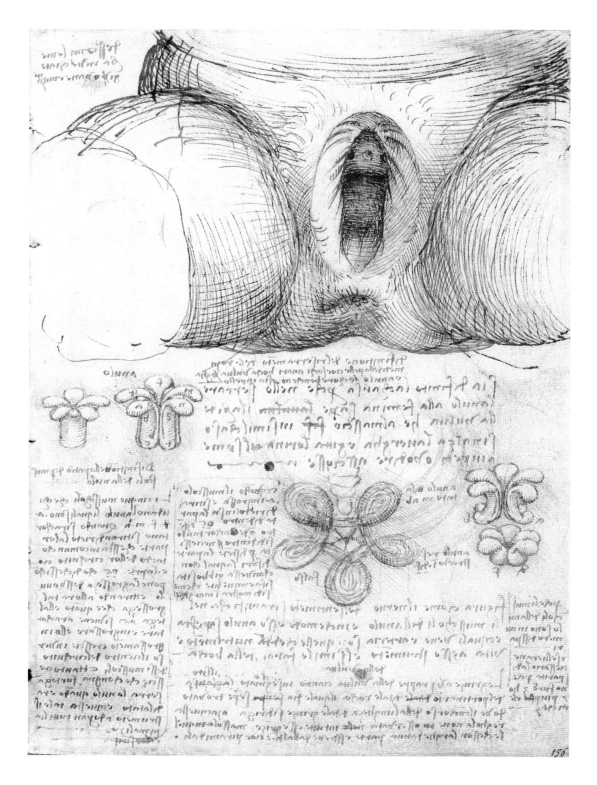

of life-giving humors to the parts of the body. In an analogy with the earth and the landscape, Leonardo saw the old man's channels as silted up and no longer able to irrigate the body. The 'irrigation' system of the human body was examined by Leonardo in his *Dissection of the Principal Organs of a Woman*, dating from c.1507, in which some forms appear in section, some are transparent, while others are shown three-dimensionally. Some organs, including the liver, spleen, kidneys and bronchial tubes, demonstrate the knowledge Leonardo had gained from dissections, while others, such as the heart and womb, are conceptualized.

From a note accompanying a drawing of a foot and lower leg, it appears that Leonardo was hoping to complete all his studies of human anatomy in the winter of 1510. He was convinced that his true task as an investigator was to explain each detail of the human body on the basis of its function. Thus the bones and muscles were conceived as perfect mechanical designs: small and economical, yet capable of many complex movements.

In the last decade of his life, particularly when he was in Rome in 1513, where he was given a dispensation allowing him to continue his studies in anatomy using cadavers (possibly because the papal authorities were convinced that he was searching for the 'seat of the soul'), Leonardo concentrated his studies on two fundamental areas: the heart and the embryo. He was the first to draw the uterine artery and the vascular system of the cervix and vagina, as well as the single-chambered uterus at a time when it was generally believed to be made up of several compartments. This was the explanation given for the mysteries of twin births and litters. Furthermore, Leonardo was the first to describe the fetus *in utero*, correctly tethered by the umbilical cord. The circulatory system was described in detail, often lavishly, in over 50 drawings of the heart. For Leonardo the circulation of blood in the heart, the flow of sap in

plants and of waters in the earth were all analogous processes. Leonardo planned an unrealized treatise on anatomy like his *Treatise on Painting*; although he observed the human body with an anatomist's eye, he was neither surgeon nor physician but a painter. For Leonardo, the knowledge of anatomy was not in itself enough; the artist had to penetrate deeper in order to express the human spirit. The body for Leonardo was the physical expression of the spirit; as a painter he could only give expression to this spirit by understanding and 'reconstructing' the body.

One project that occupied Leonardo for a much shorter period of time was for the Trivulzio Monument. In 1504 the Milanese condottiere Giovanni Giacomo Trivulzio had assigned 4000 ducats to pay for a monumental tomb to be erected in his honor in the church of San Navarro. This commission seems to have

offered Leonardo some compensation for the destruction of his masterpiece-never-to-be, the equestrian statue of Francesco Sforza. He toyed with the idea of a rearing horse, but the scheme he seems to have settled on was for a walking horse mounted on a canopy, over an effigy of Trivulzio on a coffin. Once again, however, the *Trivulzio Monument* was never completed; Trivulzio was not on good terms with Charles d'Amboise, the Governor of Milan, and was forced to flee to Naples. After Charles's death in 1511, Trivulzio returned to Milan and Leonardo's drawing of that date suggests that he hoped that the project might be resumed, but presumably the funds Trivulzio had set aside for were put to some other use. Most likely they were swallowed up in Milan's preparations against hostilities on its eastern borders.

When Pope Alexander VI had died in 1503, he had been succeeded (after the

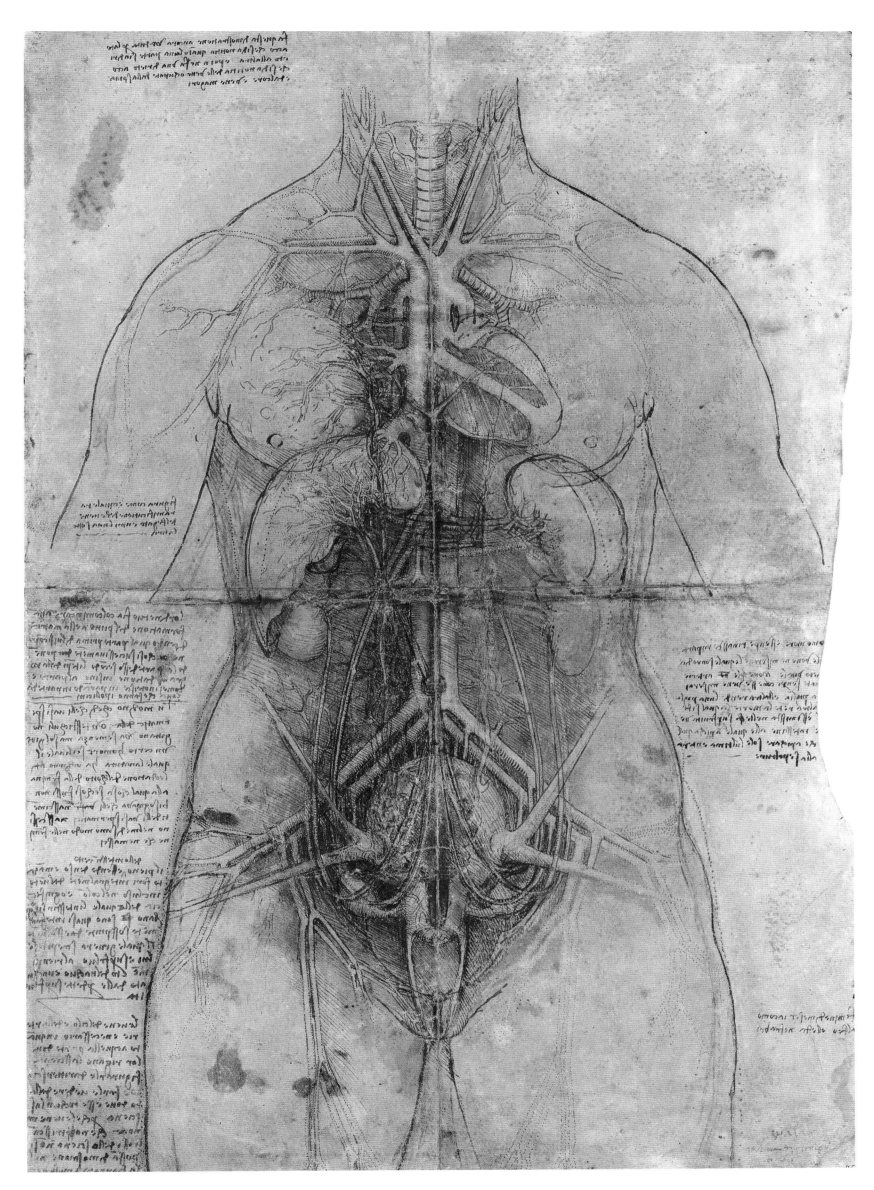

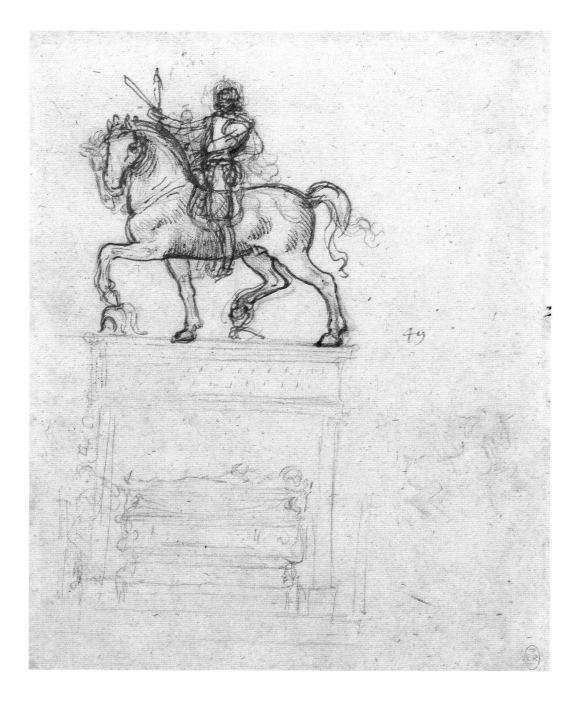

brief papacy of Pius II) by Julius II, and Cesare Borgia had found himself cut off from the papal treasury and opposed to Julius, who was a longtime enemy of the Borgias. As Cesare's Romagna dukedom fell apart, Venice was on hand to pick up the spoils. But since the land now claimed by Venice technically belonged to Rome, Julius, in preparation for war on Venice, entered into an alliance with the Emperor Maximilian and Louis XII of France. As pressure on Venice mounted, she ceded some of the lands formerly held by the Borgias but refused to give up others. Despite backing by Swiss and Romagna mercenaries, Venice was swiftly relieved of Trieste, Gorizia, Pordenone, Fiume and further territories in Hungary. At this point Julius and Maximilian successfully fostered anti-Venetian sentiments in Europe, and the result was the League of Cambrai, December 1508, which allied all major western powers against Venice.

In a sudden reversal of policy, however, in which Louis XII was now seen as the great enemy, Pope Julius resolved to rid Italy of the French through a coalition, the Holy League of 1511, which allied the Pope with Venice and Spain, with additional resources supplied by the English and Swiss. In 1512 Massimiliano Sforza, son of Ludovico Il Moro, entered Milan with the Pope, the Emperor and the Venetians and finally expelled the French.

Leonardo was in a tricky position: he would not be very popular with Massimiliano, since he had fled Milan and Ludovico at the first sign of trouble. Fortunately for him, a bloodless revolution in Florence had returned Lorenzo II de' Medici as head of state, and the following year Giovanni de' Medici was hailed as Pope Leo X and his brother Giulano became Prince of Florence. On 24 September 1513 Leonardo and his companions Salai and Francesco Melzi were on their way to Rome.

Once in the Eternal City, Leonardo was lodged in the Belvedere, the summer palace at the top of the Vatican hill. Also in Rome were Bramante, Raphael, and Michelangelo, all of whom seemed to be the preferred artists, since papal commissions for Leonardo were few. Rumors were being spread again that Leonardo was a sorcerer, rumors fueled, no doubt, by stories of night-time dissections. Of the commissions he did receive, one which interested Leonardo greatly was the project for draining the Pontine marshes around Rome. By transforming the Afonte river into a controled canal system, the marshes could be drained and the land reclaimed for much needed building land.

When the Pope finally awarded Leonardo a painting commission, he noted that he never expected the work to be completed. Leo X had learnt (according to Vasari) that Leonardo was experimenting with a varnish and he is said to have commented that Leonardo would never get any painting done because he was too busy thinking about the end of the project before he had even started!

The only surviving painting which seems, on the strength of a drawing relating to it, to belong entirely to the period after Leonardo left Florence in 1508 is *St John the Baptist*. The effects of age must surely play a part in the overall darkness of this painting, but this is merely an exaggeration of the original effect. The three-dimensionality of the figure is achieved by its being brightly lit against a dark background. This chiaroscuro effect is present to a greater or lesser degree in all of Leonardo's paintings, but in this instance it is used to underline St John's message, with the crucifix and the gesture of the raised finger found so often in Leonardo's paintings from *The Adoration of the Magi* onward.

It is difficult to determine what paintings Leonardo was working on after 1510, apart from presumably continuing work on the *Mona Lisa* and *Leda*. Some red chalk drawings from 1510 and after may be studies for a 'Christ, a Demicorps' being recorded as being at Fontainebleau in 1642. Several versions of the *Salvator Mundi*, a hieratic figure of Christ with a globe in one hand and the other raised, must be copies of the painting for which these drawings are preliminary studies.

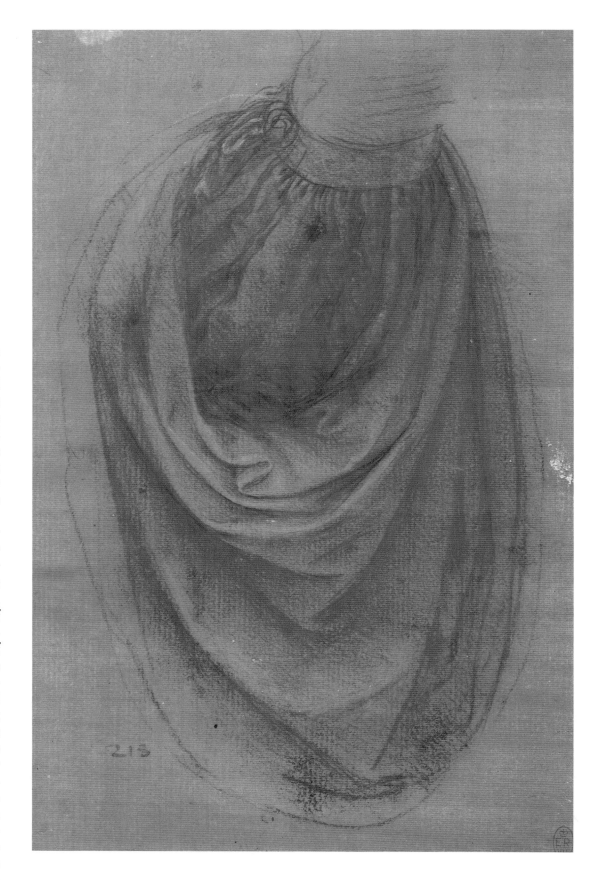

At least partly by Leonardo, though largely by one of his pupils is the *St John-Bacchus*, a painting based closely on a red chalk drawing by Leonardo formerly in the mountain monastery at Varese. The drawing is of a seated St John figure, and the transformation of the figure in the painting to Bacchus, for reasons we can only speculate on, was achieved by merely adding the crown of vine leaves and the leopard skin.

The year 1515 proved to be yet another turning point for Leonardo, as it did for most of Italy. The first day of the year brought him the news of the death of the French king Louis XII. Succeeding him, Francis I set out to regain the Duchy of Milan for France. Allied with the Venetians, Francis quickly gained control of Genoa and defeated the combined forces of Maximilian, Ferdinand of Spain, Massimiliano Sforza, the Swiss cantons and Pope Leo X. In September 1515, against cavalry, artillery and some 20,000 Swiss pikemen, Francis was the victor at the Battle of Marignano. On 14 December 1515, Francis and Leo held secret discussions in Bologna and, according to statements in the Vatican archives which show that he was paid 33 ducats for expenses, Leonardo was in the Pope's retinue. It was in Bologna that Leonardo was probably introduced to the French king, who would have been familiar with the French court at Milan and his work for Charles d'Amboise.

Following Giuliano de' Medici's death in 1516, Leonardo realized that he had again lost a possible patron and looked with disdain on the prospect of working for the Pope. Francis offered Leonardo a pension and a small chateau at Cloux, near Amboise on the Loire river, and Leonardo entered France with the title 'Foremost Painter and Engineer and Architect to the King of France and Technician of the State.' Once again Leonardo was a celebrity adored by the French court, whose king is said to have visited him in his studio.

Leonardo, at the age of 65, was crippled with rheumatism and was suffering from the effects of a stroke. While he continued to devise pageants (there are designs for spectacular animals, such as dragons), canal systems, and even a royal residence, drawn up between 1516 and 1518 and planned as the Queen Mother's residence at Romorantin, Leonardo was unable to paint.

After a hard winter, and in declining health, Leonardo dictated his last will and testament to a royal notary at Amboise on 23 April 1519. To his student and friend Francesco Melzi he bequeathed his books, his instruments and the remaining portion of his pension.

To a servant, Batista, he left half his Milanese vineyard, and to the ever faithful Salai he left the other half. To the poor of the parish of Saint Lazarre he left 70 *soldi*. On 2 May 1519 Leonardo da Vinci died, as one story has it, in the arms of the French king. Although certainly groundless, this has contributed to the tangled web of myth that has surrounded and embellished the few known facts of Leonardo's life. In August 1519 he was buried in the monastery of Saint Florentine in Amboise. In his life he had never settled and, ironically, in death Amboise was not to be his final resting place; Leonardo's mortal remains were scattered during the French Wars of Religion.

Index

Acknowledgments

The publisher would like to thank Martin Bristow for designing this book, Ron Watson for indexing it and Jessica Hodge, the editor. We should also like to thank the following agencies and institutions for permission to reproduce photographic material.

Alte Pinakothek, Munich/Scala, Florence: page 15
Archivio di Stato, Florence/Scala, Florence: page 12
Biblioteca Ambrosiana, Milan: pages 54, 58, 61, 63 (both), 92
Biblioteca Nacional, Madrid: page 62
Bibliothèque de l'Institut de France, Paris: pages 64, 65
Castello Sforzesco, Milan/Foto Saporetti: pages 72, 73
Collection of the Duke of Buccleuch and Queensberry KT, Drumlanrig
 Castle, Dumfriesshire: page 86
Collection of the Earl of Pembroke, Wilton House Trust, Wilton House,
 Salisbury, Wilts: page 98
Courtesy of the Governing Body, Christ Church, Oxford: page 18 (top)
Courtesy of the Trustees of the British Museum, London: pages 13 (both),
 34-35, 55, 85 (top)
Czartoryski Museum, Krakow/Scala, Florence: page 49
Devonshire Collection, Chatsworth House, Derbyshire, reproduced by
 permission of the Trustees of the Chatsworth Settlement: page 96
Galleria dell' Accademia, Venice/Scala, Florence: pages 38, 83, 90
Galleria degli Uffizi/Foto Ottica Europa: pages 10, 33
Galleria degli Uffizi, Florence/Scala, Florence: pages 6, 8, 11, 16-17, 30-31

Galleria Nazionale, Parma: page 43
Hermitage Museum, Leningrad/Scala, Florence: page 12
Musée Bonnat, Bayonne/Scala, Florence: page 28
Musée du Louvre, Paris/Réunion des musées nationaux: pages 2, 18
 (bottom), 32, 40, 41, 42, 50, 77, 80, 81, 95, 97, 107, 109
Museo di Firenze comm'era, Florence/Scala, Florence: page 26
Museo Mediceo, Florence/Scala, Florence: page 29
National Gallery, London: pages 44, 45, 47, 78, 84, 85 (bottom left and right)
National Gallery of Art, Washington DC: page 14 (Samuel H Kress
 Collection), 20 (Ailsa Mellon Bruce Fund)
National Gallery of Scotland, Edinburgh: page 21
Ospedale degli Innocenti, Florence/Scala, Florence: page 27
Palazzo Reale, Turin/Scala, Florence: page 1
Palazzo Vecchio, Florence/Scala, Florence: pages 79, 91
Pinacoteca Ambrosiana, Milan/Scala, Florence: page 48
Pinacoteca Vaticana, Rome/Scala, Florence: page 36
Reproduced by courtesy of the Board of Directors of the Museum of Fine
 Arts, Budapest: pages 52 (bottom), 93
Santa Maria delle Grazie, Milan/Scala, Florence: pages 66-67, 68-69, 70-71
Santa Maria Novella, Florence/Scala, Florence: pages 24-25
Scala, Florence: page 51
Windsor Castle, Royal Library, c 1994 Her Majesty the Queen: pages 4, 19,
 23, 46, 52 (top), 53, 56-57, 59, 60, 75, 82, 87, 88, 89, 94, 99, 100, 101,
 102-3, 104, 105, 106, 108